Sensing Justice through Contemporary Spanish Cinema

Titles available in the series:

Visit the **Edinburgh Critical Studies in Law, Literature and the Humanities** website at
http://www.euppublishing.com/series-edinburgh-critical-studies-in-law-literature-and-the-
humanities.html

Sensing Justice through Contemporary Spanish Cinema

Aesthetics, Politics, Law

Mónica López Lerma

EDINBURGH
University Press

Dedicated to my parents, Ricardo and Pilar, and to Julen.

Edinburgh University Press is one of the leading university presses in the UK. We publish academic books and journals in our selected subject areas across the humanities and social sciences, combining cutting-edge scholarship with high editorial and production values to produce academic works of lasting importance. For more information visit our website: edinburghuniversitypress.com

© Mónica López Lerma, 2021, 2022

Edinburgh University Press Ltd
The Tun – Holyrood Road
12(2f) Jackson's Entry
Edinburgh EH8 8PJ

First published in hardback by Edinburgh University Press 2021

Typeset in 11/13pt Adobe Garamond Pro by
Servis Filmsetting Ltd, Stockport, Cheshire
and printed and bound by CPI Group (UK) Ltd,
Croydon, CR0 4YY

A CIP record for this book is available from the British Library

ISBN 978 1 4744 4204 6 (hardback)
ISBN 978 1 4744 4205 3 (paperback)
ISBN 978 1 4744 4206 0 (webready PDF)
ISBN 978 1 4744 4207 7 (epub)

The right of Mónica López Lerma to be identified as the author of this work has been asserted in accordance with the Copyright, Designs and Patents Act 1988, and the Copyright and Related Rights Regulations 2003 (SI No. 2498).

Contents

Acknowledgments

I would like to thank colleagues, friends, and family who have supported me throughout the writing of this book. My first thanks go to Cristina Moreiras Menor, whose work has been a source of inspiration from the start. Her advice, expertise, encouragement, and friendship have been fundamental for its completion. I also thank Alejandro Herrero Olaizola, who has consistently been there for me, always offering his support and friendship. I am also extremely grateful to William MacNeil, for his huge generosity and enthusiastic support of my research, and Panu Minkkinen, who has constantly been supportive of my work.

At the Faculty of Law of the University of Helsinki, I was lucky to encounter wonderful colleagues and friends. I am greatly indebted to Samuli Hurri, for entrusting me with *No Foundations: An Interdisciplinary Journal of Law and Justice*, and to Johanna Niemi, who generously invited me to participate in her research project on "Gendered Choices in Structures of Law and Gender" funded by the Academy of Finland. Special thanks also to my colleagues and friends Massimo Fichera, Ari Hirvonen, Pia Letto-Vanamo, Stiina Löytömäki, Marta Maroni, Emilia Korkea-aho, and Miia Rinne.

At Reed College, I have been fortunate to find a vibrant intellectual community. I am especially grateful to my wonderful colleagues and friends Diego Alonso, Mark Burford, Elizabeth Drumm, Ariadna García Bryce, Christian Kroll, and Tamara Metz, for making me feel at home. I also want to thank my students at Reed, who are a joy to teach and from whom I learn so much, and Jim Holmes, for his invaluable technical assistance with everything related to film.

Feedback and conversations over the years in different conferences and events have also benefited this book. I am grateful to Ditlev Tamm, who invited me to present my research at the Center for Studies in Legal Culture at the University of Copenhagen, and to Emmanuelle Conte and Stefania Gialdroni for inviting me to deliver a series of lectures on law and film at Roma Tre University. I also want to thank all the participants (Emilios Christodoulidis, Tom Frost, Ari Hirvonen, Toomas Kotkas, Susanna

Lindroos-Hovinheimo, Andrew Schaap, and Gareth Williams) of the workshop titled "Rancière and the possibility of law" and the Center of Excellence for the Foundations of European Law and Polity Research, for generously funding it. I am especially grateful to Susanna Lindroos-Hovinheimo, for organizing a follow-up workshop at the Center for Law and Society in a Global Context in Queen Mary University of London. The influence of Rancière's work is evident in this book, and the conversations and discussions at the workshop were central for my understanding of his work.

I also want to acknowledge the institutional and financial support of the Finnish Cultural Foundation and Reed College. I also thank the external readers for their insightful comments and the editors of Edinburgh University Press, especially Sarah Foyle, for their patience and help in the process.

I am also deeply grateful to a number of friends, colleagues, and family who have encouraged me over the years and made the, at times, draining process of writing a book more enjoyable. Special thanks to Sensio Ample Lerma, Manuel Blay, Topher Davis, Daniel Hershenzon, Rebecca Johnson, Luciana Montesinos, Gabi Montesinos, and Elena Planelles.

My greatest debt is to Julen Etxabe, who has patiently read and commented on different drafts of this book. Without his constant criticism, questions, suggestions, and revisions, I would not have been able to finish this book. You are the most inspiring, brilliant, and loving person I ever met and feel fortunate to have shared the last 20 years of my life with you.

Parts of this book have already been published. Chapter 1 is a modified version of the article "Witnessing Francoism: Ethics of Non-Violence in Guillermo del Toro's *Pan's Labyrinth*," which appeared in *NAVEIŃ REET: Nordic Journal of Law and Social Research* (n. 6, vol. 2, 2015). Chapter 2 is a revised version of the article "Law in *High Heels*. Performativity, Alterity, and Aesthetics," which appeared in *Southern California Interdisciplinary Law Journal* (no. 2 vol. 20, Winter 2011). Parts of Chapter 3 appeared in "Aesthetic Irruptions: Politics of Perception in Alex de la Iglesia's *La Comunidad*," in Paul Bowman's edited volume *Rancière and Film*, (Edinburgh University Press, 2013), and in "Disenso en *La Comunidad* de Álex de la Iglesia" in *Política Común* (issue 4, 2013). Finally, Chapter 5 is a longer and revised version of the chapter "Justice between Terror and Law" in *Rancière and Law* (Routledge, 2018).

I dedicate this book to my parents, Ricardo and Pilar, for their endless kindness, love, generosity, and support, and for teaching me what is important in life, and to the memory of my cousin Miguel Ángel Orts Lerma.

Introduction: Sensing Justice

The meaning of justice and the meaning of the aesthetic may both be sensed, but they can never be codified or entirely understood. They lack an essence, or a definition; they exist in specific performances rather than as general propositions. The aesthetic and the just alike deny the application of a priori models or abstract understandings and instead focus on the tangible and unrepeatable experience of singular events. The artwork and the moment of judgment come each time differently. Reproduction is forgery.

Desmond Manderson (2000: 195)

Sensing Justice examines the "aesthetic frames" that configure both the sensory perception and the signification of justice (i.e., its "senses") through a close analysis of a selection of Spanish films produced between 1991 and 2012. This book does not treat justice as an abstract category or universal disposition that we all share as humans; nor is it a set of procedures for reaching substantive decisions or outcomes felt to be fair and legitimate. The senses of justice – in its procedural, retributive, and/or distributive dimensions – always come mediated by the sensory perceptions and affects produced by the narrative, symbolic, and visual frames that give them meaning. Whether and how we make sense of justice; whether and how we make ethical, political, and legal judgments; and whether and how we legitimize the institutions charged with administering justice, all depend upon these frames. Attention to these frames raises questions such as: What kind of sense of justice do these frames create? What kind of subjects do they show and address? What affective and ethical responses do they produce? What kind of relationship do they establish between self and other? What material and corporeal effects do they generate? What kind of judgments do they invite? In answering these questions, *Sensing Justice* is concerned not so much with *what* the sense of justice is, but with *how* that sense is produced and experienced. Engaging with legal theory, film studies, aesthetics, and politics, I seek here to contribute to contemporary debates about justice, aesthetics, and the senses.

Contemporary Spanish Cinema: The Distinctiveness of Law and Film in Spain

While an extensive law and film scholarship in Spain focuses on the filmic representation of legal institutions, actors, and legal issues (e.g. death penalty, prison system, euthanasia, and torture)[1] and a range of studies explore how films can be used as a pedagogical tool in legal education,[2] few scholars have focused their analysis on Spanish cinema produced after 1975.[3] In contrast to the works devoted to Francoist Spain (1939–1975), law and film scholarship has paid little attention to the period that goes from Franco's death to the consolidation of democracy after the transition and entry into the European Economic Market (1986) and through the 2008 financial crisis and into contemporary Spain.[4] I want to draw attention to two notable exceptions that will help explain the specific approach of this book. The first is *El derecho en el cine español contemporáneo* (*Law in Contemporary Spanish Cinema* 2009), edited by Ricardo García Manrique and Mario Ruiz Sanz; the second is *Los derechos humanos en el cine español* (*Human Rights in Spanish Cinema* 2017), edited by Juan Antonio Gómez García.

In the first of the two volumes, García Manrique and Ruiz Sanz argue that "law films" in Spain are distinct from American courtroom dramas, noting that Spanish cinema has been less interested in the dramatic structure of legal trials. They attribute this to three complementary reasons (2009: 12–13, 18): First, the Spanish legal system follows the continental European model, which does not provide the same opportunities for spectacular trials as does the common-law model (e.g. lawyers do not make great speeches, do not move physically or gesture in the courtroom, and do not vigorously cross-examine witnesses) (2009: 19). Second, the Spanish legal profession does not enjoy the same social prestige as lawyers in the US, which makes it difficult for legal professionals to be protagonists in a film. Third, the legal profession has had less relevance in the development of modern society in Spain than its counterpart has had in the United States. This is because the legal profession is negatively associated with the power structures and repressive legal practices of Franco's dictatorship. All this makes Spanish cinema generally less court-centered and more critical of legal institutions, legal actors, and legal processes (2009: 16). According to García Manrique and Ruiz Sanz, law and film scholarship in Spain has to look outside the courtroom and focus instead on specific legal issues or larger societal problems affected by the law.

Juan Antonio Gómez García makes a similar point in his introduction to his edited volume *Los derechos humanos en el cine español.* The editor proposes to treat films as legal texts, in the sense not of texts with direct normative force that would grant rights or generate legal obligations, but as texts that

enable a better comprehension of everyday legal reality due to their direct or indirect treatment of specific legal issues (2017: 21). From a methodological point of view, then, treating films as legal texts calls for a hermeneutical exercise that ascertains the legal relevance of the cinematographic text on the basis of a certain conception of law, as well as the purpose for which the film is being used (doctrinal, pedagogical, etc.; 2017: 21). Gómez García concedes that this narrative and instrumental approach puts its critical-aesthetic value in a secondary role, insofar as it contributes to a better understanding of the law and the legal content of the film (2017: 21).

Both volumes defend the specificity of Spanish law films and scholarship. This specificity has four key characteristics. First, film analysis is narrative or plot-oriented, paying special attention to the cinematic representation of legal issues, institutions, actors, or to the larger societal problems that law regulates. Second, cinematic spectatorship is mainly conceived as a visual experience. Through its images and representations, cinema invites viewers to look critically at the law and to reflect on its institutions, actors, functions, and problems. Third, both volumes conceive of law as a social and cultural practice that has its own structure and logic that the film can reflect and/ or critically examine, but not affect. And fourth, they approach film as a hermeneutic or pedagogical tool to discuss law and legal subject matters. In this way, film is a supplement to the study of law, in which the former is at the service of the latter.[5]

My approach to contemporary Spanish films acknowledges the different genre of Spanish law films and the importance of addressing the specificity of Spanish legal and socio-political context. However, this book differs methodologically from the earlier scholarship in four key aspects: aesthetic approach to film; film as a multisensorial, embodied experience; law as an aesthetic frame; and trans-disciplinary approach to law and film.

Aesthetic Approach to Film

Sensing Justice approaches cinema not as a text that represents a legal reality to be assessed or criticized, or, alternatively, as a form of popular jurisprudence that would serve to deepen our understanding of law and justice.[6] Rather, it approaches film as an "aesthetic frame" that disposes us to perceive and make sense of the world in one way rather than another, mapping a repertoire of appropriate or inappropriate responses and affective registers.[7] This approach draws on Jacques Rancière's understanding of aesthetics, by which he means not a discipline dealing with art and artworks, but what he calls the "distribution of the sensible," a way of framing what is presented to our sense experience – what can be seen, heard, felt, understood, and thought (2004b: 13). To approach cinema as an aesthetic frame helps us to understand how

the relationship between the film and the viewer constitutes the sensible world – both the world that is sensed and the world to which "sense" (i.e. meaning) is given. Attending to film as an aesthetic frame raises questions such as: What kind of sensory experiences do these frames privilege or downgrade? What kind of gaze do they create? How do they "touch" the viewer? How do they "move" the viewer in certain directions rather than in others?

Accordingly, my analysis does not focus on the narrative aspects of the film and how these reflect on specific legal topics. Rather, I examine the ways in which the film's use of cinematic techniques such as cinematography, mise-en-scène, editing, and sound shape both the content and the viewer's responses to it. An aesthetic reading of the film allows us to be aware of different regimes of perception that an exclusive focus on the narrative level does not afford. For example, chapter 4 examines the disciplinary technologies of control and surveillance that multinational corporations use to ensure compliance and foreclose dissent through Marcelo Piñeyro's 2005 film *El Método* (*The Method*). The chapter demonstrates that while narratively and visually the film invites viewers to be complicit in these technologies of control, acoustically (i.e., aesthetically) it invites us to question them. Thus, restricting the analysis to the narrative dimension overlooks the power of sound to disrupt the complicity of the viewer in the regime of the visible (what is shown/seen).

While the films analyzed generally invite viewers to reflect critically upon the prevailing notions of law and justice that dominate contemporary legal and economic systems, I argue that the combination of form and content, aesthetic and narrative, deploys the full potential of these films – for example, by actualizing alternative or unrealized possibilities that reformulate law and justice.

Film as Embodied and Multisensory Experience

In line with the work of law and film scholars Rebecca Johnson and Ruth Buchanan (2009), Alison Young (2010), and Shohini Chaudhuri (2014), *Sensing Justice* argues that a narrative approach neglects the fact that film is an embodied, multisensory practice. The book draws on the work of film theorists who have explored the embodied and multisensorial experience of cinema beyond the visual and the narrative. As film theorist and composer Michel Chion has pointed out, cinema does not just address the eye, it engages the viewer in a specific audiovisual mode of "transsensorial perception" (1994: xxv, 136).[8] In other words, viewers do not experience the visual and auditory aspects of cinema separately. Instead, the two perceptions mutually influence and transform each other, lending "each other their respective properties by contamination and projection" (1994: 9). As a result, seeing an image influences one's aural perception, just as hearing a sound influences one's

visual perception.[9] In addition, cinema "also generates rhythmic, dynamic, temporal, tactile, and kinetic sensations that make use of both the auditory and visual channels" (1994: 152).

In line with Chion's argument, film theorist Vivian Sobchack argues that "we do not experience any movie only through our eyes. We see and comprehend and feel films with our entire bodily being" (2004: 63). To explain this embodied experience of cinema, Sobchack introduces the term "cinesthetic subject," a neologism that alludes to the ways various senses interact with one another and can be heightened or diminished, as well as normatively regulated, in relation to history and culture.[10] With the cinesthetic subject, Sobchack wants to subvert prevailing theories of the gaze that restrict the cinematic sensorial experience to "an impoverished 'cinematic sight'" (2004: 71). Instead, Sobchack emphasizes the embodied vision of the film viewer who, "in-formed by the knowledge of the other senses, 'makes sense' of what it is to 'see' a movie—both 'in the flesh' and as it 'matters'" (2004: 70–71). For Sobchack, "the film experience is meaningful *not to the side of our bodies but because of our bodies*" (2004: 60, original emphasis).

In turn, film and media scholar Laura Marks proposes the metaphor of the "skin of film" to call attention to "the way film signifies through its materiality, through a contact between perceiver and object represented" (2000: xi). With the skin metaphor Marks alludes to what she calls "haptic visuality," that is, "the way vision itself can be tactile, as though one were touching a film with one's eyes" (2000: xi). In this way, "the eyes themselves function like organs of touch" (2000: 162). For Marks, it is important to distinguish haptic visuality from optical visuality. Whereas the latter perceives things as distinct in space and privileges the representational power of the image, the former "moves over the surface of its object . . . to discern texture," privileging the material presence of the image (2000: 162–163).

Finally, in order to move beyond the visual and capture the haptic experience, cultural critic and theorist Giuliana Bruno proposes talking of film spectatorship not as a "sight-seeing" experience, but as a "site-seeing" activity, where spectators are not "voyeurs" but "voyageurs" (2018: 15–16). Unlike the voyeur who observes the moving image from a static, distant, and disembodied position, the voyageur is like a passenger who physically traverses and explores the filmic space from the inside, engaging in a kinetic, haptic, and embodied experience (2018: 17, 178). For Bruno, cinema is not only an image but also a space that the spectator inhabits and experiences tangibly (2018: 65). By thinking of the film spectator as a site-seeing activity, Bruno seeks to redefine film space as "a heterogeneous space comprised of constantly moving centers . . . where the spectator-passenger [or voyageur] is mapped within the landscape" (2018: 178).

Law as an Aesthetic Frame

The aesthetic and multisensory dimension of film pushes us equally to consider law not as a mere set of logical propositions or abstract rules to be applied to a specific case, but as a collection of symbols, ideas, images, and metaphors, which form specific "way[s] of seeing and constructing the world" (Manderson 2000: 28, 43).[11] Consequently, the law itself can be viewed as an aesthetic frame: as a form of perception and signification that allocates ways of sensing, feeling, being, moving, and thinking within a given society. Law's aesthetic frames establish the boundaries between what is legally visible or invisible, what can be heard as legally relevant or dismissed as irrelevant noise, who is included or excluded as a legal subject, and so on. By approaching law aesthetically, the book explores the ways in which law is implicated in the construction of hierarchical and exclusionary distributions of the sensible. Thus, I analyze the aesthetic frames of neoliberalism (chapter 3), surveillance technologies (chapter 4), and of the abstract forces of urban planning (chapter 6). The book reflects on the role that law plays in reinforcing and reproducing the frames by which those who are perceived as "other" – political dissidents and the "vanquished" (chapter 1), LGBTQ (chapter 2), sex workers, homeless, drug addicts (chapter 6), protesters (chapter 4 and 5), immigrants (chapter 6) – are identified and categorized as less-deserving of legal protection.

At the same time, *Sensing Justice* explores how the hierarchical distribution of the sensible might be resisted and disrupted from within. Despite the pressures of the law to exhaust or "saturate" this order of the sensible, I show that there is always the possibility for a crack, a point of entry for imagination to seep in and change the existing frames of the perceptible.[12] Such cracks, even if temporary, encourage new ways of sensing and feeling and make possible new legal subjectivities. Beyond thematizing the frames governing the perceptible reality of law (Butler 2009), I show how these films reconfigure the viewer's sensory frame of perception. For instance, chapter 2 examines the use of camp aesthetics in Pedro Almodóvar's film *Tacones Lejanos* (*High Heels*), focusing on the actions of the on-screen judge (Domínguez). By analyzing the aesthetics of exaggeration, excess, artificiality, parody, and incongruity in the Judge's campy performance as a female impersonator, I argue that the film invites viewers to view the law from a queer perspective, challenging law's manifold binarisms (masculine/feminine, identity/difference, heterosexual/homosexual, natural/artificial, private/public, reason/emotion). By re-imagining law from a queer perspective, the film undermines the hierarchy that privileges masculinity, heterosexuality, and patriarchy and opens up the possibility for an aesthetic judgment that takes seriously the call

of subjects that the law has traditionally excluded. It is in this sense that the films analyzed in this book are law-related, but not because they represent particular legal institutions, actors, and issues, but because they create new frames of perception and signification for questioning the sense(s) of law and justice taken for granted.

It is important to note that approaching law aesthetically does not negate its corporeality. Quite the opposite. Law's aesthetic frames involve both symbolic ways of conceiving the world and their concretization in material practices.[13] Attending to law's aesthetic dimension requires us thinking of law not as a disembodied abstraction, but as embodied and emplaced (Philippopoulos-Mihalopoulos 2015). Just as film theorists invite us to see cinema as multisensorial and embodied, scholars working on law and the senses provide ways of rethinking legal semiotics beyond the visual to include the spatial, the aural, and the tangible (Marusek 2016: 2; see also Howes and Classen 2014; Pavoni 2018). These scholars note that, whereas the law's gaze functions as a powerful abstraction to articulate specific ways of seeing and knowing, law's materiality suggests "a set of practices involving embodied sensing" (Hamilton et al. 2018: 7). For this sensing to take place, the law needs to be inscribed or materialized in other bodies (human or non-human), which are already immersed in the world and therefore necessarily engaged in encounters with other bodies.[14] *Sensing Justice* explores how the encounter between the law and other bodies is not unidirectional but reciprocal: the law not only affects the bodies it encounters it is also affected by these bodies (Philippopoulos-Mihalopoulos 2011; Butler 2019). In other words, the bodies that the law encounters are not passive objects of legal regulation, but active bodies able to affect the law in their reciprocal interactions. By paying attention to the aesthetic and the corporeal dimensions of law, the book shows that law is at once aesthetic and material.

Use of a Transdisciplinary/Indisciplinary Approach to Law and Film

This book's aesthetic approach does not consider film as an instrument or supplement for the study of law. Whereas *El derecho en el cine español contemporáneo* and *Los derechos humanos en el cine español* treat law and film as two separate fields and make film subordinated to law, *Sensing Justice* examines their mutual constitutive relationship. Past research has typically compared law to another discipline in order to find what they can teach each other (signified in titles structured "Law *and* . . .")[15] or examined how law is represented in film (Law *in*).[16] Instead, this book views law and film as two ways of framing the sensible that mutually inform, complement, influence, intervene, and disrupt one another. An aesthetic analysis of the law is not properly inter-disciplinary, but trans-disciplinary (Manderson 2000: 36),

or even "indisciplinary" (Rancière 2009b: 3). It seeks to break disciplinary boundaries and demonstrate that "a discipline is always a provisional grouping, a provisional territorialization of questions and objects that do not in and of themselves possess any specific localization or domain" (Rancière 2009b:3).

Book Overview

Sensing Justice examines the centrality of aesthetics, sensory perception, and affect towards an understanding of both law and justice. Each chapter provides some contextualization to situate the film it analyzes within its political, social, and historical context. But in no way is this meant to limit the scope of the analysis to contemporary Spain, as the goal of the book is to open pathways to similar challenges in different national contexts. Moreover, the book seeks to expand the notion of contemporary Spanish cinema by including Mexican director Guillermo del Toro's *El Laberinto del Fauno* (*Pan's Labyrinth*) and Argentinian director Marcelo Piñeyro's *El Método*, both of which are set in Spain. Through their central topics – violence, alterity, neoliberalism, power of corporations, terrorism, and urbanism – each chapter weaves multiple ways of sensing justice in ways that may be relevant to contemporary societies throughout the world.

The first two chapters explore the ethical responsibility that arises from the encounter with groups that take the form of "the other." Chapter one is concerned with images of graphic violence and their effects on viewers. Do they cause desensitization towards violence, such that they should be eliminated? Do they encourage objectification of others, turning their suffering into a spectacle for viewers' enjoyment or entertainment? Alternatively, is it possible to watch these images in ways that do not reproduce objectifying ways of seeing, but open up instead the possibility for an ethical viewing? What affective and critical devices might this require? The chapter explores these questions through Guillermo del Toro's film *El Laberinto del Fauno* (2006), which combines the imagery of dark fairy tales with images of violence (e.g., torture and murder) in its depiction of the Spanish post-war years and the resistance of anti-Francoist guerrillas. I situate the film within the genre of human rights cinema, by challenging the emphasis on narrative and truthfulness of the Charter of the Human Rights Film Network. Instead, I follow Shohini Chaudhuri's suggestion to shift from focusing on narrative in favor of addressing aesthetic choices that lead to either moral or ethical confrontation with human rights violations. The film's graphic images of torture and murder may shock, appall, and stir feelings of hatred and revenge, but they at all times push viewers to reflect on the frames that delimit seeing and not seeing, the subject position and agency of both victims and perpetrators,

as well as viewers' own embodied investment in the scenes of violence. In this way, the film opens up the possibility of an ethical witnessing, challenging the hierarchical subject-object relationship.

Contrary to the ideals of objectivity, impartiality, and abstraction that dominate law and the administration of justice in the modern age, chapter two seeks to establish an alternative model that would emphasize fluidity, role-reversal, and aesthetic engagement as critical for understanding law and legal judgment. It does so through the lens of Pedro Almodóvar's *Tacones Lejanos* (1991). In contrast to Orit Kamir's jurisprudential reading, which argues that the film constructs a caring, compassionate, and nonjudgmental "cinematic judgment" through the actions of the on-screen Judge Domínguez, this chapter proposes that an ethics of alterity (in the Levinasian sense) sheds more light on the film than an ethics of care. By analyzing the cinematic technique of the "direct address" (when a character looks directly into the camera) and the judge's campy performances as a female impersonator, the chapter argues that *High Heels* places the viewer in several judging positions that challenge the one-dimensional compassionate judgment and opens up the possibility for an aesthetic judgment that is responsive to the call of the vulnerable other. The last part of the chapter explores how the interaction between the camp aesthetics of the on-screen judge and the viewer re-conceptualizes law as a queer performance.

The next two chapters examine the notions of political community and the logic of consensus and dissent in contemporary democracies. Chapter three rethinks the notions of political community and democracy through Álex de la Iglesia's *La Comunidad* (*Common Wealth*, 2000), and places them in the context of the anxieties attending Spain's integration in the European Monetary Union (EMU) in 1999. Taking as starting points Jean Baudrillard's vision of the "consumer society" and Jacques Rancière's account of the "politics of consensus," this chapter suggests that *La Comunidad* launches a powerful critique of the ideological presuppositions and "regimes of visibility" of Western liberal democracies. In particular, the film invites viewers to critically examine two different but interconnected regimes of visibility that determine what can be seen, said, and thought: first, the regime of "sensory commodity" proper to the consumer society; and second, the regime of the "saturated community" proper to the society of consensus. However, departing from previous analyses, it is argued that the real strength of the film lies not in its ability to render visible this order of domination, but rather in its ability to create an aesthetics of dissensus within the sensory world of the viewer. In this way, the film demonstrates not just the aesthetic dimension of politics, but the political character of aesthetics.

Chapter four examines a perceived tension in contemporary societies

between the *depoliticization* of the public sphere (through mechanisms of surveillance by states, corporations, and the mass media) and the opposite call for its *repoliticization* (through movements such as the "picketers" (*los piqueteros*) in Argentina or the anti-corporate globalization movement). The chapter turns to Marcelo Piñeyro's *El Método* (2005) which productively presents this tension in two ways: first, by inviting viewers to participate in depoliticizing structures of power, and then by inviting them to question their role and responsibility in those structures. On the one hand, the film uses the cinematic split-screen technique to grant viewers a godlike perspective and ability to watch different actions and events synchronically, as if through a surveillance camera. Job candidates are scrutinized from the point of view of a multinational corporation during massive anti-corporate globalization protests in Madrid, which the mass media presents in dismissive terms. On the other hand, the film's subtle use of sound effectively disrupts the complicity of the viewer in these structures and provides possibilities for political subjectivation. Drawing on the work of Michel Chion and Mdalen Dolar, the chapter shows how the "acousmatic sound" of protest irrupts into the viewer's given space of the visible and provides avenues for what might be called a "sonic emancipation."

The last two chapters examine strategies of policing and the aesthetic frames that underlie the logics of urbanization and (increasing) securitization of space. Chapter five explores the "aesthetic frames" that constitute the sensory configuration of security and justice in the post-9/11 "age of terror," through Enrique Urbizu's film *No habrá paz para los malvados* (*No Peace for the Wicked*, 2011). The film exposes what Michael J. Shapiro (2009) has called the "violent cartography" of national security in the context of the Madrid terrorist attack on March 11, 2004, when a series of ten coordinated bombs exploded in three different train stations, killing 191 and injuring 1,841. The film shows how Santos Trinidad, a once-respected but now drunken cop, kills three people in a nightclub with no apparent motive while the city of Madrid is implementing strong security and control measures in preparation for the G20 summit. From then on, the film leads the viewer on a double chase: Trinidad's hunt for the only witness who managed to escape, which leads him to uncover a Colombian mafia network linked to an Islamist cell planning a terrorist attack; and the police search for the triple murderer, which ironically becomes a hunt for one of their own. The chapter shows how, while at the narrative level the film seemingly reinforces the ideological discourses of security and justice constituted by the state and the media, at the level of aesthetics the film disturbs and reconfigures the frames within which the former discourses are to be understood. The film uses a post-Western aesthetic that recycles themes, tropes, and styles of classical

Western cinema to actively interrupt and modify its assumptions, ideology, and values. The last part of the chapter shows how, against the state's rhetoric of safety, protection, and prevention, the film makes visible both the failure of the law to respond to violence and the inability of the police to intervene in it effectively. By leaving the viewer with a disquieting feeling of uncertainty and danger, the film asks the question, is there a place for justice between violence and the law?

Drawing on the works of Henri Lefebvre, Chris Butler, and Andreas Philippopoulos-Mihalopoulos, chapter six explores the relationship between justice, aesthetics, and (the right to) the city through the 2012 Spanish film *Grupo 7* (*Unit 7*) directed by Alberto Rodríguez. Based on real events, the film follows a police unit tasked with cleansing the touristy downtown of Seville of prostitution and drug trafficking in order to convey an image of modernity for the Universal Exposition of 1992. The film uses real archive footage to reconstruct the events leading up to the inauguration of the Seville Expo '92, moving from images of the city under construction to images of former King of Spain Juan Carlos inaugurating the magnificent architectural structures. The film contrasts this footage with images of the slums of the city, where a sense of community is created when their inhabitants decide to fight back against the brutality of the police. By inviting viewers to experience the violent transformation of Seville, the film makes visible pervasive forms of violence (drugs, crime, police brutality, and corruption) concealed behind the promises of modernity in an allegory of the real state bubble and the 2008 financial crisis in Spain. It exposes the ways in which the state and the law (through regulations, law enforcement, and the courts) shape the social body, organize relations of power, and distribute the sensory order – meaning who and what is included or excluded and who and what is visible or invisible – in a way that erases difference and diversity. It turns out that making the city "attractive for tourists" entails supposing that poor residents have no right to the new urban landscape. The chapter argues that rather than offering a solution, the film constructs a haptic aesthetic where the city's suburbs and outskirts, its messiness and noise, generally all brushed off by the logic of progress and modernization, cannot be left out from the viewer's sensory experience of the city.

Notes

1. See for instance the collection of monographs entitled *Derecho y Cine* directed by Javier de Lucas published in *Tirant lo Blanch*, which involve more than forty volumes. See also: Rivaya 2003 (about the death penalty); Soto Nieto & Fernández 2004 (about images of justice); García Amado & Paredes Castañón 2005 (about torture).

2. Rivaya 2006; Pérez Treviño 2007; Ruiz Sanz 2010.

3. Most of their works cover a more or less "canonized" list of Hollywood law films (*Twelve Angry Men, To Kill a Mockingbird, Anatomy of Murder, Adam's Rib*), contemporary science fiction and historical American films (*Blade Runner, Clockwork Orange, Matrix, The Scarlet Letter, Schindler's List*) or European classics (*Bicycle Thieves, Sacco e Vanzetti, M*).

4. Another exception is: Bernández Rodal et al. 2008 (about domestic violence).

5. As Spanish law and film scholar Benjamín Rivaya García argues, in the study of law and film, the point of view is the law and the object is cinema; in other words, although cinema is important for the knowledge of law, the fundamental thing is not film but the law, that is, the understanding of the law. Hence, cinema has to be put at the service of law (2010: 226).

6. For a jurisprudential approach to film see, for instance, Kamir 2006 and MacNeil 2007.

7. According to Brian Massumi, affects are "ways in which the body can connect with itself and the world" and "capacities for acting and being acted upon" (1993: 93; 36).

8. By using the term "transsensorial perception," Chion wants to emphasize that "there is no sensory given that is demarcated and isolated from the outset. Rather, the senses are channels, highways more than territories or domains" (1994: 137).

9. In Chion's words, "one perception influences the other and transforms it. We never see the same thing when we also hear; we don't hear the same thing when we see as well" (1994: xxvi).

10. The term collates the word cinema with two scientific terms that designate the structures and conditions of human sensorium: *synaesthesia* and *coenaesthesia* (2004: 67–68). Whereas the former refers to an exchange (involuntary or volitional) and translation between and among the senses, the latter refers to the ways in which "equally available senses become variously heightened and diminished, the power of history and culture regulating their boundaries as it arranges them into a normative hierarchy" (2004: 69).

11. James Boyd White suggests that law should be regarded not as a system of rules or a set of social policies, but rather as a culture of argument and meaning-formation, by which he means all resources for expression, definition, and action that form and maintain a given legal community. White 1973 and 1999.

12. Cf. Douzinas and Nead: "Art is assigned to imagination, creativity, and playfulness, law to control, discipline, and sobriety" (1999: 3).

13. As Cheah, Fraser, and Grbich point out, "[L]aw and legal rules . . . serve not just to produce generalised and to a certain extent abstract bodies of legal subjects, but also act more concretely to create specific body types in particularised ways" (1996: xviii).

14. As Deleuze argues, "a body can be anything: it can be an animal, a body of sounds, a mind or idea; it can be a linguistic corpus, a social body, a collectivity" (1988: 127).

15. See, for instance, among many others: Law and Film: Moran et al. 2004; Machura & Robson 2001; Sarat et al. 2005; Law and Aesthetics: Douzinas & Warrington 1994; Douzinas & Nead 1999; Gearey 2001; Ben-Dor 2011; Dahlberg 2012; Sherwin 2011; Delage & Goodrich 2013; Goodrich 2014.

16. Bergman & Asimow 1996; Chase 2002; Greenfield, Osborn & Robson 2010.

1

Framing Aesthetics: Witnessing Francoism in *Pan's Labyrinth*

In *Pan's Labyrinth* (*El laberinto del fauno*, 2006) Mexican filmmaker Guillermo del Toro combines the imagery of dark fairy tales with portrayals of torture and murder to look back at the Spanish post-Civil War years and the resistance of the anti-Francoist guerrillas. Set in 1944, five years after the end of the Spanish Civil War (1936–1939), the film tells the story of thirteen-year-old Ofelia (Ivana Baquero), who is forced to move with her pregnant mother, Carmen (Ariadna Gil), to a remote military post where her new stepfather, Francoist Captain Vidal (Sergi López), has been assigned to exterminate the guerrillas. In parallel, the film shows Ofelia's scary fairy tale world,[1] where she encounters the Faun (Doug Jones), who tells her that she is the reincarnation of a lost princess and that if she wants to recover her true identity, she must fulfil three dangerous tasks before the moon is full (retrieve a magic key from the entrails of a giant toad, take a golden dagger from a child-eating monster, and shed a drop of her innocent new-born brother's blood). The film testifies to the horrors of these two worlds – the historical world of Francoism and the fantasy world of fairies and monsters – and challenges viewers to reflect upon their own responses.

Film critics including Paul Julian Smith (2007), Mercedes Maroto Camino (2010), Irene Gómez-Castellano (2013), and Sarah Wright (2013) have associated *Pan's Labyrinth* with contemporary legislative and civic efforts in Spain to recover the historical memory of the victims of Francoism and to revisit what has been referred to as the "pact of forgetfulness" or "oblivion" reached during the transition to democracy (1975–1978).[2] The release of the film in 2006 coincided with Spanish Parliamentary debates around the so-called *Law of Historical Memory*, enacted in support of those who suffered persecution or violence during the Civil War and Franco's dictatorship (1939–1975).[3] In parallel, grassroots organizations such as the Association for the Recovery of Historical Memory (*Asociación para la Recuperación de la Memoria Histórica*) lodged an official request to open a criminal investigation to identify and exhume thousands of corpses that remained in unmarked mass graves.

In 2008, in response to that request, Investigating Judge Baltasar Garzón opened a criminal investigation into 114,266 cases of enforced disappearance perpetrated by Franco and his supporters during the Civil War and the early years of the dictatorship (1936–1951).[4] In his decision, Garzón accused Franco and thirty-four of his high commanding officers of designing a "preconceived and systematic plan" to end the "legitimate government of the Second Republic" (1931–1939) and to exterminate political opponents through mass killings, torture, exile, and enforced disappearance (illegal detentions). Yet on February 3, 2010, following a complaint filed by three far-right organizations, the Supreme Court decided to prosecute Garzón for the crime of *prevaricación* (knowingly issuing an unjust decision). According to the complaint, Garzón had deliberately violated the principle of legality by applying international human rights law to circumvent the Amnesty Law of 1977. Although Garzón was eventually acquitted on January 12, 2012, the decision of the Supreme Court blocked any possibility of investigating those crimes on the grounds that the Amnesty Law had already settled the issue, a very problematic outcome for the victims. Indeed, in a preliminary report issued on February 3, 2014, by the UN Special Rapporteur on the Promotion of Truth, Justice, Reparation and Guarantees of Non-recurrence, Pablo de Greiff bemoaned the "immense distance" between state institutions and victims.[5] He found it especially troubling that state institutions had not done more for the victims, even though the democratic order was not at risk, recalling that "genuine reconciliation" requires the full realization of the victims' rights to truth, justice, and reparation.[6]

Earlier analyses of *Pan's Labyrinth* have demonstrated that it makes visible the violation of human rights committed by Francoism and thus participates in the recovery of the memory of the victims. This chapter draws from the film to show how the representation of graphic violence and the affective and physical responses elicited in the viewer (i.e. outrage, fear, guilt, pleasure, contempt) invite us to consider the framing that authorizes and legitimizes the violence. This chapter is thus less concerned with the content of these graphic images per se than with how this content is exhibited and witnessed. To that end, the chapter begins by situating the film within the genre of human rights cinema, by challenging the emphasis on accuracy and truthfulness championed by the Charter of the Human Rights Film Network. It adopts Shohini Chaudhuri's suggestion that the focus is shifted from the narrative representation of human right abuses, privileged by some law and human rights scholars in analyzing the film (see Narváez Hernández 2017), to the aesthetic choices that enable a moral or ethical confrontation with those abuses. Following Chaudhuri, this chapter aims not to interrogate the relationship between "truth" and "fiction" in the film, but to examine the

nature of the viewing experience created by its aesthetic choices in relation to violence and its causes.

Questions surrounding violence and its witnessing have gained greater urgency as ever more images of suffering and death are shown worldwide, whether on TV, or in cinemas, video games, the internet, or the courts (i.e. Abu Ghraib torture pictures, war atrocities, decapitation of civilians, terrorism trials).[7] These images raise a host of issues: What subjects do they show and address? What gazes and perceptions do they create? What affective responses do they produce? What judgements do they invite? What sense of (in)justice do they create? Kelly Oliver (2007), Judith Butler (2009), and Alison Young (2010) are among the scholars who have pointed out the need to explore these questions in order to understand how these images shape our interpretations and attributions of responsibility, blame, and (in)justice. What is needed, these scholars claim, are forms of responsible witnessing that enable viewers to self-critically reflect on how they engage with these images and to take responsibility for what and how they see (or do not see).

This chapter takes up that task by showing that *Pan's Labyrinth* constructs responsible witnessing. The film's graphic images of torture and murder may shock or disgust, stir feelings of pity or a desire for revenge, but they always push viewers to reflect on the narrative and visual frames that establish what is seen and what is not seen, the subject position and agency (or lack thereof) of victims and perpetrators, as well as their own affective and embodied investment in the scenes of violence. Rather than leaving viewers with a raw emotional response or ready-made value judgments, *Pan's Labyrinth* encourages viewers to adopt what feminist philosopher Kelly Oliver calls "vigilant witnessing" – "an ongoing process of critical analysis and perpetual questioning that contextualizes and recontextualizes what and how we see" (Oliver: 2007, 106).[8] The close analysis in this chapter will demonstrate how the film fosters such witnessing and explicate both the (re)presentation of violence and viewers' responses to, and responsibility for, that violence.

For these purposes, I have organized the chapter into six sections. First, I explain the notion of Human Rights Cinema from an aesthetic perspective. Secondly, I focus on the film's opening title sequence to examine the viewing position the film constructs. Then, in the next three sections, I analyze the graphic images of violence and the responses invited from viewers for the three main normative orders represented in the film: Vidal's world of Francoism, Mercedes' world of resistance, and Ofelia's world of fairies and monsters. The chapter concludes by exploring the responsible witnessing the film requires of its viewers.

An Aesthetic Approach to Human Rights Cinema

The Charter of Human Rights Film Network was established in 2004 to promote human rights film festivals around the world. The Charter defines human rights films as those that "reflect, inform on and provide understanding of the actual state of past and present human rights violations, or the visions and aspirations concerning ways to redress those violations" (Human Rights Film Network n.d.). It also specifies that "human rights films can be documentary, fiction, experimental or animation" and that they may be "harshly realistic, or highly utopian . . . offer gruesome pictures, or show the bliss of peaceful life. They may report, denounce or convey an emotional message" (Article 2.3). Nonetheless, the Charter privileges documentary films over other genres, writing that "human rights films, whatever their format, contents or character, should be 'truthful'" (Article 2.3). This truthfulness is described thus:

> [Human rights films] should inform the viewers on human rights issues and aspirations, and should not intentionally misrepresent the facts or the views or words of those portrayed. They should not be so biased as to invoke hatred and discrimination against groups and individuals, or serve political or commercial interests only. They should be explorative of the issue rather than propagandistic, and not reproduce stereotypes. (Article 2.3)

Despite its apparent openness to a multiplicity of film genres and styles, the Charter establishes the film's commitment to such truthfulness as a defining feature of human rights cinema (Collins 2017: 67).

In his seminal article "Human Rights Film Network – Reflections on its History, Principles and Practices," Daan Bronkhorst (2003) also understands truthfulness as central. For Bronkhorst, a true story should "correspond to the facts" and "be sincere, honest." A "truthful" human rights film should aim not to instruct or to communicate a particular educational message but to broaden the spectator's understanding of human rights issues. The ability of the film to produce this broadening effect depends on its commitment to truthfulness. Statements by Human Rights Watch about its Film Festival reflect a similar commitment, but emphasize the spectator as witness. The organization writes that the festival seeks to "bear witness" to the suffering of victims of human rights violations and "bring to life human rights abuses through storytelling" in a way that breaks down the indifference of spectators and prompts them to "empathize and demand justice for all people." While the organizers of the festival encourage filmmakers around the world to address human rights subject matter in various genres and pledge not to ban a film on the basis of its particular point of view, the organizing committee

of the festival warns that it will rule out "films that contain unacceptable inaccuracies of fact."

Recently, scholars like Sonia M. Tascón, Barry Collins and Shohini Chaudhuri have problematized the association of human rights cinema with truthfulness and activism. In their view, this association leads human rights activists, film festivals, and scholars to assume that film provides neutral testimony and that the cinematic exposition of human rights abuses will lead the spectator to action, transforming passive and indifferent spectators into active and political ones. According to Tascón, this assumption overlooks the fact that the documentary form often relies on codes and conventions (i.e. testimonies of survivors, interviews with professionals, the use of handheld camera) that stage actual events in order to create the "appearance of truth" (Tascón 2012: 870).[9] Moreover, documentaries risk shaping the spectators' gaze into what Tascón calls the "humanitarian gaze": namely, a way of looking that reproduces "a geopolitical relationship between donors/helpers and supplicants for help that is unequal and expected to be unequal" (Tascón 2015: 204). In establishing a clear separation between the subject who watches – normally the Western (benevolent) viewer – and the object being watched – normally the non-Western victim of human rights violations – this form repeats, as Chaudhuri notes, "the colonial view of other societies as repressive or barbaric" (Chaudhuri 2014: 7; Tascón 2015: 35; see also Swimelar 2014: 427).

In his article "Human Rights Cinema: The Act of Killing and the Act of Watching," Barry Collins calls for an examination of the role of the spectator in human rights cinema. If spectatorship in human rights cinema presupposes a moral responsibility with respect to the content viewed, "does such a concept of spectatorship not also presuppose that human rights spectatorship itself demands recognition?" he asks (Collins 2017: 78). The commitment of human rights cinema to truthfulness transforms spectators into witnesses who are to recognize the suffering of human rights victims through the act of watching (Collins 2017: 78).[10] Through the act of watching, the spectator becomes both active and responsible. Collins identifies an additional element of narcissism underlying the association of spectatorship with activism, arguing that the concept of human rights cinema ultimately recognizes and celebrates "the spectator's responsible (or indeed virtuous) recognition of the suffering of the human rights victim," making such recognition central to the genre itself. In this way, "the concept of Human Rights Cinema is organized around a desire for the spectator's recognition to itself be recognized" (Collins 2017: 78). Unlike other film genres (e.g. horror films) that situate the spectator's act of watching within fiction and relieve the viewer of any moral responsibility in relation to the horrors presented on the screen,

human rights films assure the spectator that the horrors being witnessed are true, with the implication that the spectator has a moral responsibility to not turn away from what he or she is seeing. Collins argues that "in the belief that his or her continued spectatorship is a form of activism," the spectator of human rights films is provided with "an obscene enjoyment capable of being recognized as virtuous behaviour; a sign of [the] spectator's commitment to the values of human rights" (2017: 79).

In *Cinema of the Dark Side: Atrocity and Ethics of Film Spectatorship*, Chaudhuri argues for problematizing the association of human rights cinema with truthfulness, writing that the linkage has led both human rights activists and participants in post-screening panel discussions at human rights film festivals to focus mainly on narrative (the issues raised by a film), overlooking the complex relationship between form and content (Chaudhuri 2014: 4; see also Hamblin 2016).[11] Activists fear that the focus on aesthetics, for example, the representation of violence, may lead viewers to approach human rights cinema as a thrilling spectacle or to glamorize it in a way that undercuts the actual human rights message (Chaudhuri 2014: 9). According to Chaudhuri, however, "*all* images aestheticise, mediate, transform. A non-aestheticising alternative does not exist" (Chaudhuri 2014: 9, original emphasis). Through their aesthetic choices (i.e. editing, sound, camera movement, mise-en-scène), filmmakers mediate viewers' judgments about whose death and suffering should be acknowledged and whose should be accepted or ignored, about whose violence is "normal" or "justified" and whose is "excessive" and "illegitimate" (Chaudhuri 2014: 10, 14; see also Young 2010). For Chaudhuri, critical examination of the representation of violence in a film should be less concerned with judging its violent content than with assessing how this representation mediates and affects viewers' affective responsiveness (Chaudhuri 2014: 9). The film's aesthetic choices might either implicate viewers in systems of violence or invite them to question their own relation to those systems (Chaudhuri 2014: 2).

Chaudhuri also calls for a critical assessment of the Brechtian model of spectatorship on which human rights cinema relies. This model assumes "that the spectator is by default passive, that emotions are antithetical to critical reflection, and that cinematic identification is solely based on [an] optical point of view" (Chaudhuri 2014: 5). As Chaudhuri notes, while a film tells viewers what it "thinks" about its characters and subjects through its aesthetic choices, the film's "thinking" cannot be reduced to the filmmaker's intentions (Chaudhuri 2014: 17). Viewers are not passive but active interpreters since their "own affective thinking mingles with the film and shapes their encounter with it" (Chaudhuri 2014: 17, 15); they construct their own version of what they see and feel in light of what they have previously seen and

felt. Moreover, as film theorist Vivian Sobchack notes, "Both the film's body and the spectator's body are implicated in their respective perceptive activity, enable it, and allow it expression in the world" (Sobchack 1992: 217). Film viewing, therefore, is not merely an ocular experience but also a corporeal one. For Chaudhuri, this embodied spectatorship, which emphasizes the haptic (tactile), kinesthetic, and affective investment of the spectator that the Bretchian model neglects, "is a more profound way of understanding than just thinking *about* the issues" (Chaudhuri 2014:19, original emphasis).

In what follows, I undertake an analysis of both form and content of *Pan's Labyrinth* to illustrate how the film's aesthetic choices position viewers not as voyeurs but as responsible embodied witnesses of the images of violence and suffering.

Viewers as Witnesses

From its opening title sequence, *Pan's Labyrinth* confronts viewers with images of suffering and death and emphasizes witnessing. The sequence opens with a black screen, with the sound of a child struggling to breathe and a female voice (Mercedes) humming a lullaby in the background.[12] Superimposed white titles set the historical context of the story: "Spain, 1944. The Civil War is over. Hidden in the mountains, armed men fight the new fascist regime, military posts are established to exterminate the resistance."[13] As the titles fade out, the camera rotates clockwise to reveal a close-up of Ofelia's face lying on the ground with "a thick ribbon of blood running backward into her nostril" (del Toro: 2006a). The moment the last drop of blood disappears back into her nose (the scene is shot in reverse), Ofelia looks directly into the camera and thus at the viewer and a third-person male voice-over (later recognized as the Faun) begins the fairy tale narrative. Then the camera zooms in to an extreme close-up of Ofelia's eye, plunging the viewer, both narratively and visually, into two worlds at once: the fantasy world of Ofelia/Princess Moanna and the historical world of Francoism.

The title sequence is crucial to establishing both the film's stance on the scenes of violence and the relationship the viewer is invited to establish with them. It does so through three interconnected cinematic techniques: narrative reversal, third-person voice-over, and direct address (when a character looks directly into the camera and thus at the viewer). First, through narrative reversal, the film tells the story "backwards": that is, it opens at the moment of Ofelia's death, which will take place in the future (in the final scene of the film). Then, in a single flashback, it merges this moment with events narrated in the present until the story reaches this scene again when the cause of the blood from Ofelia's nose is finally revealed. The title sequence thus sets in motion the earlier events. As Alison Young notes in another context, such a

reverse chronology "has a destabilizing effect on the viewer," for the events are displayed "not just out of order but in a manner that calls into question the sense of linear temporal and causal progression relied on by the conventions of storytelling" (Young 2010: 63, 65).

Secondly, through the third-person voice-over, the title sequence frames the entire film as a fairy tale. The voice-over tells the story of Princess Moanna, who dreamt of blue skies and sunshine and escaped the Realm of the Underworld to join the human world above. Once outside, however, she was blinded by the brightness of the sunlight, which erased all memory of her past, later suffered "cold, sickness, and pain," and eventually died. The voice-over also tells that "her father, the King, always knew that the Princess would return, perhaps in another body, in another place, at another time . . . he would wait for her." As the voice-over speaks, the camera follows the tiny figure of Princes Moanna (Ofelia) ascending circular staircases to the outside human world. Then, as she reaches the top, a blinding light occupies the entire screen – reproducing the moment Moanna/Ofelia loses her vision as she confronts the devastating reality of the outside world: bombed-out buildings, ruins, and human skulls on the ground. The sequence closes with an image of a caravan of cars bearing fascist symbols approaching the emblematic war-destroyed town of Belchite (Smith 2007: 14).[14] The fairy tale framing (which opens and closes the film) has a dual effect on the viewing experience. On the one hand, it sets the film as a deliberate tale told from the perspective of the omniscient Faun, meaning that "the viewer is placed less as a voyeur and more as an invited confidant" (Kozloff 1989: 129). On the other hand, it draws attention to the double-layering of the story – reality and fantasy, history and myth, image and voice, sight and blindness, memory and forgetting – forcing viewers to establish a critical distance for questioning what (and how) they see and hear.

Through the third technique of direct address, the film produces a face-to-face encounter between Ofelia and the viewer, replicating the Levinasian face-to-face encounter between the self and the other, which establishes the conditions for ethical witnessing.[15] For Levinas, ethics originate in the encounter with the face (*visage*) of the other. The face, he proposes, is neither the assemblage of brow, nose, eyes, and mouth, nor the representation of the soul, self, or subjectivity; instead, "one can say that the face is not 'seen.' It is what cannot become a content, which your thought would embrace; it is uncontainable, it leads you beyond" (Levinas 1982a: 86–87). In the face-to-face encounter, the other always appears in the uniqueness of her face and imposes an inevitable and asymmetrical ethical demand: "the face is the other who asks me not to let [her] die alone, as if to do so were to become an accomplice in [her] death. Thus the face says to me: you shall not kill"

(Levinas 1986: 24). In Levinas' terms, then, "It is always starting out from the Face, from the responsibility for the other, that justice appears, which calls for judgment and comparison, a comparison of what is in principle incomparable, for every being is unique; every other is unique" (Levinas 1998:104).

Through direct address, the film implicates viewers ethically in the scene of violence in two interconnected ways. First, by looking back at viewers, Ofelia openly acknowledges their presence and controverts the concept of the viewer as voyeur. In presenting Ofelia as able to exchange gazes with the viewer, the film prevents her reduction to a mere image to be looked at, while questioning the viewer's "all perceiving" self. That is, the film shows the totality of the viewer's perception to be illusory. Secondly, by directly addressing viewers (for there is no other addressee in the diegesis), Ofelia positions them as witnesses of her suffering and pain, to which they must respond "beyond" vision and knowledge.

With the help of these three cinematic techniques (narrative reversal, voice-over, and direct address), the film constructs a position for viewers that will enable them to return to this scene of violence as ethical witnesses, rather than mere voyeurs, of the three normative orders it represents: Vidal's world of Francoism, Mercedes' world of resistance, and Ofelia's world of fairies and monsters.

Vidal: Franco's "Politics of Revenge"

I choose to be here because I want my son to be born in a new, clean Spain. Because these people hold the mistaken belief that we're all equal. But there's a big difference: the war is over and we won. And if we need to kill every one of these vermin to settle it, then we will kill them all, and that's that.

—Captain Vidal

Set in 1944, five years after the end of the Spanish Civil War, *Pan's Labyrinth* portrays the post-war years not as "the beginning of peace and reconciliation" but as a "continuation of the war by other means," with the deployment of what historian Paul Preston has called "politics of revenge" against the defeated (Preston 1995a: 36, 29). After his victory in 1939, Franco himself defined the Civil War as a "national crusade" to liberate Spain from the public chaos of a Republic led by "evil and degenerate Marxists," and he devoted all his efforts to eradicating the values and institutions of the Second Republic (1931–1936). To keep the spirit of the crusade alive, Franco divided Spain into "victors" and "losers," "Spain" and "Anti-Spain," "patriots and traitors," a sharp distinction that would be the basis "for the most sweeping physical, economic and psychological repression" (Preston 2005). Approximately 20,000 Republican men and women were executed after the war; tens of

thousands died in prison and concentration camps because of the appalling conditions (overcrowding, malnutrition and disease) (Preston 2012: xi, 477); many committed suicide after suffering torture, maltreatment and humiliation (Richards 1998: 11). In addition, more than half a million survivors were forced into exile. In the words of Michael Richards, "the violence amounted to a brutal closing down of choices and alternatives: the extermination of memory, of history" (Ibid.). The vast majority "had no choice but to accept their fate": at worst, prison, torture or execution; at best, fear, humiliation and hunger (Preston 1995b: 230). Those few who continued to fight against the regime (small guerrilla groups that launched occasional attacks against *Guardia Civil* barracks) had little option but to seek refuge in the mountains, forced to prioritize survival over political activity (Richards 2013: 110). Because the guerrillas were dependent on the assistance of the civilian population, the latter became the target of the regime's general retaliation (Ibid.).

One of the strategies used by the regime to subjugate the guerrillas, and alluded to in the film, was the so-called "hunger pact." During the post-war years (also known as the "years of hunger" (Arroyo 2006: 66), as part of the regime's new economic policy of "autarky" or "self-sufficiency" an extended food-rationing system was imposed, giving local authorities unprecedented powers of social control (del Arco 2010: 460). The authorities could control the food supply for particular hostile municipalities, and, "as 'war zones' were decreed by the regime, a 'pact of hunger' would be imposed to ensure that the families of fighters had no work and went hungry" (Richards 2013: 110). In the film, the decision for a hunger pact is made during the copious dinner that Vidal enjoys along with representatives of the local authorities, who include the Mayor and his wife, the Priest, the *Guardia Civil* captain and Doctor Ferreiro (who is secretly helping the resistance), underscoring the divide between social classes and between the victors and the vanquished. At dinner, Vidal explains his strategy to his guests: to reduce the supply to one ration card for each family (rather than one card for each individual), in order to prevent "anyone sending food to the guerrillas in the mountains" and force the guerrillas to come down to the village. After examining the ration cards, the Mayor asks whether one card will suffice for an entire family. The priest replies, as he helps himself to another serving: "If people are careful, it should be plenty." The priest assures his fellow diners that "God has already saved their souls. What happens to their bodies, well, it hardly matters to Him."[16] Like the other guests, the Mayor too offers his support ("We'll help you in any way we can, Captain").

In a subsequent scene, Vidal himself is seen supervising the distribution of food. Each ration is contained in a brown bag with a printed legend that the *Guardia Civil* captain reads aloud to a large crowd of people queuing

for their ration with cards in hand. The legend, which reproduces real war propaganda, reads: "This is our daily bread in Franco's Spain! Which we keep safe in this mill. The Reds lie when they say there's hunger in Spain. Because in a united Spain, there's not a single home without a warm fire or without bread." A shot of Mercedes (Maribel Verdú) looking at the mountains reminds viewers of the starving guerrilla fighters.

This paternalistic image of the Francoist State "feeding Spaniards" (del Arco 2010: 460) is in direct contrast with the language Vidal uses to depict the defeated as subhuman: "motherfuckers," "pricks," "bastards," "losers" and "vermin," language that justifies the need for a "new, clean Spain," as Vidal tells his dinner guests.[17] Two scenes exemplify the violence against the defeated carried out in the name of "purification." The first scene involves the brutal killing of two starving farmers, father and son, who were captured while hunting rabbits in the forest and are assumed to be resistance fighters. In one of the most graphic and violent close-up scenes of the film, Vidal is shown repeatedly smashing the son's face with the bottom of a bottle (until no nose is left), simply because the son disobeyed his order to keep silent. Then he shoots the father twice in cold blood and turns back to the son to shoot him dead. A long shot reveals Vidal's soldiers watching the "spectacle" of power and victimization impassively, demonstrating precisely what objectification involves: "a refusal to feel, a denial of the sensory experience of another" (Manderson 2000: 115).[18] The soldiers' impassivity contrasts with the horror and outrage that the scene provokes in the viewer. By appealing to viewers' physical and affective reactions, the film distances them from the desensitized reaction of the soldiers, foreshadowing their different viewing positions: one is complicit, the other condemnatory. After killing the farmers, Vidal finds the dead rabbits (proof of their innocence) in one of their pouches, but rather than showing regret, he takes the rabbits with him and scolds his subordinates, who should "learn to frisk these motherfuckers" before bothering him. Evidently, under Francoism, the murder of innocent civilians is inconsequential (Davis 2011).[19]

The second scene of violence involves the torture of a guerrilla fighter captured by Vidal's troops after an attack on the food storehouse. The scene opens with Garcés, Vidal's subordinate, tying the terrified prisoner to a post in the middle of a now-empty storehouse. Vidal displays the "instruments of torture" and recites to the prisoner their uses and effects in his torture routine: "At first I won't be able to trust you. But when I use this one [the hammer] you'll own up to a few things. When we get to this one [the pliers] we'll have a closer relationship, almost like brothers. You'll see. And when we get to this one [a blade] I'll believe everything you tell me." A series of reverse shots incorporate shifting points of view, so viewers experience the victim's

powerlessness and fear as well as Vidal's coldness and cruelty. Viewers' anxiety increases when Vidal offers the prisoner, who is a stutterer, a deal: if he can count to three without stuttering, he can go free. With much self-control, the prisoner manages to count to two, but he is unable to overcome his fear and fails to say "three" without stuttering. The scene closes with a thud and a blank screen, leaving the viewer sickened and horror-filled.

Even though viewers are spared graphic details of the torture, its dreadful consequences are not passed over, making it impossible to dismiss the pain of the victim (and the sadism of the torturer): a series of close-ups show the prisoner's body curled up on the ground – his battered face with swollen eyes and a trickle of blood flowing from his lip, and his bloody and badly deformed hand. The prisoner is now begging Doctor Ferreiro to kill him because he has given up information. This transformation from victim to "traitor" is the ultimate spectacle of power for Vidal, and for the regime he represents, where the prisoner is now "speaking their words" and, moreover, is "to understand his confession as it will be understood by others, as an act of self-betrayal" (Scarry 1985: 36, 47). Viewers find themselves relieved when the doctor acknowledges the prisoner's pain and, with great risk to his own life, helps euthanize him ("You won't feel more pain," he tells him). When Vidal learns that the doctor has disobeyed his orders to keep the prisoner alive and asks him why he disobeyed, the doctor responds with a sentence that effectively seals his fate: "To obey, just like that, for the sake of obeying, without questioning . . . that's something only people like you can do, Captain." As the doctor turns away from Vidal as though trying to leave his presence, Vidal shoots him in the back, re-establishing his authority (Hanley 2008).

A superficial, less attentive reading might assume Vidal's violent acts to be symptoms of pathological evil, but they are the result of a planned and systematic effort to persecute and annihilate the defeated. The film situates Vidal's actions within the collective conditions that structure and motivate them, which enables viewers to assess the causes, and not just the consequences, of violence. At the same time, the film neither exonerates Vidal nor excuses his actions by presenting them as the product of impersonal social forces, for he remains responsible for the (sadistic) violence he inflicts on his victims. By granting individual agency to Vidal in the midst of the social conditions that frame his actions, the film compels viewers to witness, interpret, and judge the acts of violence he performs.

Mercedes: The "Heroic Memory" of the Resistance

That's why I was able to get away with it. I was invisible to you.

—Mercedes

The second part of the film shows the guerrilla fighters still able to maintain their humanity and dignity despite the brutality of the regime. The story is set in 1944, when thousands of *maquis* – Spanish Republicans who had fought in the French resistance – returned to Spain to continue their fight against fascism, hoping that with the end of World War II the Allies would join them in their struggle against Francoism (Maroto 2010: 51). In October 1944, approximately 7,000 well-trained, well-armed men entered Spain through the Pyrenean Aran Valley with the aim of triggering an uprising of the anti-Francoist resistance and establishing a Republican government (Preston 1995b: 233); the invasion was called, not without irony, "The Reconquest of Spain." Although the *maquis* managed to take several villages and towns, the vast numerical superiority of Franco's troops forced them to retreat (Preston 1995b: 233). Despite their defeat, many of the fighters selected not to return to France and opted instead to penetrate the interior, where they could either reinforce existing guerrilla bands or create new ones with more military experience (Anonymous 1996: 25). The incursion of the *maquis*, together with the strong belief that the downfall of Hitler and Mussolini would also bring Franco's downfall, raised the morale of the guerrillas and reactivated their struggle (Ibid.: 24). The guerrilla action peaked between 1945 and 1947, but then, as it became clear that the Allies' assistance would never materialize and Franco's repression would intensify, the guerrillas gradually disintegrated until their disappearance in the 1950s (Moreno 2012; 4; Maroto 2010). By the end of Franco's dictatorship, most of the guerrilla fighters had been incarcerated, executed or forced into exile.

Pan's Labyrinth turns the defeat of the resistance into a narrative of "heroic memory" that presents the guerrilla fighters and their supporters not as helpless victims but as fighters and heroes (Maroto 2010: 49). To construct this "heroic memory," the film uses two interconnected strategies. First, it locates the historical narrative "in a moment of choice between surrender, death or exile" (Hanley 2008: 39). This momentous decision is made explicit in a conversation between Doctor Ferreiro and Pedro, Mercedes' brother and leader of the guerrilla band. Pedro tells the Doctor that they will "soon have reinforcements from Jaca" and will then be able to "go head to head with Vidal." The Doctor is skeptical: "And then what? You kill him, they'll send another just like him. And another . . . You're screwed, no guns, no roof over your heads . . . You need food, medicine. You should take care of Mercedes. If you really love her, you would cross the border with her. This is a lost cause." Despite the logic of the doctor's argument, Pedro concludes: "I'm staying here, Doctor. There's no choice." Surrender and exile are no options for Pedro.

Secondly, the film transforms the seemingly futile decision of the guerrilla

fighters into a heroic (albeit transient) triumph. Two vital scenes exemplify this depiction: first, Mercedes' unexpected escape from Vidal after he had discovered that she had been secretly helping the resistance and had detained her for questioning; and second, the final confrontation between Vidal and the guerrilla fighters, when Vidal is shot dead. The staging, cinematography and editing of these two scenes mirror but invert the two previously analyzed scenes of violence and are intended to provoke opposite reactions from the viewer.

The first scene opens with Vidal's subordinate Garcés securing Mercedes to the same post that the stuttering prisoner had been tied to. Vidal orders Garcés to leave because "she is just a woman," to which Mercedes replies: "That's why I was able to get away with it. I was invisible to you." The rest of the scene works to prove Vidal wrong, highlighting how "the very core of the masculinity-power association is what makes it vulnerable" (Hanley 2008: 41). While Vidal prepares his instruments of torture, Mercedes manages to cut her ropes with a kitchen knife she had hidden in her apron. As he begins to recite the same torture routine he had listed for the stuttering prisoner, she interrupts him by stabbing him repeatedly (Orme 2010: 230). Caught by surprise, Vidal falls to his knees, and she thrusts the knife into his mouth. Replicating his torture narrative, she tells him: "You won't be the first pig I've gutted!" With a brutal slash from the inside out, which the viewer is forced to see, Mercedes slices Vidal's mouth open, drawing a grotesque joker smile on his face.

As in the previous torture scene, a series of reverse shots incorporate shifting points of view, so that the viewer can experience both the power and agency of the victim, now turned torturer, and the powerlessness and objectification of the torturer, now turned victim. The stuttering prisoner's battered face encouraged the viewer's identification with him, but Vidal's grotesque face "represents that for which no identification is possible, an accomplishment of dehumanization and a condition for violence" (Butler 2004: 145). By depriving Vidal of humanity, the film both legitimizes Mercedes' "spectacle of power" and desensitizes viewers to Vidal's suffering.

This desensitization is reinforced in the second of the scenes, the final confrontation between Vidal and the resistance fighters, who surround him right after he has shot Ofelia. Hemmed in by them, Vidal hands over his newborn son to Mercedes. Then, holding his father's pocket watch in his hand, Vidal asks the resistance fighters to tell his son the time of his death, trying to perpetuate his father's legacy. During Vidal's only "humane" moment in the film (Maroto 2010: 59), Mercedes interrupts him once again and denies him his last wish – "No. He won't even know your name" – and then Pedro shoots Vidal in the face. A long shot reveals the resistance fighters looking at

Vidal's dead body impassively, just as Vidal and his troops had looked at the bodies of the two starving farmers at the beginning of the film – the initial power relations have been reversed, and viewers are provided with a sense of just punishment and closure.[20]

The comparative analysis of the scenes of violence of these two normative orders – Vidal's Francoism, Mercedes' resistance – shows how viewers' capacity to respond either with outrage and horror or else with indifference to the suffering of others depends on the narrative and visual frames within which violence is authorized and legitimized. Theses frames determine what can be heard or cannot be heard, who counts as a human or does not, whose voices are significant or insignificant, whose violence is justified and whose is illegitimate, but they also draw up a range of appropriate or inappropriate affects (either encouraging or repressing them) in response to specific images, sounds, and narratives. As Judith Butler points out, paying attention to these frames can help us acknowledge that moral horror in the face of violence is not a sign of our humanity, because "humanity . . . is, in fact, implicitly divided between those for whom we feel urgent and unreasoned concern and those whose lives and deaths simply do not touch us, or do not appear as lives at all" (Butler 2009: 50). Therefore, as viewers, we have to ask ourselves how these conceptions of justified and unjustified forms of violence are built into the narrative. In this vein, we recognize that the film's "domain of justifiability is preemptively circumscribed by the definition of the form of violence at issue" (Butler 2009: 155). While inviting viewers to condemn Vidal's brutal national purification as abhorrent, the film justifies the counter-violence of the resistance, including Vidal's cold-blooded execution, as "punishment," "justice" and even "heroism."

The analysis thus far raises telling ethical questions, including whether such a de-sensitized view of the gutting and death of Vidal is compatible with *ethical witnessing*. Is there something in the film that saves it from becoming a Manichean reversal of good and evil, humane and monstrous, legitimate and illegitimate, innocent and culpable, justified and unjustifiable violence? Furthermore, if the film seems to engage the viewer in the objectifying logic it seeks to condemn, to what extent is a responsible view of the title sequence even possible? In the following section, I suggest that through the fairy tale world of Ofelia, the film constructs a position for viewers from which they are able to engage in vigilant witnessing.

Ofelia: The Two Worlds and Vigilant Imagination

> *I'm Princess Moanna and I'm not afraid of you. Aren't you ashamed of eating all the pill bugs and getting fat while the tree dies?*
>
> —Ofelia

Pan's Labyrinth interlaces Ofelia's two worlds – the fantasy world of fairies and fauns and the historical world of Francoism and the anti-Francoist resistance – such that it is impossible for the viewer to understand either without taking the other into account. Parallel editing reinforces this interconnection (Smith 2007). Ofelia's incursion into the muddy and insect-infected roots of the tree to confront the giant toad during her first task is crosscut with Vidal's incursion into a forest cave where he expects to find the guerrilla fighters. At the same time, the tasks that Ofelia must perform in the fairy tale world parallel the "tasks" that Mercedes must carry out in the "real" world of the resistance (Smith 2007; Picart et al. 2012). For instance, the magic key, which Ofelia must retrieve from the entrails of the giant toad in her first task in order to save an ancient fig tree from dying, evokes the secret key to the warehouse that Mercedes retrieves from Vidal to save the resistance fighters from starving. Similarly, the golden dagger, which Ofelia must take from the Pale Man's den in her second task, echoes the knife Mercedes takes from Vidal's kitchen, and will later use to slice his mouth open.[21]

Parallels can also be drawn at the level of the characters, for example, between Vidal and the Pale Man (Smith 2007). Like Vidal, the Pale Man sits at the head of a large table with a cornucopia of delicious food, which he uses to lure innocent victims – children, as evidenced by the piles of children's shoes on the floor.[22] Vidal and the Faun are also presented as parallels (Picart et al. 2012; Maroto 2010), most evidently in the scene in which Ofelia refuses to follow the Faun's orders to relinquish her new-born brother to him to complete her final task. The Faun angrily reminds her that she had promised to obey him blindly. Is she "willing to give up her sacred rights for her brother, who has caused her such misery and humiliation?" he asks. At this moment, Vidal enters the labyrinth and sees Ofelia standing alone, speaking to no one. A reverse shot visually places him in front of the Faun, as if they are mirroring each other. Ofelia reaffirms her decision: "I will," she replies. The Faun disappears into the darkness and Vidal takes his son from Ofelia and shoots her.

Film critics and scholars have variously interpreted the role and significance of the fairy tale in the film. For some, the fairy tale world is just a reflection of Ofelia's personal and psychological experience, a fantasy created by a child either to respond to (Hodgen 2007) or to escape from (Cochrane 2007; Arroyo 2006) the brutality of the "real" world. A second group of scholars view the fairy tale not as fantasy but as a form of resistance. Kuhu Tanvir, for instance, reads the imaginary world as "an extension of the [anti-Francoist] revolutionary forces" (2009: 2). In her view, the fairy tale "facilitates and almost demands disobedience" of Vidal's fascist order (Ibid.). Jennifer Orme sees the fairy tale as disobedient, failing to respect both the audience's

expectations of the genre as entertainment as well as "the rigid totalitarian narratives of fascism and patriarchy" (2010: 232). Similarly, for Alejandro Yarza, the film is a fairy tale for adults through which viewers are invited to confront their own responsibility for the proper mourning of a traumatic and silenced past and "to question blind obedience and the surrender to fate" (2018: 266, 261, 264).

A third group of scholars argues that the significance of the fairy tale lies in its ability to render visible the invisible and to speak the unspeakable. In this vein, Laura Hubner claims that the fairy tale elements function "as subversive allegories for the taboo" (Hubner 2010: 54). Likewise, Kim Edwards suggests that the fairy tale undermines Vidal's authority "by exhuming that which has been hidden and silenced" (Edwards 2008: 144). In turn, Jack Zipes argues that del Toro uses the fairy tale "to penetrate the spectacle of society that glorifies and conceals the pathology and corruption of people in power," offering "a corrective and more 'realistic' vision of the world" (Zipes 2008: 236).

A fourth and final group of critics calls attention to the ideological purposes of the fairy tale. According to Enrique Ajuria Ibarra, in the ideological "exposition of fairy-tale universal values of good and evil and moral doings and wrongdoings" the film undertakes a careful mythification of the horrors of Francoism (Ajuria 2014: 161): "Vidal embodies Francoist hegemony as a realist monster whose ogre-ization has been naturalized with the significative thrust of the fairy tale," for the audience's enjoyment (Ibid.: 161, 163). In a more positive reading, Janet Thormann suggests that Ofelia's fantasy "becomes the vehicle for the film's vision of redemptive history, and the film presents itself as the transmission of the unfulfilled potential of the past to the generation of the future" (Thormann 2008: 176).

Whereas critics debate the role of the fairy tale in the film – either as fantasy, resistance, disclosure, or ideology – I seek to emphasize that the fairy tale enables the construction of a vigilant and ethical witnessing, which is underlined from the outset. *Pan's Labyrinth* opens with an image of Ofelia and her pregnant mother, Carmen, travelling in one of the cars shown in the title sequence. Ofelia is reading a book with an illustration of a little girl playing with flying fairies. The mother scolds her: "You are too old to be filling [her] head with such nonsense." When Carmen asks for the car to stop because she feels nauseated, Ofelia takes the advantage to walk into the woods. There, she stumbles upon a stone that resembles a human eye and finds an ancient Celtic stone sculpture with a missing eye and the mouth wide open. Ofelia puts the missing stone eye back into the sculpture,[23] at which point a large insect emerges from the sculpture's mouth and looks at her. A reverse shot shows Ofelia's face from the insect's point of view. Ofelia identifies the insect

as a fairy – who will guide her through the labyrinth to meet the Faun. The sequence closes with a camera angle from the insect's perspective, as it looks at Ofelia and her mother returning to the car and follows them to Vidal's military post. While, as we saw in the first section, the title sequence invited viewers to enter the two worlds through Ofelia's eyes (engaging viewers in what she sees and experiences), this sequence encourages viewers to adopt the vigilant perspective of the insect-fairy and critically examine both worlds.

This vigilant perspective is constructed by a double mediation, where history is mediated by fantasy and fantasy is mediated by history. On the one hand, Ofelia's experiences in the fairy tale are located in her actual historical and political context. As an eyewitness, Ofelia occupies a particular subject position in a concrete socio-historical context: she is the daughter of a Republican father killed in the Civil War and is forced to move to a remote military post with her pregnant mother (who has remarried) and her new stepfather, Vidal, whose mission is to exterminate the Republicans and who subjects her to cruelty and humiliation. Ofelia's mother dies in childbirth and, as a result, Ofelia becomes responsible for her new-born brother. She finds solace only in Mercedes, who becomes her surrogate mother (Thormann 2008: 177). As an eyewitness, Ofelia testifies to what she sees and experiences as a (Republican) child under Francoism, including what she sees and experiences in the fairy tale world. By locating her fairy tale experiences in a concrete historical context, the film presents them neither as mere fantasy nor as a way of coping with the "real" world, but as part of a way of seeing and interpreting that world, that is, as part of Ofelia's individual eyewitness experience. This contextualization requires viewers to critically examine the ways in which Ofelia's specific socio-historical circumstances mediate her fairy tale world.

On the other hand, Ofelia's experiences in the historical world are located in the realm of the fairy tale, forcing viewers to pay attention to the ways the fairy tale world affects and transforms such experiences. It is in and through the fantasy world that Ofelia reasserts herself as both subject and agent: she confronts the giant toad ("I'm Princess Moanna. I'm not afraid of you") and successfully retrieves the magic key from his entrails, she manages to take the golden dagger from the Pale Man's den, and she disobeys the Faun by not shedding the blood of her innocent brother. The reassertion of her agency allows her to intervene in history (Thormann 2008: 179), most significantly during her last task: using magic chalk she manages to escape from her guarded room, enter Vidal's, drug him with her mother's sleeping medicine, take her baby brother from him and bring the baby to the Faun in order to complete the task. Ofelia's final decision to both take the baby from Vidal and refuse to spill her brother's blood as the Faun demands marks

her resistance to the two worlds (Lapolla 2011: 74). In acting thus, Ofelia refuses to allow Vidal and the Faun to determine her and her life in terms of violence and victimization. At the same time, her final choice of nonviolence distinguishes her from Mercedes, and therefore from the kind of resistance the latter represents. By distancing Ofelia from the violence of both the fairy tale world and the historical world of Francoism and anti-Francoist resistance, the film blurs the Manichean binaries of fantasy versus history and good versus evil and challenges viewers to rethink their implication in the scenes of violence. It is precisely such a rejection of violence that the film encourages viewers to reflect upon in its closing scene.

Conclusion: The Return

In its closing scene, the film returns to the title sequence to show Ofelia lying on the ground, her face looking at the viewer and the blood running (this time naturally) from her nose, while Mercedes kneels next to her humming a lullaby. A voice commands Ofelia to rise, and as she comes to life, a blinding golden light occupies the entire screen. Once viewers recover their sight, Ofelia is seen standing in a spacious and sumptuous hall where her mother, Carmen, her new-born in her arms, and her father are alive and well sitting on golden thrones. Her father, the King, says: "It was your blood and not that of an innocent that made you worthy of the throne. It was the last task. The most important one . . ." The Faun, who stands to the right of the King, adds, "and you chose well." "So, come sit by your Father's side, my child. He's been waiting so long," says her mother, now Queen of the Underworld. The three fairies, alive again, celebrate Ofelia's return by flying around her, as in the book illustration she saw at the beginning of the film. A large crowd surrounds them and applauds their reunion. Ofelia smiles and the blinding golden light reappears and then fades away to merge with a close-up of Ofelia as she dies in the "real" world. The camera then cuts to an image of Mercedes crying over Ofelia's dead body. The voice-over of the title sequence tells that the Princess "went back to her father's kingdom. And that she reigned with justice and a kind heart for many centuries. . . . And like most of us, she left behind small traces of her time on earth. Visible only to those that know where to look." As the voice-over speaks, the camera shows the fig tree she saved flowering again and the insect-fairy is staring at it.

The closing sequence brings back the three cinematic devices of the opening title sequence (narrative reversal, direct address, and voice-over) to confront viewers with Ofelia's moment of death. First, the merging of Ofelia's death with her return to the Realm of the Underworld (not with her escape from it as in the title sequence) implies a "reverse causality," whereby the future has the ability to affect the past through witnessing (Oliver 2001:

136). By merging past and future, the film compels viewers to acknowledge the effects of past harms in the present, for the sake of a better future. Secondly, through the face-to-face (re)encounter with Ofelia's death (now finally revealed on screen), the film ethically implicates viewers in the scene of violence, making them responsible for the way they respond to it. Finally, through the voice-over and the image of the insect-fairy that accompanies it, the film encourages viewers explicitly to look for the "traces" left by Ofelia in her life on earth and to rethink their position as witnesses in looking for those traces. The film thus constructs a position for viewers that encourages them to self-critically reflect on their own act of witnessing and to take responsibility for it. Through the use of these cinematic techniques in both its opening and closing sequences, *Pan's Labyrinth* posits retrospection, responsibility, and self-reflection as necessary to ethical witnessing, a witnessing that challenges the subject-object relationship and moves beyond the visual spectacle of suffering and victimization.

Notes

1. Only Ofelia sees and experiences the fairy tale world; the rest of the characters either dismiss or deny its existence or are unable to see it.

2. After Franco's death in 1975, the principal political forces agreed that securing a successful and peaceful transition required the past be left behind. In the name of national reconciliation, a parliamentary majority passed the Amnesty Law of 1977, which covered all "political crimes" committed before 1976 and precluded their prosecution. See López Lerma 2015.

3. Ley 52/2007, de 26 de diciembre, *por la que se reconocen y amplían derechos y se establecen medidas en favor de quienes padecieron persecución o violencia durante la guerra civil y la dictadura.* 53410, Dececember 27, 2007, BOE n. 310. For an analysis of the rhetoric of the law see López Lerma 2011.

4. Baltasar Garzón, Auto del 16 Octubre 2008. Diligencias Previas Proc. Abreviado 399/2006 V, Juzgado Central de Instrucción No. 5, Audiencia Nacional.

5. See UN preliminary report: "Observaciones preliminares del Relator Especial para la promoción de la verdad, la justicia, la reparación y las garantías de no repetición, Pablo de Greiff, al concluir su visita oficial a España," February 3, 2014. Available at <http://www.ohchr.org/EN/NewsEvents/Pages/Display News.aspx?NewsID=14216&LangID=E> (last accessed May 29, 2020).

6. Ibid. See also "Spain should trust its democracy and work for victims' rights" – UN expert on transitional justice. Available at <http://www.ohchr.org/EN/ NewsEvents/Pages/DisplayNews.aspx?NewsID=14220&LangID=E> (last accessed May 29, 2020).

7. Critics such as Roger Luckhurst (2010) and Frances Pheasant-Kelly (2013) locate the film in a post-9/11 context and in the global War on Terror. Guillermo

del Toro himself has stated that the film is inevitably addressed to a post-9/11 audience (del Toro 2006b). For an analysis of the impact of visual culture in the courts see Douglas 2001; Sherwin 2011; Delage & Goodrich 2013; Delage 2014.

8. This chapter draws on Kelly Oliver's definition of witnessing, by which she means both the juridical sense of testifying as an eyewitness to what one knows from firsthand knowledge and the political sense of bearing witness to something that cannot be seen, something that is beyond knowledge and recognition (Oliver 2007: 160).

9. As Tascón notes, Michael Moore's films undermine these conventions, and their ability to help convey the truth, by giving the viewer closer access to the rhetorical devices of documentary and "provid[ing] ways to strengthen this film-forms ability to tell the 'truth'" (2012: 870).

10. Collins analyzes Joshua Oppenheimer's documentary *The Act of Killing* (2012), which deals with mass killings that occured in Indonesia in 1965/66, during the violent upheavals that led President Suharto to power, to problematize the relationship between truth and fiction and the very notion of human rights film (2017: 73). Collins argues that by blurring the boundaries between fact and fiction, the film "renders impossible the act of 'bearing witness'" to the mass killings (2017: 79). Furthermore, the film does not "inform" the spectator as a passive observer of events but instead implicates the spectator in the creation of the perpetrator's grisly celebrity (2017: 80).

11. Books such as *Cine y derechos humanos. Una aventura fílmica* (Agudelo Ramírez 2015) and *Los derechos humanos en el cine español* (Gómez García 2017) emphasize historical context and use films as case studies about particular atrocities or as opportunities to discuss more general human rights issues in relation to specific historical and/or geographical contexts.

12. For the role of the lullaby in the film see Gómez-Castellano 2013.

13. All quotations from the film come from the script (del Toro 2006a).

14. At the end of the war, Franco, who had won a victory over the Republican forces at Belchite, ordered that the town should be left untouched in memory of his triumph and declared a nationalist monument. Today, Belchite remains in ruins, kept as a historic site dedicated to reminding future generations of the legacy of the Spanish Civil War and its aftermath.

15. In "Reality and its Shadow," Levinas deprives art of ethics and responsibility. In his view, art consists in replacing the object with its image (a shadow, a caricature, a neutralizing vision of the object) (Levinas 1982b: 106, 112, 111). As Alex Gerbaz argues, "If responsibility begins with the face-to-face encounter, perhaps in the age of the screen and mediated social encounters our sense of responsibility is changing. The ubiquity of screens does not mean the end of responsibility . . . ; rather, it makes the viewer responsible for reaching beyond the presence of

images in order to 'see' and respect the conscious life of others" (2008: 26.). For discussions on the ethical dimension of art from a Levinasian perspective see, among others, Cooper 2006; Saxton 2008; and Minkkinen 2008.

16. Del Toro explains that the Priest's words "are taken verbatim from a speech a priest used to give to the Republican prisoners in a fascist concentration camp. He would come to give them communion and he would say before he left, 'Remember, my sons, you should confess what you know because God doesn't care what happens to your bodies; he already saved your souls'" (Davis 2011).

17. See Preston 2005. The justification for "purification" was provided by Antonio Vallejo Nágera, Director of Military Psychiatric Services and of the Psychological Research Bureau during the dictatorship. Vallejo Nágera claimed to have demonstrated through psychological experiments the infrahuman, dangerous, and evil condition of the Republican enemies (Ruiz Vargas 2006: 325–328).

18. As Elaine Scarry explains, torture denies or falsifies "the reality of the very thing it has itself objectified by a perceptual shift which converts the vision of suffering into the wholly illusory but, to the torturer and the regime they represent, wholly convincing spectacle of power" (1985: 27).

19. Del Toro explains that he based this scene on "an oral account of a post war occurrence in a grocery store, where a fascist came in and a citizen inside didn't take off his hat; the fascist proceeded to smash his face with the butt of a pistol and then took his groceries and left" (Davis 2011).

20. As Jane Hanley points out, viewers familiar with Spain's recent past "know that the historical moment is located at the beginning of Franco's dictatorship and that the triumph of the resistance in the historical realm becomes a fantasy itself" (Hanley 2008: 39).

21. According to Ann Davies, Ofelia's movements in and out the forest and the house "suggest the imbrications of the recovery of memory in the landscape itself, a process not unlike the real excavations of the bodies of Civil War victims" (2012: 35).

22. This image makes a clear historical reference to the Holocaust (Picart et al. 2012: 274). Two mirror-like scenes emphasize this parallel: lured by the Pale Man's food, Ofelia disobeys the warnings of both the Faun and the fairies not to eat anything from the monster's table, which awakens the Pale Man, who, after placing his eyeballs into his palms, begins to gauchely chase her down the hallway, devouring two of the three fairies before Ofelia manages to escape. Moments later, Vidal, with the ghastly joker smile on his face, is also seen gauchely chasing Ofelia through the labyrinth.

23. Paul Julian Smith observes that Ofelia's act of putting the eye back into the sculpture is reminiscent of the scene in Victor Erice's *El espíritu de la colmena* (*The Spirit of the Beehive*, 1973), where the child Anna, the protagonist of the film, adds eyes to the cartoonish figure of Don José (2007: 5).

2

Campy Performances: Queering Law in *High Heels*

*[I]t is always starting out from the Face, from the responsibility for the other that
justice appears, which calls for judgment and comparison, a comparison of what
is in principle incomparable, for every being is unique; every other is unique.*
Emmanuel Levinas (1998: 104).

This chapter explores the ways in which Pedro Almodóvar's 1991 film
High Heels (*Tacones Lejanos*) celebrates performance, fluidity, and frag-
mentation as ways of perceiving and making sense of the world.[1] Contrary
to the ideals of objectivity, impartiality, and detachment that dominate law
and the administration of justice in the modern age, the film proposes that
fluidity, role-reversal, and aesthetic engagement are critical for understanding
law and legal judgment. In *High Heels: Almodóvar's Postmodern Transgression*,
law-and-film feminist scholar Orit Kamir uses the film as a powerful site and
as a means to explore alternative feminist images of law, judgment, and caring
justice. In this chapter, I provide new insights into Kamir's feminist jurispru-
dential reading of the film by placing it within the framework of ethics of
alterity, performativity, and queer aesthetics. My aim is to show how the film
re-conceptualizes law as a queer performance and opens up the possibility
for an aesthetic judgment that is responsive to the call of marginal subjects
traditionally excluded from the law.

Postmodern Re-imaginings

Orit Kamir concurs with Robin West's suggestion that the "legal imagina-
tion" no longer includes care and compassion.[2] This is worrisome, West and
Kamir argue, because the "pursuit of justice, if neglectful of the ethic of care,
will fail not just as a matter of overall virtue, but more specifically, it will fail
as a matter of justice" (Kamir 2006: 267, quoting West 1997: 24).[3] In order to
re-conceptualize law and justice to address this problem, West and Kamir call
for new cultural images. These are as powerful and memorable as traditional
images: "the plumb line, the cupped hands, the blindfolded judge and the
scales of justice, as well as the values of consistency, integrity, and impartial-

ity that they represent" (West 1997: 30). Kamir contends that *High Heels* "offers a radical and feminist alternative to the patriarchal image and ideal of Solomonic justice, which dominates our Judeo-Christian heritage, and the notion of good judging in particular" because it replaces "[t]he traditional imagery" with "imagery that links ethics of justice with ethics of care" (Kamir 2006: 268).

Through an in-depth observation of *High Heels*, Kamir interrogates feminist skepticism toward postmodernism. On the one hand, she argues that feminists should embrace and celebrate the postmodern skepticism "toward particular claims of objective truth, a particular account of the self, and any particular account of gender, sexuality, biology, or what is or is not natural" (Kamir 2006: 266, quoting West 1997: 292). On the other hand, she notes her objection to the postmodern "unwillingness to entertain descriptions of subjective and intersubjective authenticity . . . [and] promises of a nurturant or caring morality" (2006: 266). According to Kamir, *High Heels* provides a compelling example of how to combine the best tenets of postmodernism with feminism.[4] In her view, Almodóvar's postmodern imagery "transcends the apparent dichotomy" between two versions of feminism: one that focuses on the traits of care and compassion, and another that denounces "patriarchal oppression and dominance" (2006: 267). By combining these two perspectives, Kamir suggests that the film not only undermines an oppressive, patriarchal social reality but also promotes a conception of law and justice closely related to the virtues of compassion and care (2006: 267).

The justice of care is most apparent in the symbolic-representative figure of the law in the film, the on-screen investigating Judge Domínguez (Miguel Bosé), who guides the investigation of the murder of Manuel (Féodor Atkine), Rebecca's husband and her mother's former lover.[5] Contrary to judges' ingrained habits and public perception of how judges ought to conduct their affairs, in his criminal investigation, Judge Domínguez is deeply and emotionally involved in the lives of Manuel's survivors, particularly in that of Rebecca (Victoria Abril) – the prime suspect for the murder. Kamir argues that the judge's caring, compassionate, and loving attributes ensure that the state reaches the just outcome in this case; that is, Rebecca never stands trial (2006: 279). Furthermore, by enacting a parallel cinematic off-screen process, *High Heels* engages the viewer as a compassionate judge who adopts a nonjudgmental point of view of Rebecca's criminal act and reaches the same just legal outcome as Judge Domínguez (2006: 279). Kamir concludes that the film, by constructing a "caring, compassionate, and nonjudgmental" "cinematic judgment," invites the viewer to enact its alternative vision of justice of care, while symbolically rebuking the patriarchal order represented by Manuel in the film (2006: 281).

In an attempt to contribute to the task of expanding the legal imagina-
tion and re-conceptualization of law and justice, my study offers an alterna-
tive to Kamir's imagery of caring law and justice of care. Drawing on Costas
Douzinas's and Ronnie Warrington's postmodern jurisprudence, I suggest
that *High Heels* re-imagines law, judgment, and justice through an ethics of
otherness rather than through an ethics of care. As Douzinas and Warrington
explain, this other "is neither the self's *alter ego*, nor its reflection or exten-
sion," but an unfathomable other, always "call[ing] upon us to consider [him
or] her before ethical or legal decisions are taken" (1994:19). Therefore, the
ethics of otherness "always starts with the other and challenges the various
ways in which the other has been reduced to the same" (1994: 163).[6] Most
importantly, while the other can never be comprehended, "a failure to strive
towards the recognition of otherness is the greatest injustice and the most
violent oppression of the law. Justice miscarries when it denies the other"
(1994: 309).

I contend that Kamir's feminist jurisprudential interpretation of *High
Heels* risks a return to a moral philosophy reductive of difference into same-
ness, endangering the advances of postmodern critiques to the totalizing ten-
dencies of modernity. To better respect the singularity of the other, I replace
Kamir's image of a caring law with an image of "law as performance," in
which ethics starts with the demand of the other in need. In this work, I use
the term "performance" in three ways: as an action that is performed; as an
action that has constitutive and transformative effects on the world; and as an
action that is enacted in front of an audience. In the film, Judge Domínguez
and his multiple metamorphoses (as lover, judge, drag performer, and father-
to-be) represent the image of law as performance. This interpretation is not
incompatible with the overall feminist task of ending patriarchy, but it relo-
cates it in the context of queer aesthetics.[7] By doing so, my goal is to examine
and question those cultural and normative assumptions that oppress not only
women but also the LGTBQ community.

The Persecution of the LGBTQ People under Franco

As described in the previous chapter, Franco's regime illegally detained,
imprisoned, tortured, and/or killed hundreds of thousands of Republicans.
Lesbians, gays, bisexuals, transgender, and queer (LGBTQ) people were
also victims of Franco's repression in ways that Spanish society has only
begun to acknowledge recently. Their suffering was the cost of the Franco
regime's image of itself as strong, virile, heterosexual, represented in the
presentation of the *macho ibérico* as the figure of Spanish national identity
(Tsinonis 2006: 479). Homosexuality was considered an embarrassment to
the nation and a danger to the values of the regime: fatherland, family, and

God (Gutiérrez-Dorado 2008: 248). Franco used the traditional values of the Catholic Church, medical pseudo-science, and the media to promote and justify his homophobic ideology and morality (Arnalte 2008: 141). Whereas the Catholic Church condemned homosexuality as a sin against nature, Franco's appointee to head the Military Psychiatric Services and the Psychological Research Cabinet, psychiatrist Antonio Vallejo Nágera, described it as a sexual perversion that should be punished by law (Adam Donat and Martínez Vidal 2008:132). Culture and media (journals, No-Do, books, films, etc.) dehumanized and ridiculed LGBTQ people, supporting an accepted environment of homophobic social attitudes (Arnalte 2008: 7).

The Franco regime enacted a series of homophobic laws between 1944 and 1954. Article 431 of the Penal Code of 1944 criminalized acts causing "public scandal," and the police freely used the provision to arrest gays and transgender people. In 1954, Franco reformed the *Ley de Vagos y Maleantes* (Vagrancy Act) of 1933 to criminalize homosexuality, describing "those subjects who" were gay as having "fallen to the lowest levels of morality."[8] While the language of the law states its objective is to correct, rather than to punish, it provided for sentences up to three years in prison or correction camps. In 1970, the *Ley de Peligrosidad y Rehabilitación Social* (Dangerousness and Social Rehabilitation Law) replaced the Vagrancy Act to declare gays socially dangerous subjects. Claiming its objective was "rehabilitation," the law created special prisons called *galerias de invertidos* (galleries of deviants), where gays and transgender people were subject to treatment (usually electric shock therapy) to cure their "deviant" desires (Terrasa-Mateu 2008: 100). Throughout this period, rape and torture of LGBTQ people by fellow inmates and officials were rampant (Tsinonis 2006: 483–484). The Church, medicine, the media, and law conspired to justify acts of violence and mistreatment of the LGTBQ community.[9]

Almost all of the LGBTQ victims were men or transgender people. Under the Francoist patriarchal social structure, sexual pleasure was only associated with men; women were relegated to their role of mothers and wives, expected to satisfy their husbands, but understood to be without lust or sexual pleasure themselves (Petit and Pineda 2008: 172). The Penal code condemned adultery, abortion, and the use of contraceptives. Educational texts, elaborated by *La Sección Femenina de Falange Española y de las JONS* (the Feminine Section), the only women's organization allowed by the regime, were used to teach children this equation: sexuality = heterosexuality = maternity. In this system, lesbians could touch in public or even live together, socially "invisible" but largely protected from the violence of the regime (Petit and Pineda 2008: 172). Although clandestine LGBTQ organizations such as *Movimiento Español de Liberación Homosexual* (Spanish Gay Liberation Movement) were

created at the beginning of the 1970s as a reaction to Franco's repressive policies, they only began to acquire social relevance after Franco's death in 1975. On June 26th, 1977, Spain witnessed the first LGBTQ pride parade on the streets of Barcelona. However, Democratic political parties were slow to include the recognition of rights for the LGTBQ community in their political programs, afraid that it might cost them support (Arnalte 2008: 166), and the persecution of the LGBTQ people continued. The reformation of the Dangerousness and Social Rehabilitation Law of 1970 in 1978 (Ley 77/1978, December 26) left intact the discriminatory measures of the law. They were finally repealed in 1995 (the *Ley Orgánica* 10/1995, November, 23). Furthermore, the late reformation of the Dangerousness and Social Rehabilitation Law prevented the LGBTQ prisoners from benefiting from the 1977 Amnesty Law. Their court files and police records remained active in the *Dirección General de la Seguridad* until 2000 (Gutiérrez-Dorado 2008: 256).

With the 1980s came the years of sexual liberation, embodied in the emblematic scene of *La Movida* – a socio-cultural urban movement led by a group of eccentric and extravagant young artists (among others, Pedro Almodóvar, Alaska, Kaka de Lux, Ouka Lele, etc.) who challenged all values inherited from Francoist Spain. Pedro Almodóvar's films are known, among other things, for deconstructing the *macho ibérico* and exploring and challenging Spanish heterosexual sexuality (Perriam 2014: 50–53). In addition, Almodóvar makes a parodic, often stylized, recycling of Francoist folklore (i.e., Flamenco dancers or toreadors) in order to unearth and deconstruct its ideological function of cultural homogenization, to break with patriarchal and traditional family structures, or to revise and subvert Francoist institutions of the Church and the police (Yarza 1999; Marsh and Nair 2004: 4).[10] Although *High Heels* has most of these subversive characteristics, here I aim to explore how the interaction between the camp aesthetics of the on-screen judge and the viewer re-conceptualizes law as a queer performance and what sense (i.e. both sensory perception and signification) of justice this queer performance produces.

The Significance of Performance for the Viewer

High Heels' opening credits appear over two drawings depicting high heels and guns. A collage of fragmented and duplicated drawings of the characters that anticipate their roles in the film follows the credits. Most of the characters in the film have jobs that relate to performance: Manuel is the director of a television network where Rebecca works as the news anchor; Isabel (Miriam Díaz Aroca), Manuel's lover and Rebecca's co-worker, translates her newscast into sign language; and Becky del Páramo (Marisa Paredes), Rebecca's

mother, is a singer and actress. Performance defines these characters' everyday life. Two drawings of Almodóvar filming with his camera encircle the drawings of his characters, emphasizing that everything we are about to see is a part of a performance. The film's constant references to television, theater, magazines, photography, radio, and musicals further emphasizes this artifice. Media often takes precedence over personal communication, particularly when Almodóvar seeks highly dramatic effect: Rebecca learns about her mother's terminal sickness on television, and Becky learns about her daughter's involvement in Manuel's murder. In addition, Judge Domínguez learns about Becky and Manuel's previous affair from old magazine clippings and uses them as evidence. *High Heels'* overwhelming display of media apparatuses, however, does not degenerate into Jean Baudrillard's world of simulation (1993). As I will try to show, these performances have performative, that is, constitutive, effects on the various diegetic audiences and produce an ethical relation between the cinematic performance and the viewer.

In presenting law under the light of performance and performativity, I also emphasize the ways in which *High Heels* integrates the actions of the on-screen judge and his sense of justice within the aesthetic realm of the viewer. For these purposes, I focus on the aesthetics of exaggeration, style, excess, artificiality, parody, and incongruity, which play a key part in Judge Domínguez's performance as a female impersonator, and place him, and thus the law, in the realm of camp aesthetics.[11] In particular, I argue that Judge Domínguez's campy performance invites viewers to see the law from a queer perspective: to challenge, as Fabio Cleto writes, "the manifold binarisms (masculine/feminine, original/copy, identity/difference, natural/artificial, private/public, etc.) on which [legal] epistemic and ontological order arranges and perpetuates itself" (1999: 15).[12] The camp aesthetics displayed in Judge Domínguez's performance may lead viewers to re-conceptualize "law as queer performance"; that is, to examine and question those legal assumptions about identity, subjectivity, and judgment.

The following analysis of the legal questions *High Heels* poses appear in four sections. First, I focus on Kamir's image of caring law and the reason for its failure to bring justice to the singularity of the other. Then, I explore the ethical implications of thinking about law as performance rather than as caring and how the cinematic image calls upon the viewer for an ethics of response to alterity. I conclude with an analysis of the camp aesthetics in the film, how they affect the viewers, and the kind of law and judgment this relation produces.

Law as Mother: Ethics and Justice of Care

According to Kamir, *High Heels* goes a long way to position Letal/Judge Domínguez as Rebecca's surrogate mother (2006: 275). Letal is first mentioned when Becky sees Letal's poster announcing his impersonation of Becky as "the real Becky." Becky asks in dismay, "Aren't I the real Becky?" Rebecca answers that she used to go to see Letal's performance whenever she longed for Becky. That night, Rebecca takes Becky to watch the performance at the Villa Rosa, where Letal imitates Becky's appearance, gestures, voice, and style with great success. Kamir notes that, when the camera cuts to a reverse shot of the spectators, "Becky looks at him as a person would at her own distant reflection [and] Rebecca looks at him with longing and joy that she cannot express towards her mother" (2006: 275). After the performance, Letal comes to their table and Becky and Letal perform what Kamir identifies as a "bonding ritual" – they exchange "body parts" (her earrings for one of his fake breasts) (2006: 275).

In turn, Rebecca herself is portrayed as a woman-child: As Kamir notes, "Our first and lasting impression of her, in a long flashback recounting her childhood memories, as she awaits Becky in the airport, is as a little girl: receiving earrings from her mother, degraded by her, worrying over her mother, and deserted by her" (2006: 277). Moreover, the film constantly presents Rebecca in relationship to her mother, whether she is imitating her, missing her, seeking her and substitutes for her, or, in the flashback when she kills Alberto, helping her. Letal/Judge Domínguez is a surrogate mother, Kamir argues, "because Rebecca's need for a mother is so deep" (2006: 275). At the same time, Becky, the "original" mother whom Letal imitates, is an uncaring, self-centered, and irresponsible "bad" mother. Thus, Letal improves on Becky's mothering, not only in the sense that s/he provides more caring than Becky, but in the sense that Becky becomes a caring, compassionate, and responsible mother through her relationship with Judge Domínguez (2006: 275). In a sense, "she imitates her double, Letal, the judge, absorbing the caring qualities s/he developed earlier while performing Becky's motherly role. It seems that when the law performs a mother's role, a bad mother can become good" (2006: 276).

In a fundamental way, Kamir sees Becky and Letal as adversaries. They are two mothers competing "for the child's love, a love that can only be obtained through motherly love and devotion" (2006: 277). They each attempt to protect and save her from the other – Becky from the law (represented by Judge Domínguez), and Judge Domínguez from her painful existence in the shadow of her indifferent mother. The competition becomes evident after the bonding ritual between the "two mothers," when Letal asks Rebecca to follow

him to his dressing room, and a sexual encounter takes place. In Kamir's view, Letal first consummates his sexual desire for Rebecca, because this is one thing that the real Becky cannot offer Rebecca, but he can (Rebecca will get pregnant out of this sexual encounter). When Judge Domínguez arrests Rebecca and sends her to prison, Becky sings *Think of Me* and *My Life Is Yours* to her daughter, because "such complete support and self-sacrifice only she, not the law, can offer" (Kamir 2006: 276). Letal/Judge Domínguez sings the same song to Rebecca when he reveals his triple identity, reveals himself as the father of her unborn child, and proposes marriage. Thus, he becomes the supportive partner and future father of her baby that Becky cannot be (Kamir 2006: 276). Becky's ultimate sacrifice for Rebecca in the end proves she, too, can be a loving mother. Kamir observes that both Becky and Letal "become closer to each other, less readily distinguishable" over the course of the film (2006: 277).

Furthermore, Kamir argues that neither the law nor compassion in *High Heels* is portrayed as exclusively maternal. She distinguishes four other roles of Letal/Judge Domínguez: his mother's son, Paula's deserting boyfriend Hugo, and Rebecca's lover and expectant father. All these complex and different characters are inseparable from Judge Domínguez's role as judge, his criminal investigation, and his quest for truth and justice. "His insights, intuition, and emotional responses to characters and situations are relevant professional tools and sources of information. They assist him in collecting data, assessing it, and arriving at conclusions" (Kamir 2006: 279). For instance, Judge Domínguez compares Becky with his own mother, who has neglected him for ten years. Like Rebecca, he is protective of his neglectful mother, as well as hurt and angry. Through his relationship with his mother, he can recognize Rebecca as a hurt child and understand her pain. Less positively, in his role as Hugo (a drug addict and police informant), the judge treats his girlfriend Paula as an object, to be used and abandoned without explanation. As he explains to Rebecca, Paula fell in love with Hugo and tried to help him while he was investigating a case. When the case was closed, "he simply disappeared." This aspect of Judge Domínguez's character, which is also a part of the law, allows him to recognize Manuel's "inhumanity" from his own experience (Kamir 2006: 278). Finally, his feelings for Rebecca and her baby make him deeply concerned about her well-being, rendering him incapable of seeing her culpability. This loving blindness is portrayed as being legitimate and helpful in his search for justice (2006: 278).

According to Kamir, all the conclusions that Judge Domínguez reaches through his different impersonations are "true, right, and just precisely *because* they rely on his personal experience as mother, son, man, and father-to-be" (2006: 279, original emphasis). Judge Domínguez's loving and

compassionate attributes confer the ability to fully understand the needs of each individual who comes before the law. They "ensure that every person will receive equal, compassionate treatment. . . . Equality before the law means that each individual deserves to be seen, understood, and treated for who s/he is" (2006: 279). In Kamir's view, Judge Domínguez's advocacy for a justice of care promotes a feminine worldview that is highly subversive in two significant ways (2006: 279). First, care and compassion are portrayed as neither biologically female nor male. Second, the justice of care is practiced on a woman who has murdered a man. "In our patriarchal culture," she observes that "judges sometimes feel compassion for men who abuse women," but they hardly sympathize with women who kill men (2006: 279). *High Heels'* feminism is one that not only understands Rebecca's need to kill an abusive man (and abused women's needs in general) but also condones it.

In addition, *High Heels* invites the viewer to practice a "participatory identification with Rebecca . . . in several connected ways":

> [B]y giving Rebecca a point of view, by closely aligning the viewer's point
> of view with hers, by positioning her as the most dominant, sympathetic
> on-screen character, by continuously presenting the child within her, and
> by looking at her through the eyes of the two mothers who love her and seek
> her love in return (Kamir 2006: 280).

In fact, according to Kamir, the film invites us to judge each of the characters (Becky, Eduardo/Letal/Hugo/Judge Domínguez) in the same compassionate way (2006: 281). This identification with Rebecca, however, is not complete until she reveals the truth to her mother – until that moment the viewer does not know whether or not she murdered Manuel. In this way, the viewer learns about Rebecca's crime along with Becky, who, at last, remorsefully takes on the role of a good mother (2006: 281).[13] In constructing a nonjudgmental and compassionate cinematic judgment, the film invites the viewer to support the legal outcome of not prosecuting Rebecca.

* * *

Despite Kamir's insistence on the law's necessity to care for and respect each person with regard to his or her singularity in order to achieve justice, her image of mother and compassionate judge remains open to question. It seems that the judge's ethical responsibility to respect the singularity of the other is possible, provided that the other is similar to the self, but only to that extent. For instance, in his different roles as a surrogate mother, son, Hugo, lover, and expectant father, Judge Domínguez understands what the other feels, because of his own similar experiences. In other words, to make sense of the concerns and needs of the other, he must first understand the other's

similarity to himself. What Kamir does not address or explain, however, is what happens when the judge encounters a radical other; that is, another that is different from the self and whose experiences have not been felt (and maybe will not be felt). Thus, by grounding the ethical responsibility of the mother-judge in what the self and the other share, rather than focusing on their differences, Kamir privileges similarity over difference and selfness over alterity. By not distinguishing between the self and the other, Kamir's mother-judge fails to ethically respond to the uniqueness that makes the other different from the self – the other becomes a reflection of the self.

Likewise, in constituting a compassionate viewer parallel to the mother-judge, Kamir imagines a viewer-judge who also fails to respect the singularity of the on-screen characters and consequently to provide justice to them. This is particularly evident in the way Kamir interprets the relationship between the characters and the viewer. Kamir sees Becky as the imitation of Letal, Letal as the imitation of Becky (being similar to Rebecca), Rebecca as the imitation of Becky, and so on. Within this chain of similarities, the viewer is also a participant, as he or she is considered an imitation of the on-screen mother-judge. For instance, the viewer, like Judge Domínguez, may see Rebecca as a woman-child and may feel the urge to protect her as a mother would. Yet, it is important to note that if Rebecca were the reflection of Becky or Letal/Judge Domínguez (and therefore of the viewer), her otherness and singularity would be denied, and the conditions for an ethical relation between Rebecca and the viewer would not be possible. In addition, in revealing the truth to the viewer (and not to the on-screen judge), the film places the viewer in several judging positions that challenge the one-dimensional, motherly cinematic judgment that Kamir suggests.

In what follows, I will explore how the respect of each person in his or her singularity is better accomplished by imagining a "performer-judge," whose ethical performances arise from the demand of the other in need, rather than from his/her loving and compassionate attributes.

Law as Performance: Ethics and Justice of Alterity

Unlike Kamir's mother-judge, whose actions are based on competition (between two mothers) and reward (Rebecca's love), the performer-judge acts unconditionally upon Rebecca's specific demands and morphs himself to satisfy them (rather than to collect data and life experiences). Focusing on the shifts in the relationship between Judge Domínguez and Rebecca will help us to examine the ethical relation between law and the vulnerable other, and the kind of justice produced by their interaction. I take Levinas's work on ethics and the face as my starting point in exploring how ethics arise from face-to-face encounters between Letal/Judge Domínguez and Rebecca.

I am particularly interested in reading how Letal shifts identities (from lover to judge to father-to-be), and performs each according to Rebecca's direct demand for an ethical response.

Letal as Lover

Becky's arrival underscores Manuel's indifference toward Rebecca. When Becky and Manuel first reunite, the film shows them in a flashback, passionately kissing on a beach. This image then dissolves into the present with a blue background that replicates this idyllic scenery – a view that foreshadows the re-emergence of their past relationship. That same night, Rebecca overhears a conversation between the two of them, in which Manuel refuses to tell Becky that he loves Rebecca. In spite of this, Rebecca invites her husband and mother to the Villa Rosa nightclub to watch Letal's impersonation of Becky. The mother agrees to attend so that her daughter is not disappointed; the husband joins too but complains that the Villa Rosa is not a place for Becky because a cross-dresser was murdered there (and so he takes a gun with him).

The scene opens with Letal's female impersonation of Becky on the stage. When the camera cuts to a reverse shot of the three of them, it shows Becky watching the performance with narcissism, Rebecca with joy, and Manuel with indifference.[14] At one point, Rebecca looks to her mother, who is captivated by Letal's impersonation, but does not reciprocate. Rebecca then turns her look toward her husband and notices that Manuel is looking at Becky with sexual desire, as is Becky. Rebecca looks at Manuel with pain and anger; Manuel looks back at her with disdain and rapidly turns his desiring look toward Becky again. This game of looks excludes Rebecca's sexual desires. The emotional intensity of the scene is heightened by the sound of Letal's lip-synched song, *A Year of Love* (*Un Año de Amor*) by Spanish pop star Luz Casal:

> Have you ever thought what will happen.
> All that we'll miss?
> How much will you suffer?
> If you go now
> Never again will you find
> Happy times
> You lived with me.[15]

The song brings back the memory of Manuel and Becky's past together as it recounts – in a typical bolero style – the story of a breakup and the longing for the happy days they shared. At the same time, it alludes to Rebecca's fears that Manuel and Becky will rekindle their love affair. Feeling isolated and excluded, Rebecca's only option is to look back at Letal, who perceives

everything from the stage. In Rebecca's face, we may read a direct, concrete, and personal request addressed to Letal: "Comfort me!" In Levinas's ethics, the sign of otherness is the face (visage). As seen in the previous chapter, the face is neither the assemblage of brow, nose, eyes, and mouth, nor the representation of the soul, self, or subjectivity: "The face eludes every category. It brings together speech and glance, saying and seeing, in a unity that escapes the conflict of senses and the arrangement of the organs" (Douzinas and Warrington 1994: 166). In the face-to-face encounter between the self and other, the other appears in the nakedness and uniqueness of her face and expresses an irreducible, sometimes inexpressible, ethical demand: "consider me before you act[!]" (Douzinas and Warrington 1994: 166). The consideration required by her demand is "always to be accounted for prior to any thought of self or own" (Douzinas and Warrington 1994: 18). In Levinasian terms, Rebecca's demand for a specific performance is a demand that "needs no excuse or justification" (Douzinas and Warrington 1994: 170); it obliges Letal to answer it and to act upon it immediately.

After exchanging mementos with Becky, Letal acts upon Rebecca's call when he asks her to follow him to the dressing room. Inside, while Rebecca takes out Letal's feminine garments, Letal tells her that he would like to be "more than a mother" to her and initiates a sexual encounter. The sexual intercourse begins with acrobatic cunnilingus (Rebecca is swinging from an overhead pipe) and ends in penetration that leads to Rebecca's pregnancy. She finds the sexual encounter shocking at first but ends up thoroughly enjoying and admitting her need for it. Letal initiates the sexual encounter not with the purpose of "scor[ing] a victory" over Becky, but rather to recognize and assert Rebecca's sexual desires and fill Rebecca's marital void.

Letal as Judge

The next scene further emphasizes Rebecca's isolation from her mother and husband. Letal, now wearing a beard and acting as Eduardo, is seen at home with his bedridden mother. His mother sees in the newspaper a headline about Becky's first night in Madrid and shows it to her son. A close-up of the picture of them calls attention to the moment in which Rebecca's desires are excluded: seated between Becky and Manuel, Rebecca looks at Manuel with a face that denotes pain and anger; at the right of the frame and facing us, Manuel ignores her. The scene closes with two close-ups: Becky and Rebecca back-to-back (a sign of their emotional distance) and Letal noticing Manuel's gun. After this last shot, an extreme close-up of the gun cuts to an inter-title that informs the viewers that a month has passed; in the background, we see the image of a house, and then a shot is heard. This cut ties together the scene at the Villa Rosa with the criminal investigation that follows the

gunshot: Rebecca's face reminds Letal/Judge Domínguez of his duty toward her: "consider me before you act[!]" This demand will guide the rest of his investigation.

After Manuel's murder, we learn that Letal is also Judge Domínguez. A medium-long shot shows him with two policemen at the scene where Manuel's body lies. This time, he wears a black suit, dark glasses, and a beard; he is not singing love songs, but speaking in forensic terms, in an exaggerated manner: "Mr. Manuel Sancho's body lies in a prone decubitus position and show signs of rigidity." Domínguez is shown from a low camera angle, which creates an impression of height and visually highlights his role as a legal authority. The narrative level, however, subverts this illusion of authority as his own assistants repeatedly contest his descriptions of the crime scene. This subversive narrative underscores the film's challenge to the traditional image of the judge who possesses uncontested authority and knowledge.

The purpose of the criminal investigation is at odds with what one might expect; Judge Domínguez appears more intent on proving Rebecca's innocence than on investigating what actually happened. For instance, after Rebecca publicly confesses to the crime on national television, the judge persuades her in his office to recant the public confession. Judge Domínguez tellingly states: "I want to help you but you must cooperate." Try as he might to persuade Rebecca to recant, he fails and has no other option but to imprison her. Rebecca's arrival at the prison is crosscut with Becky's successful debut at the theater. The images and sounds of the two contrasting locations, prison and theater, are superimposed in the scene: as the prison gates close behind Rebecca, which replicate the closing doors of a theater, we hear the audience's applause for Becky's appearance on the center of the stage of a full theater. Interestingly, Judge Domínguez watches Becky's performances (he is seen in the audience). Becky dedicates her first song, *Think of Me* (*Piensa en Mí*) to her daughter, who is forced to listen to it on the radio of one of the inmates. At the most dramatic moment of the performance, one tear falls in the same exact spot where Becky left a red-lipped kiss on the floor at the beginning of the show.

The theatricality of all these gestures makes it difficult to interpret whether Becky's support for Rebecca is genuine or fake. It is far more complicated than what Kamir seems to acknowledge (in her view, Becky's act of dedicating her song and lyrics symbolizes complete support for her daughter) (2006: 276). From the outset, the film presents Becky as a diva who seeks media and audience appreciation (see Williams 2004: 161). She abandons her daughter to pursue her singing career. Upon her return, she is more eager to face the media than to see her daughter. Her personal assistant, Marga, is writing her autobiography. When Judge Domínguez interrogates

Becky about her alibi on the night of the murder, she answers: "I didn't kill him. You don't do that two days before an opening." Discerning between Becky's onstage and offstage performances as well as her theatricality and real emotions becomes more complicated when Judge Domínguez suggests that Becky talk to Rebecca, to which Becky replies: "When I wake up all I want is to live until 10 p.m. and do the only thing I know: perform."[16]

Letal/Judge Domínguez is the legal figure who can create the conditions for an honest relationship between the mother and daughter. This is nowhere more evident than when Judge Domínguez uses the empty and solemn courtroom (which visually contrasts with the earlier image of the glamorous and crowded theater) to bring Becky face-to-face with Rebecca. Within the emptiness of the courtroom, Becky can stop pretending (acting) and directly ask her daughter for forgiveness for abandoning her. The scene opens with Rebecca, who has not been informed of the reason why she has been summoned, entering an imposing courtroom. Becky enters next and soon finds her way to the judge's bench. Positioned in the place of the judge and powerfully looking at Rebecca from above, she interrogates her visually smaller and powerless daughter.

> BECKY: Why did you do it?
> REBECCA: I didn't kill him, Mom!
> BECKY: But you confessed it yourself.
> REBECCA: I should have killed him, but I didn't even get that. My only revenge was to say I did it.
> BECKY: Why do you torture me? Because I slept with him? Is that why?
> REBECCA: Don't be silly. You weren't the only one.
> BECKY: Well, then?

Rebecca replies, indirectly, with a question of her own: "Did you see 'Autumn Sonata'? It's about a great pianist and her mediocre daughter. A story like ours," with reference to Ingmar Bergman's film *Autumn Sonata* (1978). Rebecca explains that she has spent all her life competing with her mother in everything, but she could win only by marrying Manuel. "We both lost with Manuel," Becky defends. "Yes, but I married him. You had to prove you could take him from me! I knew it, but you had to prove it to me." The competition is not between two mothers, but between mother and daughter. Something unexpected happens at this point, however. As Becky gets off the judge's bench, she admits her guilt and asks her daughter for forgiveness: "Forgive me, Rebecca. I behaved very badly, but what can I do now?" Rebecca replies: "You can only listen." Rebecca gradually shifts positions, visually suggesting that what started as Rebecca's "trial" is now Becky's – Rebecca stands in front of her mother, who now sits as a defendant in front

of her. Rebecca confesses that she switched her stepfather Alberto's sleeping pills, likely causing his death, but she assures her mother that she did it out of her love for her. Rebecca makes her way to the judge's bench and now, from this position, accuses Becky of abandoning her: "I wanted you to live your life. You promised me we'd have fun together, that we'd never separate. But you lied. And that's something I'll never forgive." The scene closes with Rebecca leaving a profoundly upset Becky in the empty courtroom.

This scene draws attention to some of the performative aspects of the law in three significant ways. First, by leaving the mother and daughter on their own to discuss their differences, Judge Domínguez transforms the courtroom into an informal performative space of conflict resolution. With the sanction of the law, this performative space points to Becky's assumption of responsibility: she becomes vulnerable, acknowledges her (moral) guilt, and for the first time asks Rebecca for forgiveness. In turn, Becky's transformation enables Rebecca to finally confront her mother and to demand to be heard – she confesses that she killed Alberto (although she denies having killed Manuel) and blames Becky for it. Second, Judge Domínguez's absence ensures that Rebecca's specific demand is satisfied – Rebecca's particular motive, history, and need are fully heard by her mother in the legitimizing space of the court of law. By giving Rebecca a hearing before her mother (that is, letting her speak), Judge Domínguez, the law, indirectly fulfills Rebecca's request that he remember his duty to her before he makes a judgment or a legal decision. The empty courtroom is the place of a symbolic trial, not only of Becky being judged by Rebecca but also of this whole process by the viewer. In this scene, cinematic devices – such as the camera angle, mise-en-scène, etc. – and reference to Bergman's film position the viewer to become the judge of the mother's and daughter's actions. Rebecca is found legally not-guilty of killing Alberto, and Becky is found morally guilty of Rebecca's criminal acts. The legal function of the empty courtroom is to legitimize this symbolic verdict.

Judging Law, Performing Justice

It can be no coincidence that after Rebecca has been declared (symbolically) innocent in the court of law by her mother, Judge Domínguez releases her from prison on the grounds of insufficient evidence. Judge Domínguez and Rebecca have this conversation shortly after her release:

> JUDGE: Letal wants you to go to see him tonight.
> REBECCA: What for?
> JUDGE: To speak with you, I suppose. You probably have things to tell him, too.
> REBECCA: Wrong. I've nothing to tell him, he doesn't interest me. . . .

JUDGE: Why are you so aggressive? Without me, you'd be rotting in jail!

REBECCA: If you freed me because you believe I'm innocent you're only
 doing your job.

JUDGE: I wonder. You never said you were innocent.

REBECCA: I'm innocent.

JUDGE: Why confess on TV then?

REBECCA: I was desperate and felt guilty.

JUDGE: A psychiatrist can use that, but I can't.

REBECCA: You can feel guilty without being guilty, can't you?

JUDGE: Of course, but I still don't understand you.

REBECCA: I don't understand you.

JUDGE: That's called reciprocity.

REBECCA: Why do you help me? Why do you free me, if you're not
 sure?

JUDGE: I know you're innocent.

REBECCA: That should be enough.

JUDGE: But it isn't. There are so many things I'd like to ask. But I have
 no right to, even if I'm the judge.

REBECCA: For once, we agree.

This conversation reveals the shifting point of the relationship between Rebecca and Letal/Judge Domínguez. This time, he is the one who wants to be heard and pleads with Rebecca to go to see what Letal has to tell her. This positions them as equals: Letal is not only a respondent to the demands of the other in need, but he is also, like Rebecca, a legitimate claimant for the other's performance (Douzinas and Warrington 1994: 178). Judge Domínguez frees Rebecca not because he thinks she is innocent, but because there is no proof of her being guilty. Although he wants to know whether Rebecca is innocent, he recognizes the limits of legal cognition, which prevent him from fully understanding Rebecca (at any rate, not as a psychiatrist would). In turn, Rebecca also recognizes and accepts that she does not understand him fully. Significantly, their mutual ("reciprocal," as Judge Domínguez calls it) incomprehension is the cause not of conflict but of agreement. In acknowledging the other as unfathomable, they establish a non-totalizing asymmetrical relationship with each other – the recognition that the other always contains an aspect that cannot be grasped in its totality is necessary to an ethics of alterity.[17]

In his ethical task, Judge Domínguez's professional role imposes certain limits on his way of responding to the call of the other. As he explains to Rebecca, to believe in her innocence is not enough; he still needs to determine her guilt or innocence according to the logic of the system. He

recognizes that he has no right to ask some questions, even if he is the judge. While the judge remains ethically responsible to respond to the request of the other, it appears that to be just, his response cannot breach the limits of legality. This dilemma refers to what Douzinas and Warrington call the "aporia of justice": "to act justly you must treat the other both as equal and as entitled to the symmetrical treatment of norms and as a totally unique person who commands the response of ethical asymmetry (1994: 178)."[18]

Despite Rebecca claiming that she was not interested, she finally decides to hear what Letal has to tell her. In the same dressing room where they had their first sexual encounter, Letal confesses that he and Judge Domínguez are the same person, and proposes marriage to Rebecca.[19] Perplexed, Rebecca asks: "To marry whom? Hugo, Letal, the Judge?" "All of us," he answers. Next, he takes Rebecca to his hideout, a garage where his mother keeps her old things. On the way there, he explains how he created his multiple identities to infiltrate and investigate criminal cases. He also admits that she is the first person he has ever brought there and that not even his own mother knows about his impersonations. Rebecca then confronts him and judges his misconduct:

> REBECCA: How can you lie to everyone?
> JUDGE: But not to you or to me.
> REBECCA: What about the people you leave behind? Paula fell in love
> with one of your characters.
> JUDGE: There won't be more characters. Now there's only me. I brought
> Letal back to explain. The Judge couldn't.

Letal/Judge Domínguez promises Rebecca that "there won't be more characters, only me." Judge Domínguez continues to perform, however, demonstrating, as Fabio Cleto notes in another context, that he "exists only through [his] in(de)finite performing roles, the ideal sum of which correspond to his own performative 'identity'" (1999: 25).[20] After he tells Rebecca that he brought Letal back to explain because the Judge could not, Rebecca and the viewers witness yet another metamorphosis: he once again dons the fake beard, dark glasses, and the judge's clothes and introduces himself as Eduardo, the father of her unborn child. In doing so, Judge Domínguez does not cease in his performance: he adds another layer of meaning to it. Judge Domínguez, the law, is the sum of all his characters – Letal, the Judge, Eduardo, Hugo, and father-to-be.

Judge Domínguez's visual metamorphosis reflects the law's actual transformation: before encountering Rebecca, he had impersonated different characters with the mere purpose of gathering information and experiences for criminal investigations. His impersonations, Rebecca reminds him, did not

lead to justice but to abuse people, like Paula, whom he unwillingly used as informants and therefore as a means to his end, rather than as concrete and unique persons. In contrast, after the face-to-face encounter with Rebecca, Letal/Judge Domínguez starts performing not according to his investigative interests but to Rebecca's direct and concrete demand and morphs himself accordingly. It is precisely this situated encounter with the unrepeatable, unique demand of the other, that makes Judge Domínguez an ethical subject. This ethical responsibility does not depend on the attributes and experiences of the self but arises out of and from the demand of the vulnerable other.

Just as Judge Domínguez's performances have constitutive effects upon Rebecca – they enable her personal growth – Rebecca's performances have constitutive effects upon the judge, opening him up to a parallel transformation. The reciprocal yet asymmetrical transformation between these two characters leads us to re-conceptualize law in terms of that very performative medium that makes it possible for self and other to respond to one another and to be transformed by this encounter.

After introducing himself as Eduardo, Judge Domínguez rushes with Rebecca to the hospital where Becky is in intensive care. In her hospital bed, Becky's image is framed between the bed curtains, which give the impression that she still is on a stage. When Rebecca enters, she closes the curtains for a private conversation behind the scenes. Becky asks Rebecca to tell her the truth and Rebecca confesses that she did, in fact, kill Manuel. The judge enters the scene and Becky, in what could be considered "the performance of a lifetime," takes the blame for Manuel's murder. Judge Domínguez replies that a confession is not enough because he needs physical evidence. In a final scene, and behind the judge's back, the film shows mother and daughter conspiring together to manipulate the evidence. The viewers (but not the judge) are shown how Rebecca gives Becky the gun she used to kill Manuel, and Becky plants her fingerprints on it. Eventually, Judge Domínguez relies on the physical evidence that "proves" Becky's guilt and sets Rebecca free. Judge Domínguez's decision not to prosecute Rebecca is both legal and ethical (apparently reconciling the aporia of justice). By revealing to the viewer that this truth is the result of manipulating the system, the film raises the question of justice: Is Judge Domínguez's decision not to prosecute Rebecca just? How are we to determine whether it is just? Reflection on these questions leads us to explore the viewer's judgment.

Cinematic Judgment: Ethics of Response

According to Kamir, *High Heels* invites the viewer to practice a "participatory [sympathetic] identification" with Rebecca that mediates and shapes the viewer's process of judging (2006: 280). Although each character is scrutinized

and examined (for example, Becky is accused of being self-centered and uncaring, and Eduardo of abusing Paula), Kamir argues that the film invites the viewer to accept their sincere remorse and to see all but Manuel in reference to Rebecca's forgiving love and vulnerability (2006: 280–281). In constituting a nonjudgmental, compassionate, and caring viewer-judge of Rebecca, Becky and Eduardo/Letal/Judge Domínguez, the film supports its fictional legal system. The viewer-judge, like Judge Domínguez, "judges two women through shifting personae and points of view, through identification with the involved parties, and through caring for them" (Kamir 2006: 279). Like the on-screen judge, the viewer investigates, determines relevant facts, and enacts the same alternative vision of justice of care – not prosecuting Rebecca for the murder.

In exploring the use of mise-en-scène, cinematography, editing, and sound, I argue that *High Heels* places the viewer in several judging positions that challenge the one-dimensional compassionate judgment Kamir proposes. To illustrate my argument, I examine the use of two different cinematic techniques: on the one hand, the "direct address" (when a character looks directly into the camera); and on the other hand, the visual contrast between Rebecca's face and Becky's "mask-face." I demonstrate how these cinematic techniques elicit from the viewer an ethics of response to alterity, rather than an ethics of care. Through the direct address, the film produces a face-to-face encounter between the viewer and Rebecca, parallel to the Levinasian face-to-face encounter between self and other that challenges the participatory sympathetic identification that Kamir suggests. In addition, the visual facial contrast between Rebecca and Becky breaks the mimetic relation between mother and daughter and, in doing so, establishes the conditions for an ethical relation between Rebecca and the viewer: if Rebecca were just the image or reflection of Becky, her otherness and singularity would be denied, and no ethical relation between Rebecca and the viewer would be possible. In the last part of this section, I argue that by revealing what actually happened (Rebecca as the actual killer of Manuel) to the viewer and not to the on-screen judge, the film constructs a cinematic judging process that differs from the one presented in the diegesis.

Direct Address to the Viewer: Face-to-Face Encounter

High Heels opens with Rebecca's image reflected in a glass window of the airport where Becky's plane is about to arrive. The fleeting image cuts to an extreme close-up of the side of Rebecca's face. Another reflection of Rebecca looking at her image superimposed over people walking in the airport in the background follows. Next, a low camera angle shows Rebecca looking for the arrival time of her mother's plane on a huge board. While she sits in the

waiting room, the camera zoom-ins, bringing her face closer to the viewer so that her expression can be seen and her thoughts heard. Rebecca's face in close-up dissolves into the first flashback of her traumatic memory from childhood in the Caribbean, when she lost one of the earrings her mother bought for her and Alberto pretended to sell her to the locals. The flashback closes with the image of a young Rebecca running away from Becky and Alberto. Then, the image dissolves to Rebecca's adult and suffering face directly addressing the camera in close-up while her mother calls her name from off-screen. In the same shot, Rebecca takes those very same earrings from her handbag and puts them on. Then, the close-up of her face dissolves into a second flashback. This time, she remembers how she tampered with Alberto's pills, causing his death, after which her mother abandoned her to pursue her acting career in Mexico. Once again, the image of a young Rebecca fades out, while the off-screen voice of her mother confirms that she is going to abandon her. The scene closes by cutting back to the airport, where a guitar case with the name Becky del Páramo on the side slides along the baggage carousel and leads directly to Becky in the present day and in the flesh.

The unusual shot of direct address to the viewer (for there is no other addressee in the diegesis) functions as the Levinasian face-to-face encounter between self and other, in two interconnected ways. First, by looking directly at the camera, Rebecca makes visible the concealed artifice of cinema and challenges the viewer's temptation to identify with the gaze of the camera. The direct address of the camera breaks the illusion of the "mirror screen" through which the viewer identifies himself or herself as the origin and creator of meaning.[21] Rebecca's face, using Alex Gerbaz's words, expresses "her otherness, alterity, and ungraspable subjectivity" (2008: 20). It "expresses something that cannot be accounted for within the totality of the transcendental subject's intention," something irreducible that escapes identification (2008: 23–24).[22] Second, by looking back at the film viewers, Rebecca openly acknowledges their presence. The viewers are confronted with the fact that they themselves are not only the subject of perception but also the object of perception. Rebecca's direct address confronts the viewer and puts his or her all-perceiving self in question.[23] That is, it challenges the illusory totality of the viewer's act of perception.

In this way, as Julián Daniel Gutiérrez-Albilla points out, the face of the irreducible other "leaves us [viewers] entirely exposed to our shared, yet asymmetrical vulnerabilities" (2017: 25). The direct shot of the face establishes the conditions for a face-to-face encounter between Rebecca and the viewer: it prevents both Rebecca's reduction to a mere image to be looked at and the viewer's maintenance of a transcendental self. By reaching out from the diegesis of the film, Rebecca appears in the uniqueness and singularity of her

face and expresses a direct demand for an ethical response before the viewer can make any judgment.

Face and Mask-Face

The opening emphasis on Rebecca's face contrasts with the viewer's first, obstructed view of Becky's face. Becky is first seen (both in the first flashback and upon her arrival at the airport) wearing a large red hat, big sunglasses, and heavy makeup. Immediately after reuniting with Rebecca, Becky takes a small mirror from her bag to touch up her makeup, and an extreme close-up shows a distorted reflection of her face at the same time that she inquires about the presence of the press. The camera tilts up from Becky's grotesque facial reflection to Rebecca's face. Rebecca proudly replies that she kept it secret that Becky was coming back; a blurry image of Becky's red hat occupies half of the frame, pointing to Becky's incapacity to emotionally connect with her daughter. Becky complains she wanted "more expectation." Rebecca answers, with tears in her eyes, that she was full of expectation.

Becky's distorted facial reflection in the mirror visually reveals what Luce Irigaray calls a "masquerade of femininity," by which "the woman loses herself, and loses herself by playing on her femininity" (1985: 84).[24] This idea of the masquerade becomes particularly apparent in the scene in which Becky appears, applying a facial mask in front of a mirror and explaining to her personal assistant Margarita her "successful" encounter with Rebecca. As Becky speaks to Margarita, Rebecca appears on TV in the room, reading the news. Conscious that her mother is watching, she begins to laugh during a report on the casualties of a terrorist attack. Embarrassed by this, Becky complains to Margarita that she would have preferred not to have seen her daughter. The camera cuts from Becky's "mask-face" to a television screen where two Asian women appear, applying makeup on their faces in extreme close-up. Another shot reveals Manuel as the viewer while a voice-over coming from the television program comments on the images of the Asian women: "The music and the dance were at the monarchy's service for centuries. Most of the performers of the opera of the masks are women." Not surprisingly, at this precise point, Becky arrives at Manuel's (and Rebecca's) house, and Manuel turns his gaze toward her. Thus, mise-en-scène, sound, and editing connect the two scenes: by applying the mask on her face (the masquerade of femininity) like the women at the service of the monarchy on the television screen, Becky appears subordinated to the patriarchal order represented by Manuel. Within the diegetic space, Becky epitomizes Laura Mulvey's idea of the woman's "to-be-looked-at-ness" (2004: 837–848).[25] The visual contrast between Rebecca's face and Becky's "mask-face" throughout the film challenges the mimetic relation between mother and daughter, and establishes a key difference between

them: while Becky represents the celebration and naturalization of patriarchy, Rebecca appears as the victim of such patriarchy. This differentiation creates a different ethical relation for the viewer with Rebecca.

Significantly the last part of the film reiterates the facial contrast between Rebecca and Becky when Rebecca explains the motives for killing her husband to her mother (and the viewer). The scene opens inside the ambulance where viewers see Becky with an oxygen mask on her face and Rebecca holding her hand at her side. Becky asks Rebecca for the forensic details of the murder because the judge does not seem convinced by her confession. Rebecca then explains the motives for the killing: she asked Manuel if he wanted her to shoot herself or die of an overdose, and Manuel replied that he would not give a damn about how she died. Becky interrupts Rebecca and tells her to go directly to the "heavy part" because that is what the judge will want to know: "How far away were you when you fired . . . did he fall forward or backward?" Rebecca puts the oxygen mask back into Becky's face and explains that Manuel's insensitivity to her threat of killing herself was the last straw for her. She explains how she pulled the trigger, shot, and killed Manuel. The mask covers Becky's face throughout the entire scene, and she takes it off only to ask questions or make comments to Rebecca. The scene closes with Becky telling her daughter that she should find a better way than murder to solve her problems with men. Rebecca replies that her mother should teach her how.

Although Becky is sick and dying, the grotesque image of her face with the oxygen mask visually deprives her of vulnerability and, therefore, of the potential for an ethical relation with the viewer. Becky's mask-face reminds the viewer that she is the cause of Rebecca's criminal acts and invites viewers to detach and distance themselves from her. This contradicts Kamir's reading of the scene. In her view, Becky's identification with her daughter's pain and humiliation influences the viewer to judge Rebecca accordingly (Kamir focuses exclusively on the narrative level of the scene). As she puts it, "Learning of the killing in this context, the viewer is influenced by the dying, remorseful mother's attitude. The viewer joins her in the impulse to protect Rebecca, save her, and compensate for all the emotional abuse she has suffered all her life" (2006: 280). The visual technique of the mask-face deflects the viewer's attention from Becky toward Rebecca's particular motive and history as well as the pain of the murder committed without the mediation of her mother. Shifting the attention toward Rebecca, the film invites viewers to fulfill their ethical obligation to respect Rebecca's specific history and motive before any judgment is taken. Like the on-screen performer-judge, the responsibility of the viewer toward Rebecca starts with her demand for an ethical response and concludes with its satisfaction.

Truth and Justice

While *High Heels* calls upon the viewer to respect and fulfill Rebecca's ethical demand like the on-screen judge by revealing the "truth" to the viewer and not to the judge, the film constitutes a viewer-judge different from the on-screen judge. The film, however, invites viewers to reach the same decision, which is the non-prosecution of Rebecca for the murder. Richard Sherwin distinguishes, in regard to legal storytelling, three different forms of truth (factual, legal, and symbolic) that can help us to examine this issue (2000: 49). According to Sherwin,

> Factual truth tells us what actually happened as a matter of historical accuracy. Whose testimony can be believed, what the physical evidence shows, how the elements of proof add up in the course of establishing who is to blame. . . . [Legal truth, however,] says that there are times when general concepts and abstract principles of law may be more important than particular facts. . . .
>
> Symbolic truth has the power to transcend particular facts and even particular laws. In this way, like legal truth, symbolic truth may ask a decision maker to sacrifice particular facts for the sake of something larger. But like factual truth it also seeks to root the truth not in some counterintuitive generality but in a specific human reality—albeit a higher human reality than ordinary facts typically allow. (2000: 49:50)

Unlike the on-screen judge who believes that the physical evidence (factual truth) and following the rules (legal truth) will reveal Becky's guilt and Rebecca's innocence, the viewer knows that justice has not been legally attained because the evidence has been manipulated. By calling attention to Rebecca's motives for killing Manuel, *High Heels* encourages the viewer-judge to consciously sacrifice particular facts and laws for the more important sake of Rebecca. Put differently, it asks the viewer to judge Rebecca according to the symbolic truth, which is that her actions destroyed the oppressive patriarchal social and cultural order Manuel represented, and not according to the factual and legal truth. By asking the viewer to accept Becky's admission of guilt (as complicit in this order, and responsible for Rebecca's suffering), Manuel's death does not go unpunished.

Camp Aesthetics: Law as Queer Performance

In *Strange Encounters*, law and film scholars Ruth Buchanan and Rebecca Johnson suggest that focusing on the affective dimensions of thought produced through the combination of word, image, and sound in film opens up both critical and transformative possibilities for law and film scholarship

(2009: 33).[26] Their interest is less "in understanding how film's special *effects* are produced than in understanding how various cinematic techniques work through us to produce *affects*, be they terror, elation, confusion, or grief" (2009: 43, original emphasis). In particular, they focus on the ways film might "challenge or destabilize dominant 'structures of feeling,' revealing new potential subjectivities and ways of being in the world" (2009: 43). And further, which is "the place of *affect* in the constitution of legal subjectivities"? (2009: 37). Following Buchanan and Johnson's suggestion, I explore how the camp aesthetics of Letal/Judge Domínguez's female impersonations reveal new subjectivities that invite the viewer to examine and question the dominant assumptions about identity upon which traditional legal systems are grounded. I then show how the interaction between the camp aesthetics of the judge and the viewer re-conceptualize law as queer performance.

Cultural anthropologist Esther Newton notes that "[t]he role of the female impersonator is directly related to both the drag queen and camp roles in the homosexual subculture" (1999: 98). As she explains, the main opposition around which the gay world revolves is masculine-feminine; one way of presenting such opposition through one's person is drag (1999: 98). Yet, Newton argues that while all female impersonators are drag queens, not all of them are camp: "Both the drag queen and the camp are expressive performing roles, and both specialize in transformation. But the drag queen is concerned with masculine-feminine transformation, while the camp is concerned with what might be called a philosophy of transformations and incongruity" (1999: 102). Camp uses the incongruity as a creative "strategy for a situation" (1999: 102). Taking Newton's notion of camp a step further, Jack Babuscio and Judith Butler highlight its subversive aspect. For Babuscio, camp is subversive because it forces the spectator to detach from the heterosexual viewpoint of conventional standards: "masculinity (including sexual dominance over women) is 'natural' and appropriate for men, and femininity (including sexual submissiveness toward men) is 'natural' and appropriate for women" (1999: 123). For Butler, "drag fully subverts the distinction between inner and outer psychic space and effectively mocks both the expressive model of gender and the notion of a true gender identity. . . . *In imitating gender, drag implicitly reveals the imitative structure of gender itself*" (1999: 363–364, original emphasis). Letal's drag impersonation of Becky conforms to camp, as Newton, Babuscio, and Butler describe it.

The first time Letal physically appears on the screen is at the Villa Rosa gay night club, performing an impersonation of Becky in drag. Letal's performance is presented in two scenes: one onstage, the other offstage. The first scene opens with Letal emerging from behind the curtains, followed by the camera in a long take as he moves to the center of the stage. Letal performs an

old song that Becky had sung when she was younger, imitating in detail her mannerisms, style, and costume – he wears a red miniskirt, full makeup, long gloves, dangling earrings, a wig, and high heels. With sexualized gestures and exaggerated expressions, he flaunts his femininity to the men he encounters on his way to the stage. In the stylized backdrop, traditional flamenco dancers contrast with Letal's masculine features and big stature. A reverse shot shows Becky in close-up captivated and flattered by his impersonation. Then, an over-the-shoulder shot shows three other female impersonators singing along with Letal, imitating his moves and expressions from their front-row table. Another close-up of Becky's face emphasizes her pleasure on seeing her imitation. The scene closes with a zoom-out of Letal at the center of the stage.

The opening of the second scene reiterates that of the former, signaling to the viewer that what follows is part of the same performance. The scene opens with Letal, emerging from behind the curtains followed by the camera as he moves toward Becky's table and sits facing her. Then, the following conversation takes place:

> LETAL: I hope you are not upset.
> BECKY: Why?
> LETAL: You may not like the imitations.
> BECKY: They flatter me. I feel so young, so absurd. Let me look at you.
> You don't look like me but the gestures are mine.
> LETAL: I tried to copy your style. It made you unique.
> BECKY: I still am. But you can't be a pop singer at my age. I've become a
> living legend.
> LETAL: I'm more into your early years. Wigs, miniskirts, platform shoes.
> Your spirit, your style.

Through Letal's drag impersonation, Becky becomes a camp icon in the gay community. Letal's drag performance, however, is not a misogynistic representation of Becky (or women in general), but a parodic, stylized appropriation of her femininity (as Letal implies, when he tells Becky that he tries to copy the style which made her unique – wigs, miniskirts, and platform shoes). Letal's exaggerated and stagy style, gestures and expressions, and excessive makeup and feminine attire evoke a woman in fact who is already a distortion or a masquerade of femininity; they exaggerate what is already an exaggeration (Pally 1990: 33–34). Letal's campy impersonation of Becky subverts the erotic scenario of woman-as-spectacle, forcing the viewer to examine and critically detach from Becky's celebration of patriarchy.

After the above conversation, the camera moves to the right to shift the viewer's attention to Rebecca and Manuel, who are sitting on Becky's side. As soon as Rebecca introduces Manuel to Letal, they have a confrontational

encounter: Manuel asks Letal what his real name is, while simultaneously staring at his crotch. The camera tilts up from Letal's crotch (the same crotch Rebecca will undress moments later backstage) to a close-up of Letal's face. Letal then replies that he is whatever Manuel wants to call him but that his friends call him (dropping his voice) "Letal." A close-up of his face shows him staring at Manuel's gun. Evoking the former shot, the camera tilts up from Manuel's gun (the gun Rebecca will later use to kill Manuel) to his face in close-up. In return, Manuel asks if Letal's name is male or female. Letal answers that it depends, but for him, he is a man. While Manuel demonstrates his maleness by showing his gun, Letal shows his by suddenly dropping the level of his voice.[27] The comic incongruence produced by Letal's vocal dropping is Letal's campy strategy to deal with Manuel's homophobic attitude toward him.[28] Camp, through its comic incongruity, forces the viewers to detach from and question Manuel's hostile position, and to reflect on and align with Letal's marginal one.

The scene closes with Becky and Letal exchanging mementos (one earring for a fake breast). As Newton remarks, one part of the performance of the female impersonator is to make the opposition between the female "appearance" and the male "reality" evident (1999: 101). One way to do this is to pull out a fake breast and show it to the audience. By showing his fake breast to the audience, Letal emphasizes that his appearance is an illusion and reveals "that sex role behavior is an appearance [that] can be manipulated at will" (Newton 1999: 101). In addition, by breaking the illusion of femininity, Letal frees himself from other impersonators as the immediate reference group (for instance, the anonymous female impersonators that imitated his performance) and, more specifically, from Becky. In so doing, he positions himself as the drag impersonator to the viewers.

The fact that the film shows Judge Domínguez in his role of drag performer before showing him acting as a judge is highly subversive. It replaces the dominant legal assumptions of a fixed and given identity (unity, stability, permanence, depth, and heterosexuality) with fluid and performative identities (multiplicity, instability, change, surface, and queerness) (Cleto 1999: 14). This idea of fluidity and performativity is reinforced throughout the film through Judge Domínguez's multiple characters: he goes from Letal's exaggerated femininity (he wears full makeup, miniskirt, and high heels) to Eduardo's ambiguity (he is seen half in drag), and then to Domínguez's extreme masculinity (he wears sunglasses and a suit and has a beard). This rejection of legal assumptions about identity challenges the exclusive categorical oppositions (masculine/feminine, original/copy, identity/difference, natural/artificial, private/public, etc.) upon which the legal order is grounded. By re-imagining law from a queer perspective, the film opens up the possibility

for an aesthetic judgment that takes the call of the vulnerable other seriously. It enables them to express and assert their otherness and difference at the same time that it forces the viewer to respect and be responsive to their alterity. *High Heels*, in other words, transforms the law into a queer performance that disrupts the hierarchy that privileges masculinity, heterosexuality, and patriarchy.

Notes

1. The original Spanish title *Tacones Lejanos*, literally means "distant heels."
2. According to James Boyd White, the legal imagination is a manner of thinking about "legal expression and legal action that can lead to more competent, meaningful, and just performances" (1999:73).
3. In *Caring for Justice*, West argues that "while 'justice' is typically associated with universal rules, consistency, reason, rights, the public sphere, and masculine virtues, 'care' is typically associated with particularity, context, affect, relationship, the private sphere, and femininity" (1997: 23). Furthermore, while the work of judges often shows "evidence of their respect for the constraints of the ethic of justice," it hardly exhibits any sign of constraint by an "ethic of care" (1997: 23–24). However, " 'justice,' as it is generally understood, and 'care,' as it is widely practiced, are each necessary conditions of the other" (1997: 24, emphasis omitted). "The pursuit of justice, when successful, must also be caring, and the activity of caring, when successful, must be mindful of the demands of justice" (1997: 24, emphasis omitted).
4. For feminist readings of the film see: Barry Jordan and Rikki Morgan-Tomasunas (1998) praise *High Heels* for its portrayal of strong and independent women; Marsha Kinder contends that the film expresses feminist attitudes (1993: 253); and Deborah Shaw asserts that *High Heels* "celebrates representations of the feminine" (2000: 55). This reading is by no means uncontroversial. Lucy Fischer, for instance, argues that the film is antifeminist (1998: 209–210) and Caryn James (1992:11) and Paul Julian Smith (1994) argue that the film has a misogynistic message.
5. As Kamir notes, faithful to its Continental roots, *High Heels* depicts an inquisitorial legal system with the focus on the judiciary, rather than on lawyers as in the Anglo-American adversarial system. While in the latter lawyers are responsible for gathering the evidence, in the former the judge is in charge of the "search for truth and justice" (2006: 268). Accordingly, Judge Domínguez is directly and actively involved in the criminal investigation, looking for evidence, determining the facts, and questioning witnesses and defendants.
6. Taking as a starting point Jacques Derrida's "political ethical work," together with Emmanuel Levinas's philosophy of otherness, Douzinas and Warrington seek to "articulate a theory of ethical action upon which a practice of justice can

be built" without reproducing the "totalising [sic] tendencies" of Enlightenment (1994: 17.) Such postmodern jurisprudence stands in contrast both to positivism – which grounds the legitimacy of law on the formal legality deprived of ethics – and hermeneutical jurisprudence, which emphasizes the interpretative and ethical character of the law but neglects its violent side.

7. I use the term "queer" in Fabio Cleto's inclusive sense. For Cleto, queer "claims to inscribe all subordinations (of class, gender and ethnicity) into a common design while apparently respecting each subordination . . . in its historical and cultural specificity" (1999: 15).

8. Ley de Vagos y Maleantes, BOE n 198, July 17, 1954.

9. See Brincat Report (Informe Brincat), Parliamentary Assembly of Council of Europe, *Need for International Condemnation of the Franco Regime*, Doc. 10737, November 4, 2005.

10. However, as Alberto Mira notes, Almodóvar "has often defiantly expressed his unwillingness to discuss homosexuality and even gay politics, and won't acknowledge some elements of his work (such as camp, taste for melodrama and retro pop, use of drag queens, religious imagery, etc.) are part of a 'gay culture'" (2000: 250). See also Garlinger and Song 2004.

11. There has been disagreement about the meaning of camp. For Susan Sontag, camp is an apolitical and a-historical aesthetic, a sensibility that emphasizes artifice, style, and extravagance over content (1999: 54–55). For Esther Newton (1999: 96–109) and Jack Babuscio (1999: 117–135), camp is style, irony, incongruity, humor, and theatricality that only exists in the eye of the beholder. Jonathan Dollimore sees it as "a weapon of attack an oppressive identity inherited *as* subordination, and hollowing out dominant formations responsible for that identity . . . camp is an invasion and subversion of other sensibilities [besides gay sensibility], and works via parody, pastiche, and exaggeration" (1999: 221). While Mark Booth (1999: 66–79) argues that camp celebrates patriarchal oppression, Pamela Robertson sees it as a feminist practice: "a female form of aestheticism, related to female masquerade and rooted in burlesque, that articulates and subverts the *image-* and culture-making processes to which women have traditionally been given access" (1999: 271). In this study, although I rely on Newton and Basbuscio's notion of camp, I do not see it as an exclusively gay sensibility, but, following Robertson, as a "queer discourse" that includes gay- and lesbian-specific positions, as well as non-gay and non-lesbian ones.

12. As Cleto observes, camp and queer share a common investment: "questioning deviations from (and of) the straightness of orthodoxy, . . . *devoiding* the subject of its fullness, and permanence – in other words, of its transcendent immanence" (1999: 16, original emphasis).

13. To be cxact, viewers learn about Rebecca's guilt earlier in the film, when she takes the gun from the television set.

14. For Marsha Kinder, the scene shows Rebecca's homoerotic desire for her mother (1999: 258).

15. The song *A Year of Love* was originally composed by Nino Ferrer.

16. Furthermore, at one point, when Rebecca wears the earrings Becky bought her as a child, hoping she will notice them, Becky pretends to recognize them. Rebecca tells her to stop acting. Becky's theatricality is further emphasized by her artistic name Becky del Páramo. Additionally, "Becky" is diminutive of Rebecca.

17. As Douzinas and Warrington put it, "[a]n awareness of otherness cannot determine the attributes of the other, but it recognizes that there will always be aspects of every other that we cannot know" (1994: 20.) To understand fully any other's position is to appropriate that other's position as one's own, and therefore to deny that other her otherness, difference, and singularity.

18. In "Force of Law," Derrida challenges the correspondence between law and justice. By the law (*droit, loi*) Derrida means a system of rules, norms, and principles to be applied to particular cases (1992: 22). By justice, by contrast, he means the "infinite, incalculable, rebellious to rule and foreign to symmetry, heterogeneous and heterotropic" (1992: 22). This idea of justice, he argues, "is infinite because it is irreducible, irreducible because owed to the other, owed to the other, before any contract, because it has come, the other's coming as the singularity that is always other" (1992: 25.) Derrida identifies what he calls the "aporia of justice:" It foregrounds the impossibility of reducing the experience of justice to the (positive) system of rules. For Derrida, justice is an experience of the impossible, an experience that we are not able to experience: "the experience of absolute alterity" (1992: 27).

19. While for film's viewers it seems obvious that they are the same person, Rebecca along with the rest of the characters seem to ignore his multiple identities.

20. This affirmation is related to camp's perception of "life as theater" and of "being as playing role": "Depth-anchored subjectivity is dissolved and replaced by . . . depthless foundation of subjectivity as actor (in itself, non-existent without an audience) on the world as stage. And as object of camp decoding, the actor exists only through its in(de)finite performing roles, the ideal sum of which correspond to his own performative 'identity,' personality being equal to a co-existence of *personae* on the stage of Being" (Cleto 1999: 25). The camp notion of life as performance is a central aspect in *High Heels*, which focuses on the dynamics of role playing: from gender roles, people's identities, motherhood, and everyday life to law.

21. According to Jean-Louis Baudry, the darkened and closed ideological space of the cinema functions, like the Platonic cave, as a *mirror-screen* that "reflects *images* but not 'reality'" (1974–1975: 45). The projector appears as a sort of psychic apparatus that confers on the spectator the imaginary position of "transcen-

dental subject," while at the same time it conceals such a position as constructed (1974–1975: 43) For him, cinema is "an apparatus destined to obtain a precise ideological effect, necessary to the dominant ideology: creating a fantasmatization of the subject, it collaborates with a marked efficacy in the maintenance of idealism" (1974–1975: 46).

22. "Yet [as Gerbaz points out] acknowledgment of this failure to reach complete identification, to reduce to presence, is . . . fundamental to an ethics of alterity" (2008: 24).

23. Christian Metz argues that cinema offers the spectator the imaginary state of wholeness and completion, and that, in order to create such a state of completion cinema uses identification and voyeurism. Metz distinguishes what he calls "primary identification" from "secondary identification." He argues that the spectator, first of all, "*identifies with himself*, with himself as a pure act of perception (as a wakefulness, alertness): as the condition of possibility of the perceived and hence as a kind of transcendental subject, which comes before every *there* is" (1977: 49). This primary identification makes possible the identification with the characters and the events on the screen (secondary identification). For Metz, "[t]he practice of the cinema is only possible through the perceptual passions: the desire to see (scopic drive, scopophilia, voyeurism)" (1977:5 8). The voyeur possesses the privileged position of looking without being noticed (the object of perception does not know that it is being watched).

24. For a similar argument see Alejandro Yarza's excellent analysis of Pedro Almodóvar's film *Entre Tinieblas* (*Dark Habits* 1983) (Yarza 1999).

25. In *Visual Pleasure and Narrative Cinema*, Laura Mulvey recognizes three types of "gaze," each relating the desire for the images on the screen from different points of view: that of the camera, that of the characters looking at one another, and that of the spectator. For Mulvey, cinema constitutes its scopic spectator as masculine, and its object as feminine (2004: 837–848). In presenting Rebecca as the bearer of the look, the direct address undermines the patriarchal cinematic tendency (in particular, classic Hollywood cinema) to position the woman as a passive object to be looked at by the active male gaze of the viewer.

26. Buchanan and Johnson differentiate affect from emotion – our pre-cognitive responses to particular combinations of words, images, and sound (2009: 37).

27. The equation of penis and gun as a sign of masculinity is also parodied in the film: Manuel is killed by his own gun. See Zorach 2000.

28. As Babuscio observes, "in order for an incongruous contrast to be ironic it must, in addition to being comic, affect one as 'painful' – though not so painful as to neutralize the humor . . . Humor constitutes the strategy of camp" (1999: 126).

3

Dissensus in the Community: Disrupting Neoliberal Affects in *La Comunidad*

> What "dissensus" means is an organization of the sensible where there is neither a reality concealed behind appearances nor a single regime of presentation and interpretation of the given imposing its obviousness on all. It means that every situation can be cracked open from the inside, reconfigured in a different regime of perception and signification. . . . [T]his is what a process of political subjectivation consists in.
>
> Jacques Rancière (2009a: 48–49)

By combining black humor, thriller, and horror film, Álex de la Iglesia's *La Comunidad* (*Common Wealth*, 2000) tells the story of a gruesome community of neighbors who have made a pact to wait for their elderly neighbor to die so they can steal and share equally the money he won in the *quiniela* (football pools).[1] However, their plans are frustrated when the real estate agent who comes to sell an empty apartment finds the money and decides to keep it for herself. The community will do anything, including murder, to get the money. In an interview, de la Iglesia has affirmed that the violence and horror of the film are nothing compared to the cruelty of everyday reality as described in the newspapers (de la Iglesia in Hermosa, n.d.). He describes the greedy neighbors as a magnifying mirror where viewers can see their "own defects grotesquely distorted" (de la Iglesia 2001: 53). To create this grotesque mirror effect, the film uses a series of narrative and aesthetic strategies: the style of satire, caricature, and *esperpento*, exaggerated theatrical performances, extreme close-ups, intertextuality, and casting of veteran actors from Spanish cinema, television, and theater, characterized in an ugly and hideous way so as to make them both comic and frightening, hilarious, and disgusting.[2]

Critical analyses of *La Comunidad* have connected the strategies employed to the film's aims. For example in the film's constant references to Spanish dark comedies of the 1950s Burkhard Pohl finds a "realist" sensibility that goes beyond the parodic and the comic to denounce, from a detached perspective, an "inhumanely materialist society" (2007: 136, 126). Likewise,

for Peter Buse, Núria Triana-Toribio, and Andy Willis, the casting of well-established Spanish actors and the use of techniques and aesthetics (for example, choral structure) of Spanish dark comedies of the 1950s and 1960s reveal "the nagging persistence of the [conservative] past in the present" and skeptically interrogate Spain's modernizing present (2007: 125, 136). In turn, Mercedes Maroto Camino focuses on the character of Julia to emphasize the film's stance on gender relations. In her view, the film uses social caricature to denounce the sexism that pervades contemporary Spanish society and suggests avenues for social and individual change (Maroto Camino 2005). Shifting the focus to the old man's dead body, Cristina Moreiras Menor argues that de la Iglesia's use of the anamorphic gaze of the camera – the look that grotesquely distorts reality and compels viewers to look awry and not straight – aims not only to reveal the hidden violence behind the Francoist national-communitarian spirit which still persists in modern Spain, but also to do justice to the forgotten, but not departed, victims of Franco's dictatorship (Moreiras Menor 2011). Regardless of differences in outlook and focus, critics concur that the film's critical potential lies in its ability to render visible the sordid reality concealed behind Spain's democratic and European façade.

Drawing on Jean Baudrillard's notion of the "consumer society" and Jacques Rancière's critical account of neoliberal "politics of consensus," this chapter suggests that *La Comunidad* launches a powerful critique of the ideological presuppositions and *policing* practices that condition the "regimes of visibility" of Western liberal democracies. In particular, the film rethinks the notions of political community and democracy in the context of the anxieties generated by Spain's integration in the European Monetary Union (EMU) in 1999. By examining the market and the state's mechanisms of depoliticization (alienation, exclusion, and the logics of "us" vs. "the others"), the film unmasks the neoliberal promises of equality, freedom, and economic growth as fallacies, and undermines the equation of free-market economy and "consensual democracy." In its place, the film proposes a form of democracy that is contingent and open, and operates not as a mechanism of institutionalization, but rather as a force of destabilization. In this view, democracy can never be fully consolidated, for it relies on episodic disruptions of the established order and the continual renewal of the actors and the forms of democratic actions.

However, departing from previous analysis, I argue that the real strength of the film lies not in its ability to render visible this order of domination or in the manner it chooses to represent it, but rather in its ability to create an aesthetics of dissensus in Rancière's sense. This aesthetics sets up possibilities for new forms of political subjectivation not just within the fictional world of the characters, but within the sensory world of the viewer. For these purposes, my analysis turns to a marginal and often neglected character named Charlie

(Eduardo Antuña), presented throughout most of the film as a "retard" (as the neighbors call him) and sex pervert who likes to dress up as the villain from the original Star Wars movies, Darth Vader, spy on Julia (Carmen Maura) with his binoculars, and masturbate while repeating the words "The Force . . . the force" (*La fuerza . . . la fuerza*). At a given point in the film, Charlie is able to stage a *wrong* into what the film presents as the given relationship between the sensible and its meaning, facts and their interpretation, the mode of representation and its affects. Charlie's political act of subjectivation and aesthetic irruption into the viewer's field of perception disrupt and reconfigure the regime of visibility that the film imposes and simultaneously invites viewers to challenge. In this way, the film demonstrates not just the aesthetic dimension of politics (which has nothing to do with the "aestheticization" of politics denounced by Walter Benjamin (1969)), but the political character of aesthetics.

Before analyzing the film, I provide a brief overview of the Spanish neoliberal politics of the nineties in relation to Rancière's critical account of the European "politics of consensus."

Spain and the Neoliberal "Politics of Consensus"

Spain's accession into the European Community in 1986 took place the same year that the EC signed the Single European Act (SEA), aiming at achieving a single internal market by December 31, 1992. The SEA called on all member states to remove all internal trade frontiers and to assure "the free movement of goods, persons, services and capital" before the established deadline (art. 13).[3] For the next six years, the ruling Spanish Socialist Workers' Party (*Partido Socialista Obrero Español*, PSOE) strived to fulfill the EC requirements of market liberalization. In 1992, as the deadline approached, very high rates of unemployment, economic recession, police scandals, and governmental corruption hit Spain's politics and economy. Among the many corruption scandals affecting the PSOE at the time was the so-called "Juan Guerra case," in which the deputy prime minister was accused of abusing his official authority to support his brother's business. Likewise, PSOE officials were accused of supporting the illegal dirty war against ETA, the Basque terrorist group in the mid-1980s.[4] At the same time, Denmark's rejection of the Maastricht Treaty in 1992 triggered a rise of "Euro-skepticism." For the first time after Franco's death, the image of the celebrated Spanish democracy was in question, and Spaniards began to reassess the erstwhile political discourse concerning Spain's position within the EU (Closa 2001: 14). After losing the absolute majority in the general elections of 1993, partly because of the economic and political crisis, the PSOE's discourse towards European integration took a more utilitarian stance: the EU should compensate Spain

for its efforts to meet the new Maastricht Convergence Criteria (with respect to inflation rates, government deficit and debt, etc.), in order to gain entry into the EMU (Closa 2001: 14–17).

This utilitarian discourse hardened when, in 1996, after twenty years in the opposition, the conservative Popular Party (*Partido Popular*, PP) came to power. The new Prime Minister José María Aznar established the defense of the national interests and the incorporation of Spain into the EMU as his main priorities. At the same time, a Spanish nationalist discourse that was said to have disappeared with the end of Franco's regime and the consolidation of democracy resurged.[5] In Aznar's view, the sovereignty of the nation-state was the basis for the European integration process. Describing Spain as "one of the most ancient nations of Europe," he claimed that the European project would always remain compatible with Spanish national identity (Aznar 1994: 29, 162–163, 193; see also Closa 2001: 23–32). Therefore he demanded the establishment of common rules that protect the national interests of all EU members. "The rule of consensus" (*la regla del consenso*) thus "should be the basic criterion for the adoption of the fundamental decisions that affect the common politics," he explained (Aznar 1994: 168).

A backdrop for this understanding of Spain's rightful place in the EU is that Aznar sees Spain as a single (if pluralistic, multicultural, diverse, multilingual, and heterogeneous) nation. He centers basic unity among all Spaniards on the country's common history, language, and project. The peripheral Catalan, Basque, and Galician nationalisms undermine the idea of a Spanish national community, thereby threatening the integrity and unity of the nation (Aznar 1994: 31–39). However, Aznar had to negotiate the parliamentary support of two peripheral nationalist parties, Catalan *Convergència I Unió* (CIU) and the Basque *Partido Nacionalista Vasco* (PNV), in order to become prime minister in 1996. The political discourse of solidarity, respect, and diversity that characterized his electoral campaign was transformed after he won the 2000 elections by an absolute majority, acquiring a stronger Spanish nationalist tone, as he no longer needed these groups' support.

In the economic sphere, the PP government accelerated the European policies of economic liberalization, already initiated under the PSOE government, in order to fulfill both the Maastricht Convergence Criteria and the conditions established by the EU members' 1997 Growth and Stability Pact. Following Spain's incorporation into the EMU in 1999, the Euro was introduced in 2002. The defining feature of Aznar's government was its neoliberal perspective on European integration (Closa 2001: 27). Aznar argued that to strengthen economic growth, the European Union should be based on market liberalization and competitive economy.[6] A joint proposal presented with former UK Prime Minister Tony Blair in the Lisbon Summit of

2000 encapsulated Aznar's neoliberal program, calling on Europe to establish "higher growth, higher employment, [and] modernization of the economies" as its "main objective" (Aznar and Blair 2000: n.p). In this joint proposal, Aznar and Blair claimed that the role of governments has changed: their new role is to create the conditions for business to boost job creation and combat social exclusion, without imposing rigid economic and social regulations on the market. On the contrary, governments should avoid any interference in market decisions, on the premise that the liberalization of the European economy (free market, deregulation, open competition, privatization) will benefit a greater proportion of the population than any welfare program could. The proposal concludes, in a populist tone, that European leaders "will be judged by their ability to manage the intense changes that run Europe" and that they "must do everything possible to explain these changes and seek the support of the real rulers of Europe: the citizens themselves" (Aznar and Blair 2000: n.p). Aznar identifies economic growth and free market as synonymous with social well-being and democracy. His legislature (1996–2004) was nicknamed "the second transition," that the PSOE government had failed to complete the process of economic modernization, and, therefore, to consolidate democracy (Balfour 2005: 154).

In *Disagreement*, Jacques Rancière refers to the European neoliberalism of the 1990s as "the end of politics," as the reduction of politics (as a set of practices) to the management and administration of economic interests and necessities (1999: 86). Rancière observes that the collapse of the Soviet system in the 1990s provoked an "internal weakening" of the very same liberal democracy that was proclaimed to have triumphed over so-called totalitarian systems. The end of the socialist project made possible the establishment of an agreed-upon vision (at the core of the so-called Western democracies) that viewed the global market economy and "the unlimited power of wealth" as inevitable historical necessities for our world and its future (Rancière 2006d: 77). The neoliberal vision, as Brett Levinson puts it, "naturally" established the market as "the destiny of man: inevitable and necessary" (2004: 2). Faced with this incontrovertible logic, the government's task is to create adequate conditions for ensuring the optimization of interests and gains for all (Rancière 2006d: 77). In this way, Rancière observes, Marx's once-scandalous observation that governments are mere servants of international capital "is no longer the shameful secret hidden behind the 'forms' of democracy; it is the openly declared truth by which our governments acquire legitimacy" (1999: 113).

In this process of legitimization, Rancière further argues, the demonstration that governments only ever do what strict necessity requires in a world dominated by the constraints and caprices of the global market depends on

a demonstration of powerlessness: maximizing the pleasure of individuals is only possible on the basis of their acknowledged incapacity to manage themselves (1999: 113). Put differently, the State's authority lies in the depoliticization of the people. Those who deny or resist this necessity are, according to this logic, representative of an obsolete ideology and therefore against progress (Rancière 2006d: 86). The removal of conflict and dispute serves as proof of the State's capacity to solve problems and manage the interests of the population, understood as "a single, objectivizable totality" (Rancière 2006d: 78). Rancière concludes that, rather than ensuring the institutional mechanisms that guarantee the sovereignty of the people, politics became a matter of coming to an agreement on the proper "management of the local consequences of global economic necessity" (2004a: 4).

Rancière refers to this "politics of consensus" or "consensus democracy" as "post-democracy." He uses this term to denote the state practice that precludes democratic action – paradoxically, in the name of democracy (1999: 101–102). Ideally, consensus democracy "is a reasonable agreement between individuals and social groups . . . [that is] a way for each party to obtain the optimal share that the objective givens of the situation allow them to hope for and which is preferable to conflict" (1999: 102).[7] However, according to Rancière, consensus democracy is "a democracy that has eliminated the appearance, miscount, and dispute of the people and is thereby reducible to the sole interplay of state mechanisms and combinations of social energies and interests" (1999: 102). Thus, consensus does not mean a reasonable agreement in which parties discuss their problems, build up their interests, and allocate their shares; rather, consensus means

> the matching of sense with sense: the accord made between a sensory regime of presentation of things and a mode of interpretation of their meaning. The consensus governing us is a machine of power insofar as it is a machine of vision. It pretends to verify only what everyone can see. (Rancière 2010a: viii)

Consensus democracy provides a totalizing and objectifying account of the population and presupposes the inclusion of all parties with their corresponding problems, claims, and opinions. By creating the illusion of completeness, consensus democracy masks the effacement of the *demos* – those who are outside the count, the part of those who have no part (Rancière 2004a: 5). This distribution or "regime of the perceptible" is what Rancière calls *the police*, or *the police order*:[8] "the general law that determines the distribution of parts and roles in a community as well as its forms of exclusion" (2004b: 89). This given configuration of the sensible defines ways of being, thinking, doing, seeing, saying, arguing, feeling, and having within

the community. At the same time, it produces policing norms that determine who is included or excluded, who is counted or not counted, whose words are significant or insignificant, who is entitled to govern or not, and what is normal or abnormal (Rancière 1999: 29). In this police order, everyone has an assigned place, identity, and function. Consensus works by imposing such a distribution of the sensible as univocal and unquestionable – that is, it transforms politics into the police (Rancière 2010b: 149,100). Politics, for Rancière, only occurs when the fixed distribution of the sensible and the counting of the parts and parties of society are disrupted by those who have no part in that distribution, that is, in the existing order of domination (1999: 11–12, 29–30).

In the next section, I interpret the community of neighbors of *La Comunidad* as an allegory of what Rancière has called "consensus democracy." In examining the formation of this community and the ties that bind it, its forms of domination and structure, the kind of individuals and power relations it produces, I distinguish two contrasting ways of symbolizing the "common" of the community: the first is expressed in the rhetoric of the community, which presents itself as the sum of its parts and is united by common ethical values. The second is the perspective the film invites viewers to adopt. This view will reveal that behind the idyllic image that the community presents lies a hierarchical community based on division and exclusion.

The Regime of the All-Visible

From the beginning of the title sequence, an omniscient camera-eye positions viewers as godlike figures able to see everything and everyone within the story. The sequence opens with a camera movement reminiscent of the flight of a bird that shows a majestic building with a cat in one of its windows. The camera then follows the cat into the interior of a dark room with piles of trash, filthy water, and a decomposing corpse that the cat starts nibbling. The sequence closes with an image of the cat dissolving into a spiral, at the center of which appears an eye, the credits inform us, belonging to the actress and film protagonist Carmen Maura. The camera isolates her terrified face at the left of the frame and reveals the cause of her fear: fifteen people arranged in a way reminiscent of a police line-up. As the title of the film points out, these are the members of *La Comunidad*. The title sequence marks the centrality of the building, sets a general mood of suspicion and surveillance emphasized by ominous music (Moreiras Menor 2011: 160), and, most importantly, establishes a "regime of the all-visible," a world of total visibility in which everything (public and private, exterior and interior, appearance and reality) seems to be on display for the viewer. From this position, the film invites viewers to critically examine two different but interconnected regimes of visibility that

simultaneously distribute bodies, images, and places and determine what can
be seen, said, and thought: first, there is the regime of "sensory commodity"
proper to the consumer society symbolized by Julia; and second, the regime
of the "saturated community" proper to the society of consensus symbolized
by the neighbors.

Julia and the Consumer Society

The film opens with an image of Julia on her cell phone talking with her hus-
band in front of the building shown in the title sequence. As she approaches
the building to meet her clients, she finds a joker's card on top of a sewer
grate with the name Madrid written on it. The image of the sewer symbolizes
Julia's entry into the building: as if she were opening the entrails of Madrid,
as Moreiras Menor (2011: 160) points out, Julia opens the door to find a
dirty foyer with filthy walls, damp stains, and a trash container with the name
of the street on it: "Carrera de San Jerónimo 14" – the street of the *Congreso
de los Diputados* (Spanish Parliament). Located at the heart of the city (and
of Spain), the building's majestic façade masks the "rotten" reality, which, as
the dead body and the images of the sewer and trash imply, pervades Spanish
society. Notwithstanding the decaying conditions of the building's interior,
Julia focuses on the "superb advantages" of its location when trying to sell
the apartment to her clients: "You can go anywhere from here," she tells
them. From that moment, the film transforms the building (a metaphor for
Madrid and hence for Spain) into a theater of deceptive appearances, wherein
individuals find themselves ascribed to specific forms of sensory commodity
within a global market economy.[9]

Echoing Jean Baudrillard's vision of the "consumer society," the film por-
trays a society immersed in the logic of the market: its inhabitants, whether
real estate agents, middle-class clients, or petty workers, equate prestige,
power, and happiness with acquisition and consumption, without realizing
that, in so doing, they are contributing to their own alienation (1998: 191).
As Baudrillard argues in *The Consumer Society*, consumption is a whole system
of values that has become naturalized, not by fulfilling individuals' desires for
comfort, satisfaction, and social status, but, rather, "by *training them in the
unconscious discipline of a code*, and competitive cooperation at the level of
that code" (1998: 94, 192, original emphasis). Through TV, advertising, and
the mass media, "the logic of consumption" confers on commodities, not
merely a use-value and economic exchange-value, but most significantly a
sign-value: a sign of status differentiation (Baudrillard 1998: 61). By acquir-
ing and displaying material goods, by their way of consuming, individuals
attempt to differentiate themselves from others, that is, to gain prestige,
status, and identity. The consumer experiences this process of differentiation

as one of freedom and choice, rather than as *"one of being forced to be different, of obeying a code"* (Baudrillard 1998: 61, original emphasis). The first part of the film illustrates this double process of differentiation and homogenization: the way in which the sign-value dimension of the commodity simultaneously establishes the mode of perception and signification so that consumers can no longer distinguish between the real and its representation.

The first compelling example comes from Julia and her husband Ricardo (Jesús Bonilla), who has recently started to work as a bouncer in a disco. The couple's problems begin when Julia finds the apartment she is trying to sell so luxurious that she decides to spend a romantic night there with her husband. With a TV, leather sofa, king-sized waterbed, and even a Jacuzzi and a Finnish sauna, the apartment symbolizes everything she lacks and desires to possess. Its fancy decoration and material comforts, and its central location, hold the promise of bridging the distance between what Julia is and the fantasy of what she aspires to become, where all its objects are "thinly disguised narcissistic delusions transferred onto the idealized commodity" (Gabriel and Lang 1995: 95). Thus, in the next scene, Julia is wearing an elegant pink suit and happily cooking dinner in the kitchen of the luxurious apartment, hoping to fulfil, at least momentarily, her fantasy of social status.

Ricardo's arrival interrupts Julia's fantasy, complaining that his friend Antonio Pesadas is driving a Mercedes taxi, a job he considers superior to his job as a bouncer in a disco. In a society where people compete for social status, Ricardo defines himself by comparing his lifestyle with that of Pesadas, measuring his own progress against the other man's in the years since the insurance company where they both worked laid them off. He feels inferior to Pesadas, and cannot join in Julia's enjoyment of the apartment. The final wreck of their romantic night comes when they begin to use the waterbed and cockroaches start falling from a crack in the ceiling. The apparent perfection of the apartment is as false as the promises that Julia sells her clients. The camera cuts away to an unidentifiable figure who viewers will later learn is Charlie, dressed as Darth Vader and breathing heavily, spying on Julia and Ricardo with binoculars. The apartment does not even provide privacy.

The film is no less negative about the other inhabitants of the building. The first time the neighbors appear on screen is when the fire department enters the building, alerted about the water leak from the apartment above where Julia and Ricardo are now watching TV. *Mise-en-scène* and cinematography link the neighbors' first appearance on screen to a series of images on the television. First, it shows a couple of vultures in close-up, looking for prey from a tree while a voice-over states, "The vulture, nature's gravedigger, devours the dead. When one vulture finds a carcass, twenty more appear to share it. A voracious jackal joins them. The somber party

continues until nothing's left." From a low angle shot that echoes the image of the two vultures looking for prey from a tree, the camera shows a couple, Encarna (María Asquerino) and Paquita (Marta Fernández Muro), wearing dark housecoats and standing in the old stairwell of the community. A zoom-in brings them closer to viewers, making the couple's excitement evident as they look towards the dead man's apartment. The film will later reveal they have been watching him for years in this way. Eager to confirm the old man's death, the rest of the neighbors gather around in front of his apartment like vultures before a carcass: Charlie (dressed as Darth Vader), his controlling mother, Dolores (Kiti Manver) (who slaps him in the face for "dressing like a drag queen!"), Ramona (Terele Pávez) (who also slaps Charlie in the face), and Julián (Manuel Tejada) and Hortensia (Paca Gabaldón). When a fireman mistakes Julia for the community's administrator, the neighbors turn their attention to Julia, positioning her as the intruder, the jackal who does not belong to the community: "Who's she? Who are you? We don't know her."

The meaning of the scene is two-pronged: on the one hand, it visually highlights the contrast between community and individual. The neighbors position Julia as the intruder who does not belong to the community – they assume she is the new owner of the apartment that is for sale – and who threatens to seize the old man's money, which much like the vultures with the carcass they stand ready to claim. This draws attention to the fact that the same logic of consumerism governs the neighbors' values and attitudes, their drives and desires as Julia's. The characters continue to reveal their rapacious nature in subsequent scenes; Domínguez (Enrique Villén), another neighbor, digs through the old man's garbage, singing a pirate song: "Fifteen men on a dead man's chest . . ." Moments later, Julia sings the same pirate song when she finds 300 million pesetas stashed under the tiles of the old man's apartment.

The first part of the film ends with a mirror-like repetition of the earlier sequence at the luxurious apartment: while Julia, who is still in the apartment, dreams about the possibilities the money could bring her, Ricardo's arrival interrupts these dreams. He explains that he has quit the disco because the owner has beaten and humiliated him and tells Julia that he prefers not to imagine anything, even something lucky. At this precise moment, a TV advertisement with the catchphrase, "The strongest drug isn't speed. It's MONEY," displays a series of images of expensive cars and beautiful women, forcing Ricardo to imagine precisely the things he cannot afford. He tells Julia, "In this life, we'll never put our asses in one of those [expensive cars], unless we catch Pesadas' taxi." By contrast in the ensuing scenes, Julia takes the advertisement as inspiration. She has no qualms about "eliminat[ing]"

Ricardo by telling Oswaldo (Roberto Perdomo), a Latin lover and dance instructor, that her husband has died and she is free to accept his offer of a night of passion. Her individualism takes over. This contrasting impact of the advertisement on Julia and Ricardo dramatizes Baudrillard's description of the impact of inequality: "[t]he very process of production of aspirations is inegalitarian, since resignation at the bottom end of the social scale and freer aspirations at the top compound the inequality of objective possibilities of satisfaction" (1998: 63).

In a society where money is the "strongest drug," individuals like Julia become addicts, "unable to live without self-delusions, mediated by material goods, which ultimately aggravate [their] condition" (Gabriel and Lang 1995: 98). Those like Ricardo who cannot see themselves as consumers are made invisible. By keeping everyone in their place, the logic of the market ensures that those individuals who might question their role as consumers are silenced: "[m]otives, desires, encounters, stimuli, the endless judgments of others, . . . [and] the appeals of advertising . . . make up a kind of abstract destiny of collective participation, set against a real background of generalized competition" (Baudrillard 1998: 65). This is the double strategy of the market society: an ideology based on social homogenization and a concrete social logic based on structural differentiation (Baudrillard 1998: 66, 50).

The Community of Neighbors and the Politics of Consensus.

The second part of the film opens with the party that the community of neighbors organizes for Julia, who has continued to stay in the apartment. While nominally welcoming her to the building, their real intent is to inquire about her knowledge of the money. While they all wait for Julia's entrance, the scene visually positions the community's administrator, Emilio (Emilio Gutiérrez Caba), as a commanding figure. At the moment Oswaldo announces Julia's arrival everybody is looking at Emilio, who orders everyone to get ready and, as the music begins, directs their moves like the conductor of an orchestra. Following Emilio's cue, the neighbors put on a show of an ideal community to entice Julia and prevent her from being suspicious. The significance of this farcical performance, I argue, consists less in confirming the viewers' suspicions about the rapacity and hypocrisy of the community than in the possibility of critically examining the regime of visibility that organizes the neighbors as a community and assigns each particular places, powers, and functions. By simultaneously showing their acting and the behind the scenes direction of Emilio, the film discloses the gap between what the neighbors present as the "common" of the community and the underlying divisions that define it (Rancière 2004a: 12).

The neighbors' performance takes place in three acts, each of which

reconfigures the regime of intelligibility and the *sense* of community (Rancière 2009c: 31). Act one starts off with the fake party. Julia asks if all the people at the party are neighbors. Oswaldo responds that they are a "very tight community." Emilio adds that all the neighbors share a common interest in the building, as most of them have lived there all their lives. Paquita and Encarna mention that the only neighbor who did not share an interest in the common good was the old man, who went crazy after winning the *quiniela* and never wanted to leave his apartment. Laughing hysterically, they reveal it seemed he was afraid of them. As if wanting to dispel any concerns Julia might feel about this exchange, Oswaldo repeats that they are all like a family and that he feels lucky to live in the building. The scene closes with an image of the community singing and dancing together around Oswaldo and Julia, performing the harmony he described.

The second act opens in the elevator when Julia tries to escape with the money in a suitcase after discovering the true intentions of the community. While in the first act the neighbors introduce themselves as a community bound together by a shared sense of belonging and identity, in this act, they portray themselves as a contractual (that is, legal) community based on an agreement that allegedly entitles them to equal shares in the old man's money. Joining her in the elevator, Domínguez explains that the neighbors agreed to watch the old man day and night to prevent him from escaping with the money and then to share it after his death. Now the other neighbors want to kill him because they suspect he might have the money. Suggesting the community has been involved in crime for some time, he also explains that an engineer who lived in the luxurious apartment, did not accept the rules of the community and suddenly "disappeared." He and Julia try to exit the elevator, but it suddenly lurches, trapping Domínguez's body between floors and brutally cuts it in half. At this moment, Hortensia tries to get the money, but Julia overpowers her. She explains to Julia that the old man didn't enjoy his money, and the neighbors were only ripping off the tax administration. The rest of the neighbors join them in the stairwell and try to persuade Julia to share their community of interest: "There's enough money for everyone in there. You got what you needed to have. You won your share."

Act three opens when Emilio violently forces Julia into the luxurious apartment.[10] He tells her she is an outsider who is threatening to destroy the ethical bond of the community. They gave her the chance to "be one of them" and "share the luck" of living in the building, but she has chosen instead to pursue her own pleasures and interests. The selfishness of which Emilio accuses her clashes with the values of solidarity, respect, and sacrifice which he attributes to the community: "I feel sorry for your kind . . . You people think only of yourselves . . . You people don't want responsibilities . . . Well,

we are different here. This is a community." As evidence, Emilio provides a
list of each member's particular needs: "García . . . needs a little car to get
around town. Paquita . . . needs to get her teeth fixed . . . Know what I'm
talking about? About solidarity, respect. We believe in respecting others. You
don't know what that means."

In the name of the common good, Emilio has allocated power (the most
capable), wealth (equal shares to the old man's money), rights (individual
and collective), rules (to prevent people from damaging others in the pursuit
of their interests), and duties (to follow the rules of the community), all of
which serves as a yardstick for the community's sense of equality and justice.
Furthermore, the prosperity of the community could only be achieved if the
neighbors abide by the common rules (i.e., to watch the old man a few hours
each day). Following these rules gives each the right to share equally in the
old man's wealth. Emilio positions himself as the catalyst and embodiment
of such commitment: he has worked tirelessly to make the agreement pos-
sible and turned away better job offers for the sake of the common good. The
plan failed because he took his first vacation in twenty years, then returned
when the community let him know Julia had gotten into the apartment
before him. These facts reaffirm the fact that his leadership and management
are the glue that keeps the community together. Emilio informs Julia that all
the problems, interests, and needs of each member are heard and taken into
account. Thus, the list of each member's needs is amended year by year. The
equality of everyone in the community seems equal to the sum of its parts
and their problems with nothing left over. Emilio presents the values of the
community as the embodiment of a democratic regime and criticizes Julia's
selfishness, consumerism, and hedonism (people thinking only of themselves,
devoid of responsibilities, who enjoy living the present life day by day with-
out knowing the value of solidarity, family, and respect) as a threat to this
regime. In Emilio's view, Julia is not the victim of the logic of consumption.
On the contrary, she is responsible for it. Her limitless desire for consump-
tion ruins the search for the common good embodied in the community and
must, therefore, be excluded from it.[11]

Whereas onstage the neighbors portray themselves as an ideal consensual
community (on the basis of a shared identity, agreement, and ethical bond),
behind the scenes the film unmasks an order of domination based on inequal-
ity and exclusion. This is most explicit in a conversation that takes place
between Charlie and his mother at the fake party. Charlie asks his mother's
permission to leave. His mother replies that he has to stay because Emilio says
so. Charlie then complains that he never wanted to be part of the agreement
and that she forced him to sign it. His mother warns him that if he leaves,
he may end up like the engineer. When Domínguez later reveals who the

engineer was, viewers realize that the neighbors murdered him. The conversation undermines Emilio's claim of a consensual community, as Charlie is not a willing partner.

Throughout the film, the community treats Charlie as an inferior being (a "retard," as Castro calls him), dependent on his mother's care and incapable of independent will and thought. By relegating Charlie to this category, the community excludes him from the public space of collective negotiation and decision making. As Charlie is a "retard," his unwillingness to participate cannot be recognized as "disagreement," but as mere noise that need not be taken into account. By denying his capacity to speak and to think and act independently, the community justifies Charlie's exclusion. Paradoxically, in order to maintain the illusion of consensus, Charlie *must* sign the agreement. By his signature, Charlie is *included in the community without being part of the community*: he "consents" to the given distribution of parts and functions without being allowed to participate in the making of that distribution. Through Charlie's "inclusion," the community effaces any trace of the false count and exclusion, constructing a "saturated community" in which the entirety of places, roles and identities are distributed "ruling out any supplement" (Rancière 2011: 249).

By keeping everyone in their place, the logic of consensus dismisses any possible miscount in the configuration of the "common." In this logic, "the givens of any collective situation are objectified in such a way that they can no longer lend themselves to a dispute, to the polemical framing of a controversial world within the given world" (Rancière 2009c: 48). There are only two options for those who would challenge it: either they are made to accept the common project, values, and rules and become members, but not participants of the community (like Charlie); or, if they refuse (like the old man and the engineer), or are otherwise perceived to have violated these rules (like Domínguez), they become a threat that has to be eliminated, by force if necessary. The community's perception that it is at risk of dissolving produces the effect of unity through inclusion. Moreover, this unity is maintained through exclusion and hatred towards those who are deemed selfish and unsupportive. What Emilio describes as a "being together," as an act of solidarity and of respect for the other, is actually "a coming together in order to exclude" (Rancière 1995a: 23).

Julia sees through Emilio's rhetoric and replies to his long "monologue": "You are a fraud and a thief, like me, like everybody." Emilio defends himself, asserting that he is entitled to the money because the old man guessed the scores of the soccer lottery thanks to him. Emilio tells Julia: "He asked for advice. He said, 'Sporting against Real Sociedad,' and I said, 'Tie.' I don't know, it just came out of my mouth. No one else in Spain marked 'Tie.' Just

me." According to Emilio, this gives him the right to a share of the profits. He explains that the old man became greedy and decided to keep the winnings for himself instead of sharing it with him and with the community. "As if we didn't exist," he complains. "We were neighbors. A lifetime together, meeting in the elevator, in the bar. It meant nothing to him. He could have given us a part, or just gifts." As Emilio tells the story, the neighbors had a prior claim to the money that the old man had denied them when refusing to share what was their due.

Despite Emilio's myth about the origins of the community, the community he is referring to is founded precisely at the moment in which the neighbors conspire to steal the money from the old man. The previous "being together" of the community, which the old man had supposedly violated when refusing to share the winnings of the *quiniela* is a myth. The idea of "coming together" arises at the moment the old man wins the *quiniela*. What brings about the consensus community is, therefore, as Cristina Moreiras Menor points out, not the sharing of experiences, values, or space by all its members, but rather their materialist dreams and desires (2008: 388). Around these dreams and desires, Emilio has fabricated a sense of community that serves his own interests. Now that Julia threatens to destroy his plans, as the engineer did before her, she must be eliminated. Hence, when Julia sees through Emilio's rhetoric and accuses him of being "a fraud and a thief, like me, like everybody" and of using the neighbors, Emilio stops pretending and tries to kill her. The scene ends when Julia kills Emilio. When she thinks she is finally safe, the neighbors enter, but she is able to hide in the balcony with the suitcase. Like the cat of the credit sequence, she jumps in the old man's apartment, falling in the exact spot where the old man's body was found. Visually, Julia's materialistic dreams put her in the same exact position as the dead old man, afraid of the neighbors and in danger of ending up like him. A cutaway from Julia's apartment shows that Charlie is witnessing everything through his binoculars.

Charlie's Dissensus

From the outset, the film has established a regime of the all-visible that allows viewers to critically observe the gap between appearance and reality in both consumer and consensual societies. The film shows how the interplay of the logic of the market and the logic of consensus confines individuals to a depoliticized place: the market through its order of differentiation and competition; consensus through its order of classification and identification. These two logics transform society into a homogeneous and objectifiable *police-like* order that prescribes a specific regime of visibility that simultaneously "passes itself off as the real," and imposes codes of conduct that determine indi-

viduals' behaviors and attitudes, discouraging them from questioning their assigned places and roles (Rancière 2010b: 148).

However, this regime of the all-visible presents a threefold dilemma: first, it establishes a hierarchical relationship between viewers and characters (viewers can see what the characters cannot); second, it establishes a position of mastery over the viewer (the film explains the "reality" that viewers are not able to see for themselves); finally, it presents this reality as univocal and incontrovertible, "the world as it is," which becomes altogether visible to the viewer with all its appearances and realities, inclusions and exclusions, and that the viewer has to accept as the world he or she lives in. Arguably, this topography of hierarchy, mastery, and ineluctability risks reproducing the police order the film claims to denounce. In this section, I show how Charlie, seemingly the least capable character of the film, stages a dissensus within the film's regime of visibility that, exposing the contingency of the given, generates a new topography of the possible. This is precisely the point where Charlie's political act of subjectivation and aesthetic irruption within the viewer's field of perception meet.

Rancière defines the politics of emancipation as a set of practices by which the presupposition of equality for anyone and everyone is demonstrated through action (1995a: 63). Through the act of political emancipation, the demos – those who have no part in the distribution of the sensible – dissent from the identity, role, and place the police order has assigned them and, enacting their equality, are able to reconfigure the political realm. As he puts it, "politics exists because those who have no right to be counted as speaking beings make themselves of some account" (1999: 26–27). Politics is not, according to Rancière, a discussion or negotiation between parties about their interests, values, or opinions. Neither is it a quarrel over the solutions to be applied to a problematic situation. It is a disagreement over what the police order has established as the "common" of the community;[12] it is a dispute over the configuration of the perceptible itself, that is, over the frame within which one sees something as given (Rancière 2004c: 304). Politics is, in this sense, an aesthetic act that reconfigures the perceptible partitions that define the sum of the parts and their capacities. This acting out or demonstration is not the act of a subject who has an identity prior to the conflict in which it is named as a party. Rather, the political act occurs through a process of *sub-jectification*, by which those not previously identifiable within the given field of experience are able to appear and inscribe "subject names" on it (Rancière 1999: 35, 37). This moment of inscription – which coincides with the political act – reveals the existence of a *wrong*, which is an inequality and miscount of the parts of the community.[13] For Rancière, politics is synonymous with democracy, which "is neither a form of government that enables oligarchies

to rule in the name of the people, nor it is a form of society that governs the power of commodities. It is the action that constantly wrests the monopoly of public life from oligarchic governments, and the omnipotence over lives from the power of wealth" (2006d: 96). Democracy is thus "a way for politics to be" (Rancière 1999: 99).

The last part of the film offers an example of such political emancipation. The sequence begins with an image of Julia trapped in the old man's apartment and the neighbors trying to get inside by breaking down the door. At this point, Charlie unexpectedly enters the old man's apartment from a hole in the ceiling (which he planned to use with the old man) to help Julia escape. As Charlie and Julia make their way out to the rooftop, unbeknownst to Julia, Charlie exchanges the suitcase with the money for an identical one filled with Monopoly money. On the rooftop the following exchange takes place:

> Charlie: This is my plan. You escape. I'll create a distraction, like in the
> Death Star.
> Julia: What Star?
> Charlie: Han Solo distracted the Stormtroopers while Luke and the
> Princess fled, remember?
> Julia: This isn't *Star Wars*.
> Charlie: The Force is with me.
> Julia: They could kill you.
> Charlie: Don't worry, nothing will happen. I'll play dumb as always. Trust
> me.

Julia runs off with the suitcase and Charlie, still wearing a Darth Vader mask and cape, confronts the neighbors with a fake plastic sword. He says: "Too late. The princess is gone. The rebellion will triumph. Long live the Republic!" Oswaldo and Castro (Sancho Gracia) demand "Republic! What fucking Republic? Why is this retard here?" and beat him up. His mother pronounces "Your father was right. We should've drowned you at birth," and they all go after Julia.

In the quoted conversation between Charlie and Julia, Charlie uses the fictional world of the film *Star Wars* to explain his plan of escape.[14] When Julia warns him that he does not live in a fictional world, but in one where he could actually get killed, Charlie tells her to trust him and assures her that he will "play dumb as always," implying that nothing will happen if he continues to play the marginal role that the community assigns him. At the same time, Charlie's confession that he will play dumb "as always" reveals his playing dumb as a deliberate and willful strategy. He is smarter than they think. Behind the role, the community has assigned him — and he has stra-

tegically adopted – is an intelligent person capable of outsmarting them. By playing "dumb" and encouraging the community to ignore him, Charlie not only manages to distract the neighbors and facilitate Julia's escape but also to protect himself. Had the community realized he had the money, they would most likely have killed him.

What appears at first as a utopian fantasy – the fantasy of a freak dressed in Darth Vader apparel imagining rescuing Princess Leia from the Imperial Stormtroopers – becomes the narrative framework for actual events. In the end, Charlie becomes the hero Han Solo, able to defy the Galactic Empire (the community) in order to help Princess Leia (Julia). Likewise, his words "The Force is with me," used earlier in the context of masturbation, become representative of his real strength, forcing viewers to recast him no longer as a freak or a pervert. For the first time, Charlie dissents from the identity, role, and place he had been assigned. While the community continues to hear his words as mere noise and perceive his actions as invisible, for the viewer, he inscribes himself as an equal. Charlie's appearance as a political subject (not the "illusion," but his emergence) introduces a heterogeneous element into the viewer's field of perception that at once breaks it and reconfigures it. By acting out the presupposition of equality, Charlie brings a *wrong* into the open: like the rest of the neighbors, viewers had been practicing the same politics of exclusion they thought they were criticizing.

Equality, according to Rancière, "is not a value to which one appeals" (Rancière 1995b: 65). Neither is it "a given that politics then presses into service . . . a goal politics sets itself the task of attaining. It is a mere assumption that needs to be discerned within the practices implementing it" (1999: 33). There is, therefore, no need for an explicit invocation of the term *equality*, or for recognition of the presupposition of equality by the community, in order for it to be effective or discerned. It is rather those who interpret the action, "a third people" as Rancière (1999: 88) calls them, "whether participants or not, that will recognize the equality out of which people act" (May 2009: 6). The community's only response to Charlie is violence. Its inability to recognize Charlie's equality is no obstacle to the viewer's recognition of his act as political, nor to marking this political action as a failure. Charlie's success lies in staging for the viewer both the act of subjectification that makes him emerge as an equal (political) subject[15] and the wrong that disrupts the seamless order of the police.

In a central way, Charlie's aesthetic irruption is a dispute over the film's own configuration of the sensible in relation with the viewer, that is, over the frame within which the film invites viewers to observe something as given. By demonstrating that he is other than expected, which is not to say that he reveals a reality concealed beneath appearances, Charlie stages a dissensus

between two sensory worlds: 1) the regime of the all-visible, which presents itself through identification and classification as incontrovertible reality, and 2) the world created by Charlie's political subjectivation, which through dis-identification and declassification breaks apart the unity of the given and exposes its contingency.[16] The meeting point between these two worlds sketches a new sense of reality, a new configuration and ways of making sense of it. This sense subverts hierarchy and mastery and opens up a space for a "community of equals" between Charlie and the viewer – a horizontal community with no assigned places or destinations.

This aesthetics of dissensus can have a political effect, following Rancière, provided that one no longer understands this as a relationship of cause and effect (2009a: 15). The politics of the film escapes the intentions and strategies of the filmmaker, for between the idea of the filmmaker and the sensation and comprehension of the viewer there is always a "third thing," "the film itself," whose meaning no one owns or controls, but that nevertheless subsists between them (2009a: 14–15). The political strength of *La Comunidad* does not lie in the specific effects it aims to produce on the viewer or in the way it invites viewers to critically observe a certain reality. It is rather the encounter between the film (insofar as it is a "third thing") and the viewer (insofar as we are emancipated from the totalizing gaze of the camera) that makes Charlie's aesthetic irruption political.

Charlie and Julia: A New Community?

Charlie's political act of subjectivation has unforeseen consequences for Julia. In the climactic scene in which Julia and Ramona confront each other under the gigantic equestrian sculptures,[17] Ramona replicates but inverts Julia's earlier words to Emilio in order to make her admit that she is like the neighbors ("You're just like us, like everyone!"). This time, however, Julia sees her reflection in Ramona and rejects the identification: "No. I won't be like you!" and throws the suitcase with the money at Ramona, who, in trying to catch it, falls to her death in the courtyard of the building. A low angle shot shows Julia looking down at Ramona's body. Ramona lies on the floor the same way Julia (and the old man) did moments earlier in the old man's apartment, which visually suggests that Julia could be the one lying dead had she not renounced the money. The moment Ramona lies dead on the ground, the rest of the neighbors arrive and start fighting among themselves, like vultures over a corpse, for the money they believe is inside the suitcase. Viewers learn about the community's fate from a newspaper headline shown in close-up: "Neighbors kill each other for money that doesn't exist." Greed, as Domínguez had predicted, has led the community to its own destruction and death.

Several days after the incident, Julia reads the following ad in the news-paper: "Darth Vader needs Princess for a serious relationship. Julia, I need you. The Force is with me. Those interested go to 'El Oso y el Madroño'" (The Bear and the Strawberry Tree, a symbol of Madrid). Julia meets up with Charlie at the bar and asks him directly: "Why didn't you tell me you switched suitcases? They almost killed me." Charlie explains that had he told her, the neighbors would probably have guessed it, and she would not have been able to escape. More importantly, Charlie admits that he also wanted to see if Julia was like his mom. The scene closes with an image that both replicates and distances itself from the party that the neighbors staged to get the money from Julia. If that scene presented a grotesque image of the community of neighbors pretending to sing and dance happily around Julia and Oswaldo in order to inquire about the money, this last scene shows a gro-tesque image of a "community" of freak-look-alike customers happily dancing and singing around Julia and Charlie: a *castizo* group of male working-class customers dressed in *chulo* outfits (traditional Madrilenian clothes with flat cap, waistcoat and neckerchief) join Charlie and Julia in dancing at the sound of the *organillo* (barrel organ). While they sing a *tuna* (a traditional song sung by University student groups), its lyrics expressing their love for Portugal, Charlie shares 5,000–pesetas bills with everyone.[18]

Critics have interpreted this ambiguous ending in disparate ways, debat-ing whether it resurrects the anachronism that the community of neighbors represents (Buse et al. 2007: 135–136), or transcends it by creating "an *other* community" (Moreiras Menor 2011: 159). The scene could be interpreted as both return and departure, both as the impossibility of eliminating every order of domination that coexists and as the possibility of creating new forms of political subjectivation (new Charlies) that are able to dissent from the regime of the given.

According to Buse, Triana-Toribio, and Willis, the *castizo* version of Madrid presented at the bar is "just as anachronistic and antiquated as the murderous elevator which creaks up the centre of the block of flats" (Buse et al. 2007: 135). Hence, the scene of the dancing *chulos* "is not really a depar-ture from the temporal isolation of the *comunidad*, but a return to it" (Buse et al. 2007: 135). Although the joyful and cheerful community at the bar may visually echo the community of neighbors, by reducing the community at "El Oso y el Madroño" to the Francoist *castizo* community of neighbors, Buse, Triana-Toribio, and Willis overlook the anti-national character of the former and, with it, the critical character of the scene.

The different meanings of the term *castizo* illuminate the scene. As Deborah Parsons explains, mid-nineteenth century *costumbrista* literature used the adjective *castizo* to describe the customs, lifestyle, and habits of the

lower classes of Madrid, in particular, the social identity of the working-class inhabitants of the low-lying *barrios* (neighborhoods) of Lavapiés, La Latina, and Embajadores (Parsons 2003: 10; Parsons 2002: 184). The lively urban street culture, *verbenas* (street parties), and arrogant public attitude of this social group soon came to dominate the cultural identity of the city (referred to as *lo castizo*). As a particularly localized identity, "*lo castizo* contrasted with both the national and imperial symbolism of the city on the one hand, and its burgeoning European modernity on the other" (Parsons 2003: 10). The term *castizo*, however, was constantly appropriated and redefined over the years. At the beginning of the twentieth century, writers of the "Generation of 1898," such as Azorín and Miguel de Unamuno, in reaction against urban modernity, used the term to refer to "the representative values" of a fantasized rural Castile. Later, Franco appropriated this meaning for his nationalist, Castilian discourse. Under his dictatorship, *castizo* lost its local and marginal connotations and was naturalized into a "genuine" and "authentic" expression of Spanish national cultural identity (Parsons 2002: 183). The *castizo verbenas* as an expression of the Madrilenian local identity and tradition were banned for the sake of a more homogenous national community. Franco declared Madrid the "symbolic capital of his own vision of a centralized imperial regime, its local urban identity submerged under a myth of universal 'Spanishness'" (Parsons 2003: 1). After Franco's death, with the electoral victory in 1979 of the Socialist Mayor of Madrid Enrique Tierno Galván, the local and traditional verbenas were reinstated.

Buse, Triana-Toribio, and Willis observe that the Francoist nationalist *castizo* character of the community of neighbors is apparent throughout de la Iglesia's film: for example, in the casting of all the actors that play the neighbors in the community (except for, conspicuously, Eduardo Antuña [Charlie]), "whose personas are steeped in 'Spanishness,' thanks to their long-standing presence in all sorts of Spanish drama: cinematic, televisual and theatrical"; and whose presence expresses "a nagging persistence of the past in the present" (Buse et al. 2007: 122, 125). The film self-consciously invokes the Spanish tradition of the *sainete costumbrista* of the 1950s and 1960s.[19] The old furniture and wallpaper of the interior of the building, the neighbors' old-fashioned clothes and the *guateque* (party in a house) with a record player playing music of the fifties (in particular, "Why Wait" by Pérez Prado and his Orchestra) all project the nationalist values of Spanishness (rejection of the outsider, homogeneity, and unity) embodied by the community.

In contrast, Charlie and Julia are visually and narratively located within the post-Franco democratic Spain. The actors playing Charlie (Eduardo Antuña) and Julia (Carmen Maura) are not traditional actors of the *sainete costumbrista* (Carmen Maura is particularly well known for her collabora-

tions with Pedro Almodóvar in the 1980s). This post-Francoist timeframe is further reinforced through Charlie's fictional world of *Star Wars*, based on a movie that premiered in 1977, the year of the first general election after Franco's death.[20] At the same time, Julia's modern pink suit contrasts with the old-fashioned clothes of the neighbors, visually dissociating her from them. Charlie and Julia are not merely representative of democratic Spain, but act against the Francoist *castizo* ethos that the community of neighbors represents. Moreover, Charlie is not a freak "autistically trapped in 1977 with his Darth Vader outfit" (Buse et al. 2007: 134), but an intelligent person who consciously uses his "retard" persona to outsmart the community. Charlie's fictional world metaphorically alludes to the triumph of the Republic ("Long live the Republic") over the forces of the Empire (Franco's dictatorship).

Charlie's political act of emancipation can be read as a collective act for the memory of the Republican victims, symbolized in the film by the 88-year-old man's body. The film situates the foundation of the community of neighbors in the year 1981, the year that Real Sociedad won the Spanish title for the first time against Real Sporting de Gijón,[21] and the discovery of the old man's body around 2000 or 2001 (since almost twenty years have passed since the old man won the *quiniela*). As Moreiras Menor remarks, this timeframe allegorically locates the (national) project of the community between the year of the failed attempt of the coup d'état against democracy, led by Lieutenant Colonel Antonio Tejero, and the year 2000, in which the *Asociación para la Recuperación de la Memoria Histórica* (ARMH) initiated the exhumation of Republican mass graves (Moreiras Menor 2008: 379). As Moreiras Menor further argues, the film's opening with the image of the dead body invites viewers to question Spain's politics of memory concerning the victims of Franco's dictatorship and, particularly, Aznar's rejection of the work of the ARMH, claiming that this would unnecessarily reopen old wounds in the Spanish society. By inscribing himself as equal while claiming "Long live the Republic," Charlie includes himself as a "conflictual actor" carrying a right not yet recognized by Spain (Congress passed the Law of Historical Memory in 2007).

After shattering the Francoist community of neighbors and freeing themselves from their claustrophobic and repressive interiors, it can hardly be taken as a sign of a return to their pasts that Charlie and Julia are at ease among a bunch of local working-class *madrileños* freely celebrating their local festivities and expressing "their love" for Portugal in a public bar. Divorced both from Francoist exclusive nationalism and the neoliberal politics of consensus, this joyful and cheerful community in which Charlie and Julia participate is more "authentic" (than the neighbors), welcoming and open to the other (rather than hatred driven), and generous (rather than greedy and

self-interested). By presenting all these distinctive features in the Madrilenian *chulo* outfit, the scene ridicules the *castizo* Spanishness of the community of neighbors and shows that "among those who know how to share with anybody and everybody [their equality], [democracy] can conversely inspire courage, and hence joy" (Rancière 2006b: 97).

The last shot of the film suggests, however, that the elimination of the consensus and national order of domination does not guarantee a permanent democracy. The shot shows a close-up of the suitcase containing the fake monopoly money in the bloodied courtyard with the silhouette of Ramona's body painted on the floor. The camera then shows an image of the Monopoly money flying over the Madrilenian skyline between the emblematic Banco Bilbao Vizcaya building and its equestrian sculptures, while the music from the bar "El Oso y el Madroño" continues to play extra-diegetically. The opening scene of the film brought viewers inside the interiors of the wrecked building of La Calle San Jerónimo to expose the bleak reality hidden behind a European façade. The closing scene reverses this move and suggests that, although freed from the logic of national consensus, the new community remains subordinated to the requirements of European economic and banking policies. The community at the bar "El Oso y el Madroño" is left with the same old pesetas for which the neighbors have killed each other, which have the same value as the Monopoly money until they are changed into Euros. The fact that Charlie and Julia disrupt the prevailing police order does not mean that other forms of domination are not likely to be created or do not already exist. By placing this community on the horizon of a forthcoming European Monetary Integration, the film suggests that the democracy it relies on are episodic disruptions of the established order, and can never be fully consolidated.

Notes

1. Álex de la Iglesia's *La Comunidad* was a Spanish box-office hit in 2000. The film received fifteen Goya nominations and won in three categories: Best Actress (Carmen Maura), Best Supporting Actor (Emilio Gutiérrez Caba), and Best Special Effects (Félix Bergés, Raúl Romanillos, Pau Costa, and Julio Navarro).

2. As William Ian Miller notes, "we cannot avoid one of the most troubling aspects of so much of the disgusting: it attracts as well as repels. The disgusting has an allure; it exerts a fascination: it manifests: difficulty of averting our eyes at a gory accident, the attraction of horror films" (1997: 22; see also Plantinga 2009: 212).

3. Single European Act (SEA), No L169/2, Official Journal of the European Communities (29.6.1987). Available at <https://eur-lex.europa.eu/legal-content/EN/TXT/PDF/?uri=OJ:L:1987:169:FULL&from=GA> (last accessed June 15, 2020).

4. In 1994, Mariano Rubio, former governor of the bank of Spain accused of tax fraud, and Luis Roldán, head of the Civil Guard, were arrested for misappropriations of funds.

5. As Xosé Núñez Seixas notes, "The presence of state nationalism may be diluted, but it is persistent, while the intensity of its expression varies according to the presence of external and internal enemies" (2001: 720).

6. See: "Primera iniciativa común de un presidente español y un primer ministro británico. Aznar y Blair harán hoy una propuesta conjunta para crear empleo en la UE. A través de una carta firmada por ambos y dirigida a los demás gobernantes europeos." El Mundo, Monday, November 30, 1998. Available at <http://www.ucm.es/cgi-bin/show-prensa?mes=11&ano=1998&dia=30&art=1 &tit=b> (last accessed June 15, 2020).

7. This reflects John Rawls's notion of "distributive justice," according to which, "[t]he justice of a social scheme depends essentially on how fundamental rights and duties are assigned and on the economic opportunities and social conditions in the various sectors of society" (1971: 7).

8. Police here is not related to the petty police, the representative agent of law and order, nor Rancière uses it in Michel Foucault's sense of the term, a matter of governmentality, that is to say, "the art of government."

9. In his film "El día de la bestia" (1995), Álex de la Iglesia portrayed an apocalyptic image of Madrid dominated by global capitalism (see Compitello 1999; Moreiras Menor 2002; Córdoba 2016).

10. In the precedent scene, two policemen arrive (later viewers learn that Charlie has called them) to the crime scene, where Domínguez's body lies dead. Julia tries all sorts of tricks to leave the building with the police, but every time the neighbors frustrate her attempts. Julia explains to the police that "they," the neighbors of the community, want to kill her because she has found "something" they have been looking for, for years. But, when asked what is this "something," unable to tell them the truth, she responds that she has found the luxurious apartment and "people can be very envious." The policemen think she is crazy and leave the building without her.

11. In *Hatred of Democracy*, Rancière identifies a contemporary intellectual tendency "to dismiss the political signification of democracy." This tendency asserts that a greedy and insatiable consumer of televisual spectacles and commodities presents an internal threat to democracy (2006d: 7, 88). This antidemocratic discourse claims that the laws of capitalist accumulation rule the world because democratic man (and woman) is a "being of excesses." Thus, democratic individuals are "not victims of a system of global domination. They are the ones responsible for it, the ones who impose the 'democratic tyranny' of consumption" (2006d: 88). Democracy is, according to this tendency Rancière criticizes, a form of society governed by the limitless desire of consuming individuals. This

limitlessness ruins the search for the common good embodied in the State and must therefore be repressed by it (2006d: 1, 8, 17). For Rancière, this is the paradox of the dominant usage of the word democracy today: "good democratic government means a form of government which can master the excess threatening good policy. This excess can be named, its name is *democracy*" (2007: 86, original emphasis).

12. As Gabriel Rockhill notes, the "common" is more than "an attribute shared by" the members of a community; it is what actually "makes or produces a community" (2004b: 102–103).

13. Rancière defines "wrong" as "the mode of subjectification in which the assertion of equality takes its political shape." He distinguishes wrong from the lawsuit: "objectifiable as the relationship between specific parties that can be adjusted through appropriate legal procedures. Quite simply, parties do not exist prior to the declaration of wrong. . . . What is more, the wrong it exposes cannot be regulated by way of some accord between the parties. It cannot be regulated since the subjects a political wrong sets in motion are not entities to whom such and such has happened by accident, but subjects whose very existence is the mode of manifestation of the wrong" (1999: 39).

14. Charlie refers to the scene where Han Solo, a smuggler who joins the Rebel Alliance against the authoritarian Galactic Empire, helps Princess Leia and Luke Skywalker (the hero of the saga, and whose father was killed by cyborg Darth Vader, commander of the Empire) to escape from the Imperial Stormtroopers. The Death Star is the ultimate Imperial weapon. With the help of the Force (a metaphysical power), Luke destroys the Death Star.

15. For Rancière, a "political subject is not a group that 'becomes aware' of itself, finds its voice, imposes its weight on society. It is an operator that connects and disconnects different areas, regions, identities, functions, and capacities existing in the configuration of a given experience – that is, in the nexus of distributions of the police order and whatever equality is already inscribed there, however fragile and fleeting such inscriptions may be" (1999: 40).

16. For Rancière, "Any act of subjectification is a disidentification, removal from the naturalness of a place" (1999: 36). Subjectification "is the formation of a one that is not a self but is the relation of a self to an other" (1995b: 66).

17. Not by chance, the building headquarters of Banco Bilbao Vizcaya Argentaria. As Susan Divine explains, "the use of the iconic BBVA situated at the confluence of the Gran Via and La Castellana brings to the front concerns over how monumental space and historical memory are united through concerns of money and capital" (2012: 351).

18. The *Tunas estudiantiles* are thought to have their origins in the Medieval Ages (thirteenth century). *Tunos* was the name given to poor students who sang on the streets in order to collect money to pay their University costs. During

Franco's dictatorship, the *Tunas* were considered dangerous to the regime and subjected to strict control (*Dirección General de Seguridad,* March 10, 1955).

19. For example the dark comedies of directors such as Fernando Fernán-Gómez's *La vida por delante* (1958) and *El Extraño viaje* (1963), Marco Ferreri's *El Pisito* (1958) and *El Cochecito* (1960), and Luís García Berlanga's *El Verdugo* (1963). See Buse et al. 2007: 126.

20. Other contemporary cinematic references in the film are: Hitchcock's *Psycho* (1960), Polanski's *The Tenant* (1976), Marc Caro's and Jean-Pierre Jeunet's *Delicatessen* (1991), and Andy and Lana Wachowski's *The Matrix* (1999).

21. In 1981, Real Sociedad of San Sebastián (Basque Country) won, for its first time, the Spanish football league championship against Real Madrid (itself the team representative of Franco's dictatorship). This could be read as symbolizing the fight of the periphery against the center.

4

The Sound of Protest: Acousmatic Resistance in *El Método*

No sounds define the age we're living in more clearly than protest sounds.[1]

This chapter turns to the 2005 Argentinian-Spanish thriller film *El Método* (*The Method*), directed by Marcelo Piñeyro, to examine the disciplinary technologies of control and surveillance that multinational corporations use to ensure compliance and foreclose dissent. Piñeyro's film tells the story of a macabre job interview conducted by a multinational corporation, with seven candidates competing for an executive position. The seven candidates, five men and two women, are gathered in a luxurious room on a high floor of a skyscraper at the heart of a financial district in Madrid.[2] Throughout the film, their only contact with the outside world is via a large glass window. The film is set during anti-corporate globalization protests against a summit of the International Monetary Fund (IMF) and the World Bank, but the film's characters can barely hear or see the protests.[3] The goal of this chapter is twofold: first, it examines how the film uses the multinational corporation and its method for selecting candidates as an allegory of Foucault's panoptic society; second, it shows how the film relies on the protest's "acousmatic sound"– sound that one hears without seeing its source – in order to displace the primacy of the visual and provide avenues for "sonic emancipation."

Beyond Panopticism: The Grönholm Method

The title of the film alludes to the selection process known as the *Grönholm method*, which involves a series of unsettling, and increasingly cruel, psychological tests that examine how the candidates react to "game-like situations" that force them to compete and to eliminate each other by whatever means they deem expedient (Sosa-Rodríguez 2013: n.p). An agreement that they are required to sign before the interview includes the statement, "No-one is obliged to do anything they do not want to do, but while they remain in the room they must accept the conditions described in the Grönholm method." One disquieting characteristic of the selection method is that no interviewer is physically present in the room. Instead, candidates are locked in a confer-

ence room that is watched by CCTV cameras and fitted with computers, which display instructions on their monitors. When a candidate fails an elimination round, their computer monitor switches off, and a mechanical voice communicates to them, "It's over!" An even more disquieting aspect of the interview is that the first test reveals that there is a mole among them, whom they must expose, which fosters a permanent state of suspicion and paranoia among the candidates. If *La Comunidad* shows that a community of neighbors are willing to do anything for money, *El Método* shows how ambitious and self-confident executive candidates blindly comply with the ever-more-objectionable demands of the game for the promise of a job in a multinational corporation (Piñeyro, in Galán 2005). Furthermore, whereas *La Comunidad* uses the community's building and its occupants as a bleak allegory of a consumer society, *El Método* uses the corporation's building and its occupants as a metaphor for the corporatization of Spain (Sosa-Rodríguez 2013: n.p).

As some commentators on the film have pointed out, the Grönholm method for selecting candidates has notable parallels with Foucault's account of the Panopticon (Parés Pulido 2017; Dillon 2017). The multinational corporation, like the Panopticon, creates what is in effect a cell of spatial isolation and confinement that enables constant monitoring and surveillance from an unseen position. The enclosed space of the interview room thus functions as a "laboratory of power," where a faceless interviewer carries out a series of tests to judge the candidates' performances, assess their characters, and draw up classifications and monitor their effects (Foucault 1977: 204, 203). Under the gaze of the unseen interviewer, the candidates become objects of examination and categorization, "never subjects in communication" (Foucault 1977: 200). At the same time, the corporation makes the candidates aware of the presence of the CCTV cameras, which leads them to alter their behavior to conform to the perceived expectations of the corporation. The main goal of this panoptic method is to instill in the candidates a "state of conscious and permanent visibility" that turns them into "docile bodies" complicit in their own subjection (Foucault 1977: 201, 202–203, 138). As Foucault writes, "He who is subjected to a field of visibility, and who knows it, assumes responsibility for the constraints of power; he makes them play spontaneously upon himself; he inscribes in himself the power relation in which he simultaneously plays both roles; he becomes the principle of his own subjection" (Foucault 1977: 202–203).

A scene in which Ricardo, the mole in the group, sets a trap for Enrique provides a striking example of the subduing effects of this state of permanent visibility. Ricardo reveals to Enrique in private that while still a student in Argentina, he had been a union leader and that he is now afraid that the

corporation might find this out. Ricardo gets Enrique to acknowledge that if he thought he could change something by protesting, he would join that protest. Worried that Ricardo might portray him as a turncoat based on this information, Enrique defends his ideological position: for a company executive to support a protest would be hypocritical. At this point, Montse, the secretary, enters the room and asks all the candidates what they think about the protests. Enrique does not speak until Montse presses him, saying that if he knows something about Ricardo that the company should know, he should reveal it. Enrique brings up Ricardo's past as a unionist, thinking that this is what the employer expects him to do. Ricardo then reveals his identity as the mole and thanks Montse (another mole) for her performance. Ricardo asks Enrique in front of all of the candidates if he stands by his decision to out Ricardo. Flustered, Enrique answers that he doesn't know, to which Ricardo responds that he should come back when he has clarified his ideas. Enrique is thus eliminated.

The method shows that no physical force is necessary for self-regulation. As Foucault puts it: "There is no need for arms, physical violence, material constraints. Just a gaze. An inspecting gaze, a gaze which each individual under its weight will end by interiorising to the point that he is his own overseer, each individual thus exercising this surveillance over, and against, himself" (Foucault 1980: 155). The mere idea of being watched, without knowing when and by whom, along with the fear of being eliminated for making the wrong decision or saying the wrong thing, forces candidates to internalize the surveillant gaze of the corporation. Placing candidates under a constant but unverifiable regime of surveillance ensures they become "their own guards" (Foucault 1977: 201; Parés Pulido 2017: 243). In doing so, the multinational corporation guarantees "the automatic functioning of power" and, simultaneously, the neutralization of any kind of resistance (Foucault 1977: 201). Within the prison-like building of the corporation "[v]isibility is a trap" (Foucault 1977: 200).[4]

Reading the film through Foucauldian lenses exposes what lies behind the alienating power of global corporations (including objectifying and humiliating practices, a lack of ethics, greed, sexism, and destruction of the environment) and how invisible and unverifiable disciplinary mechanisms that ensure blind obedience and self-regulation wield this power (see Bakan 2004). However, some commentators have insisted that despite the film's critical outlook, the political efficacy of the film is compromised. For instance, Alfredo Dillon argues that by exposing the dangers of the neoliberal system, the film creates a reassuring viewing experience, with its spectators doing nothing other than ratifying their condemnation of the cruelty of multinational corporations (Dillon 2017: 14). For Dillon, the film's explicit

strong position against the corporate world presupposes an addressee who will not dissent. The complicity of film and viewer, in this case, is based on the rejection of what is shown/seen (2017: 14). In turn, Marina Parés Pulido argues that by depicting how individuals lose their power in the face of the corporate logic, the film announces the inexorable advance of capitalism, sacralizing it to the extent that is presented as insurmountable and inevitable (Parés Pulido 2017: 251–252).

This chapter takes a step further and argues that the film does not "fail" in its denunciation of the dangers of neoliberalism and its disciplinary mechanisms of power, but rather is simultaneously complicit *and* critical: while visually the film invites viewers to participate in depoliticizing structures of power, acoustically it invites them to question their role and responsibility in such structures. To demonstrate this dual character, this chapter explores specific features of how the film looks and sounds. It first focuses on the split-screen technique as a strategy that the film uses to reflexively explore, expose, and interrogate the practices of surveillance that mediate the act of looking. My analysis will show how these techniques not only become an integral part of the narrative but are also embedded in the film's visual form as additional elements of the surveilling gaze reproducing the panoptic logic of the Grönholm method that the film sets up to criticize. In this way, *El Método* enacts what film scholar Catherine Zimmer calls "surveillance cinema," by which she means not just the recurring tropes or iconographies of surveillance, but also "the multiple mediations through which practices of surveillance become representational and representational practices become surveillant" (Zimmer 2015: 2).

The chapter then focuses on the sound of protest in the film. Because Foucault's panopticism depends on vision and visibility, critics of the film often reduce their analysis to the visual, overlooking the role and power of the sound of the anti-corporate globalization protest. To demonstrate the potency of the aural, I analyze the only scene in the film in which viewers hear the sound of protest. The scene uses the acousmatic sound of protest to disrupt the complicity of the viewer in the regime of the visible (what is shown/seen) and to open up space for imagination and interpretation. Drawing on the work of Michel Chion and Mdalen Dolar, I seek to show how the acousmatic sound of protest irrupts into the viewer's given space of the visible and sonically emancipates the viewer.

The Split Screen: Framing the Space of the Visible

The film opens by introducing the seven candidates one by one. They are performing their daily routines shortly before the interview, each in their own location. They appear in separate screens in a sequence that lasts throughout

the opening credits. First, we see two equally sized parts. On the right side, a medium shot shows Julio's wife sleeping; the camera then pans left to show Julio (Carmelo Gómez) awake in bed. On the left side, a close shot of a digital alarm clock marks 7:00 am, setting the time frame; the clock is then replaced by an image of Julio, who wakes up and takes underpants and a shirt from a drawer. The voices of TV news reporters state that the anti-corporate globalization protests have taken to the streets of Madrid. The screen then splits vertically into three parts. On the left, Julio is having breakfast. On the right, a TV set shows images of the protests. In the middle, Ana (Adriana Ozores) and her son are also having breakfast, and they are talking about the protests that are being shown on TV. While the spatial arrangement on the screen might suggest all three images are from the same house, the splitting lines and details make evident the different locations. Images of Ricardo (Pablo Echarri) and his family at home also having breakfast and watching the TV news replace the image of Enrique with his family, preserving the effect of their seeming all to be in the same house. Then the screen returns to having two halves. On the left side, a series of close-up shots show Nieves (Najwa Nimri) taking some pills, then putting on makeup, and finally gazing at herself in the mirror. Simultaneously, on the right half, a TV screen shows a series of images of clashes between police officers and protesters. Two different images of Fernando (Eduardo Fernández) replace both halves, as he enters a bar, declines the waiter's offer of alcohol in his coffee, and finally reads the *ABC* newspaper headline: "The IMF-WB Summit begins today in a besieged Madrid." The off-screen TV news anchor relates that the city has become an "impassable bunker." Then the split changes again, showing a large traffic jam in the city in three halves. Finally, a set of images of Enrique (Ernesto Alterio) sitting in a cab, unperturbedly organizing his agenda in his PDA, while the radio in the cab is reporting the protest; and of Carlos (Eduardo Noruega) riding a motorcycle through a police checkpoint and a security control to access the corporation building, appears consecutively in the three halves. A close-up shot shows posters on walls that claim "Countering the IFM-WB another world is possible." The title sequence ends here.

The split-screen technique breaks the commitment to transparency of classical cinema (which is based on concepts such as the invisibility of cinematic techniques and technology) and calls attention to (visual) mediation.[5] A number of film and media theorists have underscored the reflexive nature of this technique. For instance, according to film theorist Christian Metz, filmmakers use the split-screen technique to *double* the film's scopic mediation, as it presents viewers with "a spectacle that is inside some kind of frame, door, window, etc. that itself is enframed inside the rectangle of the screen" (Metz 2016: 52). The internal frames, which act as second frames, are "per-

ceptible traces" left by the enunciation to call attention to the main frame, the site of enunciation itself (Metz 2016: 53–54). In a similar vein, film and media scholar Malte Hagener suggests that the split-screen technique "foregrounds the artificial mediated nature of the image" and draws attention to "the act of framing itself by visibly displaying the basic principle that forms the condition of possibility for the image" (Hagener 2008: n.p.). For media theorist Anne Friedberg, the split-screen technique creates what she identifies as the "post-perspectival" mode of perception that defines the contemporary condition, which is no longer centered along a single and stable frame of reference, but instead constructed out of multiple and fractured perspectives (Friedberg 2006: 194). Yet, as Friedberg points out, following Deleuze and Metz, this multiplication and fragmentation of the screen remains enframed within the delimited boundaries of the master frame, that is, the frame that frames the frames and actively organizes and structures how and what viewers see (Friedberg 2006: 200–201). Thus viewing, although multiple and fragmented, still occurs within the film's frame and its logic of visuality. It is this paradoxical effect of the split-screen technique that I aim to analyze in *El Método*, specifically its use in the opening and closing sequences.

The split-screen of the opening title sequence fulfils at least three purposes. First, it has narrative functions: it introduces the candidates and provides initial impressions of them; by having them share the overall screen in disparate settings it hints that though they do not know each other yet, they are destined to converge in the same space; it portrays the candidates as if they are functioning automatically within a regulated time and space; by juxtaposing the characters with coverage of the protest, it sets the story in an environment of social tension; and it visually anticipates the fragmentation among the candidates that will develop over the course of the film. As other critics have noted, the split-screen functions in the film as an allegory of the social fragmentation and individualism that constitute the essence of contemporary societies under the neoliberal economic system (Rubio Alcover 2014: 156; Dillon 2017: 12; Parés Pulido 2017: 239).

The split-screen also serves a reflexive function in enabling the film to call attention to itself by explicitly displaying the usually invisible aesthetic frames that mediate, and hence construct, the viewer's cinematic visual experience. The use of intra-diegetic devices reinforces this reflexivity, as a TV set, a computer screen, a window in a room, a mirror, or a CCTV monitor function as secondary and tertiary frames, each demarcating the space of the visible in a different manner (Hagener 2008: n.p.). The display of this multiplicity of frames within frames and screens within screens creates a post-perspectival mode of seeing that makes viewers aware that "how the world is framed may be as important as what is contained within that frame" (Friedberg 2006: 1).

Yet, as I will demonstrate in this section, the split-screen in this film functions less as a reflexive strategy and more as a surveillant device, and therefore its effect is less about interrogation and more about legitimation. I show how in using the split-screen in its opening sequence and by showing candidates on multiple video screens in its closing sequence, the film does not simply surround and present the story; it also structures it. In other words, it imposes a "method" that in this instance is a particular way of seeing and understanding the world that is complicit with the technology of surveillance and control that it aims to expose and criticize.

From the outset, the split-screen of the opening sequence creates a viewing position that mirrors the all-seeing gaze of the faceless interviewer at both the graphic and the structural levels.[6] The screen is divided into two or three equal parts, each of which displays a candidate in a separate and contained frame, visually restricting each of them to an enclosed space. At the graphic level, this design recalls the spatial arrangement of the Panopticon with its split cells – as well as a multiple-monitor surveillance set up. Each part thus acts like a small theater, "in which each actor is alone, perfectly individualized and constantly visible" (Foucault 1977: 200). This arrangement of the space of the screen turns the candidates into objects to be observed, examined, and classified by the viewer and establishes an asymmetrical relationship between the viewer (the subject/seer) and the candidates (the object/seen).

The split-screen also empowers the position of the viewer at the structural level. Unlike techniques such as crosscutting or parallel editing, which present events sequentially in time, the split-screen grants viewers godlike omniscience, allowing them to be in two or more places at once and to watch two or more events simultaneously (Bordwell and Thompson 2004: 258).[7] For instance, the split-screen allows viewers to see a single character from different perspectives in the same shot or the same character twice in the same image at the same time. Through the split-screen, the opening sequence produces two kinds of visibility. On the one hand, the spatial fragmentation of the image into quadrants creates an individualizing visibility that makes it possible to observe the candidates separately. On the other hand, the presentation of two or three separately framed views within the larger frame creates total visibility that allows the viewer to observe several candidates at once.

The live broadcasting of the anti-corporate globalization protests on TV and the radio, to which all the candidates appear to listen just before the interview, also manifests this simultaneity. The broadcast serves to connect all candidates acoustically while creating a sense of "real time" and immediacy that emulates the temporal logic of video surveillance: what you see is what is happening here and now (Levin 2002; Hagener 2008). Thomas

Y. Levin analyzes this temporal relation between the live televisual broadcast and surveillance in his seminal essay "Rhetorical of the Temporal Index: Surveillant Narration and the Cinema of 'Real-time.'" According to Levin, since the late 1990s, with the advent of the digital age, cinema has increasingly incorporated the aesthetics of real-time broadcast so characteristic of television and closed-circuit television surveillance within its narratives to the point at which "cinematic narration could be said, in many cases, to have effectively become synonymous with surveillant enunciation as such" (Levin 2002: 582). Levin argues that by appropriating the rhetorics of the real-time broadcast (as exemplified by Mike Figgis's film *Time Code* [2000]) cinema has replaced "an impoverished spatial rhetoric of photo-chemical indexicality . . . that governed the earlier photographic condition . . . by a *temporal indexicality*, an image whose truth is supposedly 'guaranteed' by the fact that is happening in the so called real-time" (Levin 2002: 592, original emphasis). This shift from spatial referentiality to temporal indexicality testifies, Levin further argues, to a fundamental "recasting of the cinematic medium in terms of what could be called rhetorics of surveillance" (Levin 2002: 593).

While the split-screen technique does not recur after the opening title sequence, the rest of the film explores the implications of framing by means of several intra-diegetic devices, that is, by embedding one image within another. Thus, as noted, a TV set (as we have seen in the opening title sequence), a computer screen, a CCTV monitor, or a window in a room function as secondary and even tertiary frames throughout the film. A compelling example of this intra-diegetic framing device occurs toward the end of the film, when Nieves and Carlos, former lovers and now the only remaining candidates for the position, are instructed that their final test will involve forcing the other to act in a specific way: Carlos has to cause Nieves to break down, and Nieves has to cause Carlos to quit the interview. At this point, the image switches to black and white and the characters are seen on the surveillance monitors that the invisible interviewer is watching, creating a split-screen effect that mirrors the opening sequence in three ways. First, the white-and-black images follow Carlos through a number of physical spaces (the bathroom, the corridors, the interview room), confirming (for the viewer) the candidates' suspicion that they have been under video surveillance during the entire selection process. Moments later, after Nieves appears to have convinced Carlos to quit the interview, the image switches to black and white once again when it shows through the CCTV screen monitors Nieves standing at the door of the interview room deciding whether to stay and win the position or leave and take Carlos up on his offer of a life together. She eventually chooses Carlos. The black and white monitor screen again shows Nieves, now in the hall of the corporation building looking up at Carlos as he

ascends in the elevator to the 35th floor as the winner, revealing that not only the interview room but the entire building is under surveillance.

While the black and white images of the CCTV monitors foreground the mechanisms of surveillance, because the film does not reveal who is watching the CCTV footage, viewers are invited to identify not with the characters and their circumstances, but with the all-seeing, omniscient surveilling gaze of the multinational corporation. Ultimately the surveilling gaze of the viewer embodies the empty space from which the surveilling gaze seems to emanate, thus recreating the panoptic ideal that "it does not matter who exercises power. Any individual, taken almost at random, can operate the machine" (Foucault 1977: 202).

Both the opening and the closing sequences of the film construct a viewing position that seems, at least at first, analogous to the panoptic gaze of the warden-interviewer – granting viewers a godlike vision or placing them in the empowering position of the CCTV operator. Like the faceless interviewer, the viewer remains invisible, free from the objectification and subjection of surveillance. Yet unlike the panoptic interviewer's, the viewer's all-seeing, omniscient position is an imaginary one. As apparatus film theorists Christian Metz and Jean-Louis Baudry argue, the viewer passively confuses their own visual agency with that of the transcendental eye of the camera "which has looked before him at what he is now looking" (Metz 1982: 49) and therefore obliges "him to see what it sees" (Baudry 1974–1975: 45). In confusing his/her gaze with that of the camera, the viewer is not the subject of the look and the creator of meaning but the ideological object of the cinematic apparatus. Like the powerless candidates in the film who submit to the power of the invisible gaze of the interviewer, the powerless viewer submits to the power of the disembodied, invisible eye of the camera on condition that the camera itself remains hidden or invisible (Baudry 1974–1975: 46; Metz 1982: 96). The identification with the camera confers on the viewer the imaginary position of a "transcendental subject", able to see and know everything while hiding this position as constructed (Baudry 1974–1975: 43; Metz 1982: 50). For both theorists, the only way to resist and break through the ideological effects of the cinematic apparatus is to make its materiality visible.

One could also argue that the reflexive nature of the film serves to break the correlation between the viewer and the camera because it exposes the constructed nature of the image and hence reveals the viewer's transcendental power as imaginary. However, even though the film exposes the surveillance technology and techniques (CCTV monitors, split screens, and intra-diegetic devices) that mediate the act of watching, the camera itself, the central component of the cinematic apparatus, always remains invisible to the viewer (Metz 2016: 64). As film scholar Catherine Zimmer points out in another

context, such invisibility implies "that the surveillance apparatus is ultimately the film's camera, rather than a technology within the film, further eliding any distinction between cinematic and surveillant technique and technology" and thus "between the surveillant gaze and the cinematic" (Zimmer 2015: 22, 50). In this way, rather than merely functioning as reflexive devices to interrogate the representational conventions and narrative mechanisms of an increasingly surveillance-centered media, these devices become *practices* of surveillance (Zimmer 2011: 439, original emphasis). The film site of enunciation becomes surveillant itself.

The Acousmatic Sound of Protest

So far, this analysis of the relationship between the viewer and the image has presupposed the cinematic experience as exclusively visual. While the focus on the frame and its regime of visuality affects how we see the world (how our vision is mediated and controlled), listening and sound also have power. In what follows, I examine the ways the film uses the sound of the protests to undermine the panoptic regime of visibility and open up a possibility for resistance.

In *Audio-Vision: Sound on Screen* (1994), French critic and composer Michel Chion seeks to conceptualize sound in a way that goes beyond the classical hierarchical subordination of sound to image.[8] Chion proposes the concept of the "acousmatic sound," which unsettles this hierarchical relation between sound and image and demonstrates that sound is at least as powerful as the image. Chion notes the Greek origins of the term *acousmatic*, first used by poet Jérôme Peignot and theorized by Pierre Schaeffer to describe "sounds one hears without seeing their originating cause" (1994: 71). For Chion, the voice functions as an acousmatic presence in a film only when it "has not yet been visualized" because its source has not appeared on-screen but "remains liable to appear in the visual field at any moment" (1999: 21). He argues that when "we cannot yet connect [the voice] to a face – we get a special being, a kind of talking and acting shadow to which we attach the name *acousmêtre*," or acousmatic being (1999: 21). Chion defines the acousmêtre as an acousmatic character who is "neither inside nor outside the image . . . because [the visual space of the film does not include] the image of the voice's source – the body, the mouth," yet unlike the voice of a narrator or of a witness who comments on the images as a detached observer is not clearly positioned off-screen and is "implicated in the action, constantly about to be part of it" (Chion 1994: 129). In "wandering the surface of the screen without entering it," the voice and sound create a disequilibrium and cause a tension of image and sound, of the visible and the audible, of the body and the voice (Chion 1999: 24).

Chion distinguishes four types of acousmêtre. First, "the already visual-
ized acousmêtre": a voice that is temporarily absent from the image but it
can be connected to a face or a body the viewer has already seen (1999: 21).
Second, the "commentator-acousmêtre": the invisible voice whose face is
never shown and which comments on the images as an observer only, with no
personal stake in them (Chion 1999: 21). A completely detached commenta-
tor is not an acousmatic being, for the latter must be implicated in the action
or always be about to be part of it. Third, "the radio-acousmêtre": radio and
telephone are acousmatic media because they transmit sounds without show-
ing the people speaking (Chion 1994: 71). Chion identifies a key difference
between the radio and the filmic acousmêtre: "cinema has a frame, whose
edges are visible; we can see where the frame leaves off, and offscreen space
starts. In radio, we cannot perceive where things 'cut,' as sound itself has
no frame" (Chion 1999: 22). Fourth, the "complete acousmêtre": the voice
whose face or body has not yet been seen but "who remains liable to appear
in the visual field at any moment" (Chion 1999: 21).

According to Chion, the acousmêtre's inside/outside position confers a
quartet of special powers: "the ability to be everywhere, to see all, to know
all, and to have complete power" over the action (Chion 1999: 24). The
acousmêtre is, therefore, the "*panoptic fantasy* . . . of total mastery of space
by vision" (1999: 24, original emphasis). Chion argues that the moment that
connects the voice of the acousmêtre to a body (even through an image only
of the speaking mouth) "drains it of its powers." He calls this occurrence the
"de-acousmatization" of the voice (Chion 1999: 27). The sight of the source
of the voice "attests through the synchrony of audition/vision that the voice
really belongs to a particular character, and thus is able to capture, domesti-
cate, and 'embody' her," to enclose the voice "in the circumscribed limits of
the body" (Chion 1994: 130–131).

In *A Voice and Nothing More* (2006), philosopher and film critic Mladen
Dolar takes Chion's notion of the acousmêtre a step further. Dolar proposes
that "the acousmatic voice proper" is not just on the threshold of the frame of
the visible, refusing to reveal its source; it is dislodged from the visible. That
is, the acousmatic voice "always displays something of an effect emancipated
from its cause. There is a gap between its source and its auditory result, which
can never be quite bridged" (Dolar 2006: 66–67). For Dolar, the invisibility
of the source allows the viewer to concentrate on the voice without visual dis-
tractions. Further, the separation of the voice from its visual source endows
the voice itself with "authority and surplus-meaning" (Dolar 2006: 61). This
"surplus-meaning" stems precisely from the impossibility of attributing the
sound to a spatial point (Dolar 2011: 120). Hence, the "surplus-meaning"
of the sound differs from the meaning (or content) of the sound; the term

describes the acousmatic powers that exceed this latter meaning (Kane 2014: 209). Dolar identifies a disjunction between the visible and the audible: "the visible world presents relative stability, permanence, distinctiveness, and a location at a distance; the audible presents fluidity, passing, a certain inchoate, amorphous character, and a lack of distance" (Dolar 2006: 79). Whereas the power of the visible lies in its ability to "establish the distance, the nature, and the source of the voice, and thus neutralize it," the power of the acousmatic sound emerges from the impossibility of its being "neutralized with the framework of the visible" (Dolar 2006: 79). Dolar concludes that what Chion calls de-acousmatization – the loss of the power of the voice owing to its being embodied – cannot exist because "[t]he source of the voice can never be seen, it stems from an undisclosed and structurally concealed interior, it cannot possibly match what we can see" (Dolar 2006: 70). Since the voice emanates from inside the body, from the diaphragm, the gap between cause and effect, visible and audible can never be entirely closed (Kane 2014: 150). Thus, the fact that the mouth or the face is revealed "does not demystify the voice; on the contrary, it enhances the enigma" (Dolar 2006: 70).

Drawing on Chion and Dolar, I argue that *El Método* presents two kinds of acousmatic sound that have opposite power effects: the acousmatic sound of the news media through radio and TV (the film never shows the speaking subject on the television) and the acousmatic sound of protest. The former is used as an "added value" that reinforces the panoptic space of the visible; the latter is used as a "complete acousmêtre" that resists and breaks that space.

Framing the Crowd: Media Coverage of the Protest

Viewers first hear about the anti-corporate globalization protests in Madrid through the mediated voices of the reporters that emanate from the radio and TV sets that appear during the opening title sequence. The acousmatic voices of the TV news anchors report that tens of thousands of young people have arrived in the city, convened by over eight hundred anti-globalization movements to protest against some of the men who decide the planet's future. The voices of the TV anchors remark that some of these protesters have already tried to breach the police cordon and that the security forces have prepared a deployment rarely seen before. Then they emphasize that authorities fear that the most radical anti-capitalist groups will repeat in Madrid the scenes of violence witnessed in Seattle, Prague, and Genoa during earlier summits. The TV anchors also explain that protesters object to the neoliberal policies of the International Monetary Fund and the World Bank and accuse both entities of being instruments of the multinationals, which seek to exploit child labor, sell genetically modified food, and turn the planet into a garbage dump. They note, however, that the IMF authorities consider free trade to be

vital for the Third World and believe that only a free, global market can spark
the growth of weaker economies. "Meanwhile," one TV voice continues,
"Madrid has become almost an impassable bunker. Police controls, streets
blocked to traffic, and crowd-control barriers are making the city a hell for its
inhabitants." In turn, the radio broadcaster complains that "protesters want
to demonstrate, but they won't respect our right to work. They are going to
protest against the multinational companies and run in front of our police in
sneakers made by those same multinationals." A series of TV images accom-
pany the media coverage of the protest: trains arriving in Madrid, crowds
protesting in the streets, traffic jams bringing the city to a halt, and a massive
security operation (checkpoints, police cordons, crowd-control barriers, and
weapon detectors). The TV news channels also use archival footage of previ-
ous protests to show images of clashes between police and protesters and of
protesters destroying public property and throwing stones at the police.

The voices of the news media do not create a tension between image and
sound but rather provide what Chion refers to as "added value." He defines
"added value" as the "informative value with which a sound enriches a given
image so as to create the definite impression . . . that this information . . .
'naturally' comes from what is seen, and is already contained in the image
itself" (Chion 1994: 5). The "added value" that the media's words give to the
images "goes far beyond the simple situation of apolitical opinion slapped
onto images; [it] engages the very structuring of vision – by rigorously fram-
ing it" (Chion 1994: 7). In other words, the media's words guide and struc-
ture the meaning of the images, giving "the false impression that sound is
unnecessary because it merely duplicates a meaning in reality it brings about"
(Chion 1994: 5).

The voices of the TV news anchors frame the anti-corporate globalization
protesters as radical young people ready to engage in violent acts and there-
fore as a threat to public order. By noting the similarities with the protests
in Seattle, Prague, and Genoa, the TV anchors anticipate violence from
protesters and justify the securitization and control of the public urban space
(Boykoff 2006: 212). When the TV news anchors report that the city has
become "hell" or "an impassable bunker" and show archival footage images of
unruly protesters, their voices forge an immediate relationship between what
is seen and what is heard. Image and sound thus are fused together to provide
a single message: the urban space of Madrid is under siege, and police inter-
vention is necessary to guarantee citizens' safety. Like the TV news anchors,
the radio broadcaster also portrays protesters as the problem: protesters are
disrupting the everyday lives of law-abiding (non-protesting) citizens who
are trying to exercise their right to work, including the broadcaster himself
(Boykoff 2006: 214). In highlighting the disruptiveness of the protest, the

radio broadcaster avoids explaining that one of the main reasons protesters have taken to the streets of Madrid is to fight for the rights of the workers they are disrupting, workers whom the IMF enables multinational corporations to exploit. The radio broadcaster goes so far as to denigrate the protesters' fight by deeming them complicit in corporate values. The strident car claxons and police sirens that come from the TV sets create an overwhelming sensation of chaos and insecurity that acoustically reinforces the public disorder.

Un-framing the Crowd: The Subversive Powers of the Acousmatic Sound of Protest

The sound of the anti-corporate globalization protests is heard only once in the film, in a scene that occurs about halfway into the story when candidates approach the glass window of the interview room with curiosity, looking outside for the first time since entering the building. The scene shows the candidates from two points of view, from inside and from outside the corporation's window, thus from two very different spaces that demarcate the politics of visual and aural perception deployed by and against the protest.

From inside the interview room, a medium shot shows three male candidates (Ricardo, Enrique, and Carlos) standing with their backs to the camera as they look down onto the streets and comment indifferently that they cannot see or hear the protests from where they are standing. This scene recalls an earlier scene in which another combination of three male candidates (with Fernando instead of Carlos) is shown in the restroom, facing the wall. They then seemed equally indifferent as they speculated whether cameras might be surveilling them even in the restroom. The window in the interview room thus functions not as a transparent opening onto the reality outside, but as a wall between two worlds, that of the candidates and that of the protesters. Ensconced behind the window-wall, the candidates feel altogether removed from reality – they look out on the tops of other skyscrapers as if they are on top of the world. From this position, they are distant spectators of, rather than participants in, the world outside. The corporation's glass window is a frame that at once delimits the candidates' visual field and draws a spatial distinction between inside and outside.

From outside the corporation building, a horizontal static shot shows the candidates behind the glass window of the interview room, providing an off-screen point of view for the first time in the film. There is no reverse shot showing a character embodying this point of view, which suggests that the viewer ultimately embodies the invisible space from which the off-screen gaze emanates. The angle from which the camera shows this scene places the viewer at the same height as the candidates. From this perspective, the window functions not as a wall that separates two worlds but as a transparent

screen that puts candidates on display: the candidates are framed not as subjects observing but as objects of the viewer's gaze. The glass window of the corporation, transparent from the outside and "opaque" from the inside, enforces the panoptical method, which requires the total visibility of the candidates and the total invisibility of the observer. By showing the candidates from these two points of view – from inside and from outside – the film makes visible that surveillance comes from everywhere (Foucault 1977:195), but more importantly, it also draws attention to the fact that the viewer's visual complicity is required for the surveillant gaze to exercise its ubiquitous power.

The scene also invites viewers to listen to the acousmatic sound of the protest from both inside and outside the corporation. From inside, the voices of the protesters become almost inaudible as soon as they pass through the glass window of the interview room. The window of the corporation marks the spatial boundary between the outside and the inside, the visible and the invisible, but it also determines what can be heard and what cannot be heard, and what is sound and what is noise. As Dolar explains in another context, the sound of protest "is the intrusion of an outside into the inside; it presupposes a division of space into a part that is supposed to be isolated, close, . . . and a part that is external and hence threatening" (Dolar 2011: 130). The silencing of the street noise when Carlos accesses the 35th floor is no coincidence. Noise, economic and social theorist Jacques Attali remarks, is often associated with "destruction, disorder, dirt, [and] pollution" (Attali 1985: 27). It evokes disorder and subversion that need to be channelized, repressed, monitored, and controlled. The noise of protest in the film – the voice of dissent and disorder – threatens to disrupt the given order of the corporation and therefore has to be suppressed, silenced, tamed, and kept out. The sound of protest pierces the boundaries of the interview room and fuels the candidates' curiosity about the reality outside, testifying to the permeability of the spatial partition of outside/inside, to the crack within that partition. The sound of protest is for Dolar "the sound of this crack" (Dolar 2011: 130). By employing relaxing music, the corporation seeks to communicate to the candidates the harmony and safety of its world, sealed off from the noisy space of the streets of Madrid.[9] Music used as an instrument of control must appear, Attali proposes, "tranquil, reassuring and calm" (Attali 1985: 7).[10] The suppression of the sound of protest is a weapon of power. For power to function, candidates are to be isolated from the outside world not only visually but also aurally.

The aural experience is very different from the other side of the window. From outside, viewers can clearly hear the well-known slogan *El pueblo unido jamás será vencido* (The people united will never be defeated) – even if it is

improbable that the voices would be heard so clearly from the spatial position suggested by the camera's point of view.[11] As Chion points out, "the notion of a point of audition is a particularly tricky and ambiguous one" (1994: 89). Unlike visual perception, which allows the spatial position of the looker to be inferred precisely, "the specific nature of the aural perception prevents us, in most cases, from inferring a point of audition in space," a result, Chion notes, of the omnidirectional nature of both sound (which, unlike light, spreads out in many directions into space) and listening (which picks up sound in the round) (Chion 1994: 90). While the visible space of the screen is contained (or specifically not contained) within the frame, the space of the audible escapes the frame, for as Chion comments, "for sound there is neither frame nor preexisting container" (1994: 67). Sound, unlike the image, is frameless.[12] The problem of localizing a sound in film often becomes the problem of locating or identifying its source in the space of the screen, redirecting the focus from the sound itself (Chion 1994: 69). The fact that no character in the scene can hear the sound of protest suggests that sound is addressed to the viewer. While visually, the scene aligns viewers with the omniscient disembodied gaze of the surveilling camera, acoustically the scene enmeshes viewers in the protest. Enveloped by the sound of protest, viewers can no longer be reduced to passive objects submitting to the power of looking and the visible. Viewers are also listening subjects. But what exactly are they listening to? How does this listening affect the relationship between the visible and the audible? How can this sound without a body resist the subjugating effects of surveillance?

The film does not show the source of the sound of protest. As a consequence, the sound of protest is acousmatic, for it cannot be located in the space that is visible and yet is implicated in that space. The invisibility of the source bestows three different but related subversive powers on the voice of protest. First, the impossibility of tying the voice of the protesters to a visible body or face destabilizes the apparent unity created by the synchronization of sound and image, voice, and body. In contrast to the voices of the reporters, which function as "added value" to the image, the acousmatic voices of the protesters generate tension or contrast between the visual and the audible, between what is seen and what is heard, breaking the illusion of unity. Second, the separation of the sound of protest from its visible source forces the listener to pay attention not simply to the meaning or the message conveyed by the sound of protest ("The people united will never be defeated") but also, and more importantly, to the voice itself. The acousmatic power of the voice derives not from its ability to convey its message, but from its ability to make itself acoustically present in the framework of the visible and yet resist being neutralized by it. By making itself perceptible without being

visually present, the acousmatic sound of protest circumvents the entrapment of visibility and resists visual classification, fixation, and objectification by the state, the corporation, the media, and the cinematic gaze itself. Third, the impossibility of fixing the voice to a spatial location and of unveiling its source leaves its visual identification to the viewer/listener's imagination and interpretation, thus allowing the heterogeneity and individuality of the crowd to materialize in each listening of its disembodied sound.[13] By imagining a form of "disembodied" resistance, *El Método* demonstrates the existence of a point of entry where imagination can sneak in and resist the depoliticizing logic of visibility and the surveillance that subdues it.[14]

These subversive powers of the acousmatic sound of protest give the film its political potential. Whereas visually the film aligns viewers with the gaze of the camera – which presents the panoptic corporate power as cruel but ultimately omniscient and inescapable – aurally the film breaks the viewer's conformity with the given order of the visible and produces a counter-space that exposes the limits of visibility and questions its inescapability. By rendering the sound of protest acousmatic, the film thwarts, even if only fleetingly, any straightforward relationship between cause and effect, between the visible presentation of events and the interpretation of their meaning, opening up avenues for sonic emancipation.

Conclusion

The final tracking shot of the film shows an image of a now-transformed Nieves as she leaves the corporation building. Her back is to the camera as she walks through an empty and silent street full of shattered urban furniture, burned cars, and scattered pamphlets following the protests. Nieves' exiting of the corporation building is in direct contrast to Carlos' entering at the beginning of the film, with a massive security operation deployed in the city to control the protest. Critics of the film have interpreted this closing shot as the film's retreat from a compelling critique of the dangers of neoliberalism. For instance, Parés Pulido argues that with the last apocalyptic scene, the film affirms that the inexorable advance of capitalism is the destruction of the human and points at all of us, viewers, as culpable (Parés Pulido 2017: 249). For Agustín Rubio Alcover, the last image "reinforces the competitiveness component of whoever may fall above any other value (empathy, attraction)" (Rubio Alcover 2014: 155).

My alternative reading of the final shot of the film is more optimistic. Visually, in showing Nieves moving away from the camera and submerging herself into the depth of the urban landscape, the shot suggests that she is distancing herself from the surveillant gaze and thus releasing herself from its controlling and subjugating effects. Furthermore, as Nieves moves away from

the camera, she becomes part of a space where the traces left behind by the protests function as the visual reminders that "all is not well with the political settlement of the state" (Wall 2015: 151). Additionally, the final scene takes place in silence (viewers hear only the sound of Nieves' steps) and, as Dolar notes, silence "is never quite an absence of sound. . . . Sound, by its temporal nature, is always on the edge of fading away, but also in the impossibility of ever quite dying" (2011: 132). The fact that we do not hear the sound of the crowd does not mean that it is not there in hiding, surreptitiously lurking at the edge of the visible and waiting to irrupt at any moment.

Notes

1. The slogan of the project "Protest and Politics" by sound recordist Stuart Fowkes, who has collected sounds of protest of the last decade (including anti-Trump protest in Portland and demonstrations opposing Brexit in the UK). Available at <https://citiesandmemory.com/protest/> (last accessed June 15, 2020).

2. The film is loosely based on the Catalan play *El mètode Grönholm* (2003) by Jordi Galcerán. For an analysis of the differences between the film and the play see Palomeras 2005. Marcelo Piñeyro acknowledged in an interview that the script, co-written with Mateo Gil, was also inspired by films including *12 Angry Men* (Sydney Lumet, 1953), *La chinoise* (Jean-Luc Godard, 1967), and *They Shoot Horses, Don't They?* (Sidney Pollack, 1969) (López Pérez 2010: n.p.). The film won two Goya Awards in 2006: Best adapted script (Mateo Gil and Marcelo Piñeyro) and best supporting actor (Carmelo Gómez).

3. The anti-corporate globalization movement (also referred as to the Global Justice Movement) accuses the World Trade Organization and the International Monetary Fund of implementing neoliberal policies such as deregulation, privatization of public services and industries, fiscal austerity programs, and trade liberalization that favor multinational corporate profits over the rights of workers, consumer safety, and the environment (Boykoff 2006: 206–207). As the alternative, the anti-corporate globalization movement proposes democratic control and requires corporate accountability.

4. In "Postscript on the Societies of Control" (1992), Gilles Deleuze posits that a "society of control" has replaced Foucault's "disciplinary society." He writes: "The factory constituted individuals as a single body to the double advantage of the boss who surveyed each element within the mass and the unions who mobilized a mass resistance; but the corporation constantly presents the brashest rivalry as a healthy form of emulation, an excellent motivational force that opposes individuals against one another and runs through each, dividing each within" (1992: 4–5).

5. For an analysis of reflexive strategies used in film, see Stam 1992.

6. In his analysis of the split-screen technique, Jim Bizzocchi distinguishes three

levels: "the narrative, the structural and the graphic" (2009: 2). He explains: "The narrative level considers the relationship of the split-screen sequence to critical story parameters such as plot, character, and storyworld. The structural level investigates the formal relationships between the frames, including the treatment of cinematic time and space, the identification of any overall master-frame or figure-ground relationship, and the relationship of the split-images to the soundtrack. The graphic level is a closer look at the design details, considering variables such as frame shapes, number, layout, sequence initiation, and treatment of motion" (2009: 2).

7. Media theorist Lev Manovich refers to the split-screen technique as "spatial montage" that involves "a number of images, potentially of different sizes and proportions, appearing on the screen at the same time" (2001: 270).

8. In his analysis of the "off/on-screen" sound in cinema, Metz argues: "The situation is clear: the language used by technicians and studios, without realizing it, conceptualizes sound in a way that makes sense only for the image. We claim that we are talking about sound, but we are actually thinking of the visual image of the sound's source" (1980: 29). For an analysis of the important role that the voice plays in film see Whittaker and Wright 2017.

9. As Jacques Rancière states, "Power is not so much in the spectacle as in the racket that it authorizes" (2003: 47).

10. Attali identifies three strategic uses of music by power: "Make people Forget, make them Believe, Silence them" (Attali 1985: 19). A contrasting example is provided by the deployment of music as an instrument of torture as at Guantanamo Bay, where the jailers played deafening heavy metal music. See Cusick 2016: 379–392.

11. Through the anti-corporate globalization protest in the film, Marcelo Piñeyro also comments on the protests that took place in Argentina during the 2001 financial crisis, when thousands took to the streets of Buenos Aires in protests against President Fernando de la Rua's decision to cut public spending, to reform labor law to the detriment of workers' rights, and to impose the economic measures known as *el corralito* (Vilas 2006: 129). In accord with IMF austerity guidelines, President de la Rua and Minister of Economy Domingo Cavallo decided to freeze the amount of money that people could withdraw from their banks each day and to force citizens to convert their accounts in dollars to devalued pesos. Protesters, mostly unemployed persons and their families, took to the streets employing protest strategies such as *el corte de ruta* or *piquete*, which included blocking strategic public arteries and access routes to the city. They formed what became known as the "picketers movement" (*los piqueteros*) (Vilas 2006: 125–126). At the same time, President de la Rua declared a state of siege, making lawful the intervention of the armed forces to suppress the protests (Vilas 2006: 131). The aggressive police response, with rubber bullets

and tear gas used to clear Plaza de Mayo, left at least six demonstrators dead. On December 20, chanting *"El pueblo, unido, jamás será vencido"* and defying the president's curfew, protesters gathered in front of Government House and the Parliament and forced President Fernando de la Rua to resign (Vilas 2006: 132).

12. According to Christian Metz, "We tend to forget that a sound in itself is never 'off': either it is audible or it doesn't exist. When it exists, it could not possibly be situated within the interior of the rectangle or outside of it, since the nature of sounds is to diffuse themselves more or less into the entire surrounding space: sound is simultaneously 'in' the screen, in front, behind, around, and throughout the entire movie theater" (1980: 29).

13. Separating the voice from the body does not mean negating the body. The acousmatic voice implies the presence of a body from which it emanates, even if the body is not visible. As Dolar puts it, the voice "is a bodily missile which has detached itself from its source, emancipated itself, yet remains corporeal" (2006: 73). The voice is thus at once part of a body, as it stems from it, and "not its part," as projected out into the air, it has freed itself from the body (Dolar 2006: 73). This paradoxical relationship between voice and body allows the viewer both to connect the voice to the corporeality of the invisible plurality of dissenting bodies from which it emanates and to separate it from those bodies.

14. According to Brandon LaBelle, "The acousmatic, in requiring of us a type of psychic labor, a negotiation with what has gone missing or what we may not have access to, incites our imagination as well as fantasy" (2018: 37). As LaBelle further argues "practices of acousmatic listening and invisibilities . . . give challenge to other insistent ways in which political acts and public life are understood by way of appearance"(2018: 54).

5

Surveilling Terror: Post-Western Topographies in *No Rest for the Wicked*

There is no peace for the wicked, says the Lord

Isaiah 48:22.

This chapter focuses on the "aesthetic frames" that constitute the sensory configuration of security and justice in the post-9/11 "age of terror," through Enrique Urbizu's film *No habrá paz para los malvados* (*No Peace for the Wicked*, 2011).[1] The film exposes what Michael J. Shapiro (2009) has called the "violent cartography" of national security in the context of the Madrid terrorist attack on March 11, 2004, when a series of ten coordinated bombs exploded in three different train stations, killing 191 and injuring another 1,841 people.[2] As Shapiro explains, these violent cartographies are "historically developed, socially embedded interpretations of identity and space" whereby "enmities give rise to war-as-policy" and which involve "forces, institutions, and agencies that identify the . . . spaces where bodies are judged to be dangerous" (Shapiro 2009: 18–19). This chapter places the film under the "aesthetic frames" these violent cartographies construct and inquires as to the extent to which it supports or challenges their underlying narratives of securitization. In doing so, I seek to assess a shift in contemporary politics and aesthetics that Jacques Rancière (2006a) has called "the ethical turn" of aesthetics and politics that followed the 9/11 terrorist attacks.

Combining thriller, *film noir*, and post-Western genres, *No Peace for the Wicked* tells the story of Santos Trinidad, a once-respected but now frequently-drunk, cowboy-like cop working in the missing persons unit. Like in *El Método*, the action takes place while the city of Madrid is implementing strict security measures in preparation for the G20 summit. At the beginning of the film, Trinidad (José Coronado) shoots three Colombians in a nightclub after hours, an apparently motiveless killing. From then on, the film leads the viewer on a double hunt: Trinidad's hunt for the only witness to his action who manages to escape him and Judge Chacón's quest to identify and apprehend the murderer of the three Colombians. Along the way, Trinidad unknowingly discovers a plot by a Colombian drug cartel linked to an Islamist

cell planning a terrorist attack. Trinidad's actions, which end in a fight to the death between him and the terrorists, apparently neutralizes the Islamic cell. Yet the film ends with an image of a crowded shopping mall where a series of undetected bombs remain active, suggesting danger is imminent.

Although the events and characters in the film are fictional, they evoke the places, methods, and strategies behind the 2004 Madrid bombing attacks as they were disclosed in the 2007 court proceedings against the perpetrators.[3] The film shows the Madrid neighborhood of Lavapiés, where one of the leaders of the real-life terrorist network owned a cellphone store; the countryside headquarters where the explosive devices were actually assembled; and Atocha railway station, where three of the bombs exploded. The attack planned in the film, like the 2004 attacks, used cellphones for detonation. The film also uses the footage from the video that the terrorists recorded on the day of the Madrid attacks. In the footage, three hooded men read a message in Arabic claiming responsibility for the attacks, which they justify as retaliation for Spain's participation in the US-led "War against Islam." They also warn that they will continue to commit more bloody attacks if Spain does not halt its "injustices" and "killing" of Muslims they had perpetuated as anti-terrorism measures (Reinares 2010: 86, 97). By thus connecting the events of the 2004 Madrid train bombings to the scenes and narrative details of the film, *No Peace for the Wicked* invites viewers to examine the narratives, images, and tropes surrounding terrorism and anti-terrorism policies in the post-9/11 age of terror.

Earlier readings of the film suggest that it reinforces the violent cartography of national security and the moral landscape of post-March 2004 Spain. By contrast, this chapter aims to demonstrate that while at the narrative level the film seems to reinforce the ideological discourses of security and justice constituted by the state and the media, at the level of aesthetics the film disturbs and reconfigures the frames within which the viewer understands these discourses. As explained in the introduction, this approach draws on Rancière's understanding of aesthetics, by which he means not a discipline dealing with art and artworks, but a "distribution of the sensible," a way of framing what is given to our sensorial experience or what is otherwise excluded and remains outside it (Rancière 2004). The aesthetic frames function as markers that determine who is an enemy or who is a friend, who is to be perceived as terrorist or not, and what and who is to be feared or not.

The chapter is divided into four sections. The first section describes the religious and Wild West rhetoric that President George W. Bush used to justify an ("infinite") war against terror. Then I draw a contrast between the construction and management of the public's perceptions of fear and terror as forms of state legitimization and the manner in which Urbizu's

film constructs opposing "aesthetic frames" that allow us to challenge them. The next section situates the film in a post-Western aesthetics that recycles themes, tropes, and styles of classical Western cinema to interrupt and modify its assumptions, ideology, and values. The chapter concludes with an analysis of Judge Chacón (Helena Miquel), who embodies law in the film, to show that even though the law may be incapable of neutralizing violence, a "different place" for justice may still exist between terror and law.

Infinite Justice and the Ethical Turn

Soon after the terrorist attacks of 9/11, President George W. Bush launched the War on Terror, which he called "Operation Infinite Justice" before bowing to Muslim protesters who pointed out that only Allah could provide infinite justice and renaming it "Operation Enduring Freedom" (Roy 2001). Using overtly religious overtones and imagery, President Bush described his pre-emptive military strike in Iraq, Operation Enduring Iraqi Freedom, as a "crusade . . . against a new kind of evil" (see Lincoln 2006: 119), against a new kind of enemy who hates both freedom and the American "way of life" (Roy 2001).[4] By constructing a Manichean worldview of good versus evil, Bush justified military action as the only possible option, calling upon his allies to follow the military course. As he put it in a well-known statement directed at foreign governments: "You're either with us or against us in the fight against terror."[5] Right after launching a series of airstrikes in Afghanistan, he declared: "We're a peaceful nation. Yet . . . there can be no peace in a world of sudden terror. In the face of today's new threat, the only way to pursue peace is to pursue those who threaten it. We did not ask for this mission, but we will fulfil it."[6] In a clear allusion to the biblical passage of the film's title, President Bush enacted the role of a holy warrior launching a mission not out of a personal will, but based on (divine) mandate: a war on terror that seems destined today never to end.

Alongside his use of religious rhetoric, Bush's outward appearance was embedded in the mythic cowboy imagery of the Wild West, which is central to America's self-understanding of its history and national identity (Hoffman 2011: 325). In a white hat and cowboy boots, he visually associated himself with the figure of the sheriff (Hoffman 2011: 326). Like the heroic sheriff of the cinematic Old West, who would stand alone if need be in order to defeat those outside the bounds of civilization (Indians) or law (outlaws), President Bush would not hesitate to fight the new evil (terrorists) in defense of the American way of life. Invoking Wild West rhetoric, he declared that he wanted Osama Bin Laden "dead or alive"; he also labelled Saddam Hussein's government an "outlaw regime," giving Saddam and his sons forty-eight hours to leave Iraq (Dodwell 2004).

In *Prisoners of the Infinite* (Rancière 2010a), Rancière compares the imagery Bush invoked and the representation of sheriffs in classical Western films. In his view, a difference is discernible between the morality of Westerns and Bush's call for "infinite justice." In classical Westerns, sheriffs often risk their lives to save outlaws from a lynch mob and deliver them to justice. Bush's infinite justice implies a type of "justice without limits" (Rancière 2010a: 82), a justice that erases all distinctions that can delimit its practice. As Rancière notes, Bush eliminated the distinction between "legal punishment" and "the vengeance of individuals" as well as those between "the law" and "the political, the ethical or the religious" (Rancière 2010a: 82). In doing so, the U.S. president justified "enhanced interrogation techniques" in violation of Art. 3 of the Geneva Conventions and the denial to Guantanamo Bay detainees of their status as prisoners of war, and of their rights to legal counsel and a fair trial. In this way, traditional distinctions "all wind up being abolished at the same time as the forms of international law are effaced" (Rancière 2010a: 83). Rancière argues that the term "infinite justice" and its resemblance to religious rhetoric was no accident; it meant precisely what it said: "the assertion of a right identical with the omnipotence hitherto reserved for the avenging God" (2010a: 83).

For Rancière, the term "infinite justice" not only designates a retaliatory or pre-emptive strike against an enemy attack; most importantly, it entails a levelling out of the symbolic space he identifies with the "ethical turn" of contemporary politics and aesthetics (Rancière 2006a). This "ethical turn" is a shift in the symbolic order of society, where the specificity of political and artistic practices is dissolved, and where earlier distinctions between law and fact, between what it is and what ought to be, are erased (Rancière 2006a: 2). It is a transformation of the social order of perception in so-called democratic societies after 9/11, where the gap between the law's abstract literalness and where polemics over interpretations of the law is closed (Rancière 2010b: 102). This gap is precisely the space of dissensus so necessary for political action and which is filled instead by an ethical conception of the community as a unified entity (Rancière 2010b: 104). As Rancière understands it, the term ethical, which is etymologically associated with the idea of an abode or way of being,[7] divides the world in two. On the side of good is a consensual practice that matches the letter of the law to a community's specific way of life, with no gaps or spaces for dissensus (Rancière 2010a: 82). On the other side lies a world of evil that is made infinite or absolute and "can only be enacted through a war to the death" (Rancière 2010b: 104). The problem, Rancière notes, is that this evil "cannot be righted except at the price of another evil which remains irreducible," that is, equally infinite (2010a: 115). In this new form of symbolism, war on terror and infinite justice fall within

the same field of indistinction, a form of preventative justice that levels down and destroys everything that appears to threaten the ethical bond of the community (Rancière 2006a: 5).

Rancière argues that this ethical turn can be observed in post 9/11 cinema, which borrows and modifies classical Old West tropes and archetypes. For instance, classical Westerns dramatized scenarios that presented different forms and motivations for violence (Rancière 2010a: 115). In these films "freelance sheriffs and righters of wrongs used to wield, without inhibition, the violence of the common law, or of morality, against the violence of those who followed the law out of mere greed" (Rancière 2010a: 114). Nowadays, those political or aesthetic scenarios seem to have fallen into a state of indistinction, where it is no longer possible to distinguish different types of violence in their aims, character, and effects. This is precisely what the ethical turn means for Rancière: the flattening of all forms of action under the same, one-dimensional mode of perception (Rancière 2006a: 2), all of which takes place in a single, ethical scenario of (infinite) evil and justice.[8]

The biblical undertones of *No Peace for the Wicked* as well as its constant references to cowboy imagery seem to align the film squarely with the violent cartography identified by Shapiro and with Rancière's ethical turn of cinema in the new age of terror. According to critic Diana Norton, the film falls into a neo-imperialist trap of stereotype and institutional racism that equates terrorist potential with foreigners and immigrants (in particular, Latin American and African characters) (Norton 2015: 179). Maria Pilar Rodríguez argues further that by exposing the incapacity of the state to meet terrorist threats, the film suggests that only the individual intervention of someone like Santos Trinidad who is willing to circumvent the rules and fight evil with its own violent tools can neutralize such threats (Rodríguez 2016: 152). For Jesús Ángel González, the film's Western references establish an analogy between the traditional enemy in Westerns (Indians) and the contemporary enemy of the US-led "war on terror" (Muslims) (González 2016: 6), with the overall purpose of warning viewers about "the risks of applying 'posthumously' the logic and moral assumptions of classical Westerns in contemporary situations" (González 2017: 70). In what follows, I confront these readings by locating the film in what Neil Campbell (2013) calls "the politics of post-Western aesthetics," which, as I will show, challenge rather than reproduce the logic and ideology of infinite evil and justice. I do so first by analyzing how the state and media construct, manage, and legitimize feelings of insecurity, fear, and terror and then by showing how the film deconstructs these frames in the aesthetic register.

The Media and the Securitization of the State: Fear and Terror

The title sequence of *No Peace for the Wicked* frames the context of the story within the post-9/11 climate of terror, drawing attention to the role that news media plays in managing the public's perceptions of insecurity and danger (Cohen 2002). The sequence opens with a close-up of a slot machine: Santos Trinidad (whose name recalls Enzo Barboni's well-known 70s Trinity series) plays the machine.[9] In the background, the TV news reports that:

> The Islamic Republic now has 3,000 centrifuges, 2700 more than those known of up to the present day and, experts say, enough to make an atomic bomb within a year. The president of Iran denies this and once again, insists that they are only doing uranium for peaceful purposes.

The camera then cuts to a close-up of Trinidad's cowboy boots and in a foot-level shot follows his footsteps to the counter, where another close-up shows a picture of a missing girl whose disappearance he is investigating. Echoing the news media reports in *El Método*, the TV news now reports that:

> There are just four days to go before Madrid is host to the forthcoming G20 summit. Madrid is taking strict security measures and it is estimated that over 15,000 members of the state security forces will be in place throughout the course of the summit. Violence is expected from young anti-system protesters, which has invariably accompanied the latest summits. Although border controls and access to the capital have been tightened, thousands of these violent protesters are already in the city.

The sequence closes with an image on TV of female dancers who resemble the image of the saloon girl from the slot machine. Trinidad drunkenly orders one last drink, but the bartender refuses him and throws him out of the bar.

The TV reports merge two disparate images to produce a single social problem. The first report portrays Iranian possession of weapons of mass destruction as an imminent threat and thereby induces a diffuse sense of terror – potentially, anyone, anywhere, at any time, might become a victim. The second report constructs the image of protesters against the neoliberal system represented by the G20 summits as violent, calling for increased security measures in anticipation of protester violence. By tying together the Iranian nuclear threat, political activists, and terrorists, the news media converts disparate situations into a single object of fear (Rancière 2014: 27). This fosters feelings of rejection directed against this object and mobilizes a sense of the community as unified by threats to its security. The underlying message is that anything that threatens the self-perceived safety of the community should equally be feared. This is what "consensus" means for Rancière: "not

the romantic absurdity of responsible partners together discussing facts and solutions to objective problems, but the immediate identification of the subject who fears" and the object of fear (2014: 27).

Media inducement of fear and terror helps to construct a given regime of visibility and invisibility. Here, it is useful to draw a distinction between fear and terror. Fear is a concrete, tangible threat expressed by an embodied adversary (Bégin 2014: 60; Lezra 2016: 215). Fear, in other words, puts a face to the threat and "provides it with the concrete features which will make it into an appropriate target of hatred and struggle" (Žižek 2002). Terror, on the other hand, "is not simply a stronger type of fear, responding to a more frightening and diffuse threat. Terror is a way of feeling, naming, and explaining that causes trouble both in everybody's mind and in the global world" (Rancière 2006c: 275, my translation). Put differently, terror is a "mode of perception," a way of mapping the perceptible that imposes itself as a self-evident order and "links a regime of thinking about causality with a moral regime of interpreting Good and Evil" (Rancière 2006c: 275, my translation).

Rancière observes that states make use of the widespread sense of powerlessness that terror produces for their own benefit: unable to protect their citizens against this invisible and elusive threat, as a result, governments take control of what is in their power, "the production and management of [the sentiment of] insecurity" (Rancière 2010c; see also Virilio 2012:15). Rancière writes: "To foresee dangers is one thing; to manage the sentiment of insecurity is another, one in which the state will always be more expert perhaps because it is the very principle of its power" (2010a: 113). The feeling of insecurity gives the state the justification to create a permanent state of surveillance in the name of guaranteeing security (Ahmed 2004: 76); or, more precisely, it gives the state the power to create a permanent state of insecurity in order "to enforce its governance" (Corcoran 2010: 14) and legitimize itself (Newman 2007: 5). Terrorism and anti-terrorism run the risk of falling into a state of indistinction, in which each justifies and legitimizes the other's existence and actions (Agamben 2002: 24; Newman 2007: 5). In this way, anti-terrorism policies become floating signifiers ready to be applied indiscriminately to everything deemed to be a threat to the community's safety, and which legitimizes in advance the intervention of the state.

Unsurprisingly, the initial response from the state, as depicted in the film, is to meet threats identified and magnified by the media by enhancing surveillance and security measures. The film presents the urban space of Madrid under a state of constant surveillance: helicopters patrolling the city, checkpoints, patrolling guards, bomb-sniffing dogs, chemical and biological weapon detectors, and CCTV cameras in streets, parking lots, hotels, and nightclubs. The display of highly aesthetic images of surveillance generate

what Bruce Schneier (2003) calls a "security theatre," with a double effect: on the one hand, it creates a feeling of safety and protection promised by increased surveillance (Patel 2012: 216); on the other hand, it reinforces the perception of insecurity and vulnerability portrayed by the media.

According to Diana Norton, the constant use of surveillance mechanisms within the film reconstructs the urban space of Madrid as a borderland – that is, as a contested territory characterized by racial segregation and conflict (Norton 2015: 177). In her view, the main camera of the film reproduces this segregation by recreating the static (supposedly objective) point of view of the surveillance camera. For example, in a scene that takes place in the immigrant neighborhood of Lavapiés, the static shot participates in Trinidad's ethnic profiling of the neighborhood's residents as criminals (Norton 2015: 185). Through the false objectivity perpetuated by security footage, static shots imitate surveillance and thus reveal the racial biases that permeate Spanish society.

However, in my view, the film does not construct a unitary viewing position but offers contrasting perspectives that problematize rather than reinforce the omniscient gaze of the security apparatus. One of the most notable examples is when Judge Chacón interviews members of different police departments, who demonstrates not only their ineffectiveness but also their lack of coordination and cooperation. First, Judge Chacón interviews Cerdán (Eduard Farelo), from the narcotics bureau, about the dismissal of an investigation into one of Trinidad's victims, Pedro Vargas, in 2004. Cerdán explains that there was a bureaucratic problem ("a civil servant forgot to lodge the prosecution appeal on time, and the case was dropped"). Then, Chacón questions Inspector Mérida, from the Foreign Intelligence Unit, about why his unit took charge of a narcotics case: Mérida explains that one of their informants told them that Vargas was connected with El Ceutí, the leader of a group of radical jihadists, but that they have since lost track of him. Another member of the Foreign Intelligence Unit, Ontiveiros (Pedro María Sánchez), explains to Chacón that the unit lost track of El Ceutí because "the terrorists are unpredictable, because they move a lot, which makes it very hard to identify them, to locate them, to nail them." In Ontiveiros's narrative, the lack of a concrete, identifiable enemy creates what James P. Walsh (2016: 6) calls an "unpredictable topography" of invisible networks whose undetectable tactics and ability to hide in plain sight render terrorist suspects impossible to capture or restrain (Walsh 2016: 6). However, the following exchange highlights Chacón's belief that lack of coordination plays a bigger role:

Chacón: But El Ceutí's people were still bringing cocaine to the
 Colombians?

Ontiveiros: That's why the case went back to narcotics.

Chacón: But in narcotics they are not aware of it. Aren't you talking to each other?

Against the state's rhetoric of undetectable terrorists working in the shadows, Chacón's interrogations draw viewers' attention to bureaucratic sloppiness, lack of coordination between different police units, and failure to pursue known suspects. In so doing, the film invites viewers to critically examine the effectiveness and rationale of the state's management of fear and terror.

Trinidad and the Politics of the Post-Western

Some critics have argued that by showing the incompetence of the security forces Urbizu's film suggests that salvation can only be achieved with the help of rogue police officers like Santos Trinidad, who navigates the same terrain as the terrorists and fights them with the same violent means. I disavow this conclusion by inscribing Trinidad in what Neil Campbell calls "post-Western aesthetics."

In *Post-Westerns: Cinema, Region, West*, Campbell defines post-Westerns as films that borrow from and engage with traditional Western cinema in order to comment on "its deeply haunting assumptions and values" (2013: 31).[10] He argues that post-Westerns rescue traditions, themes, tropes, and styles established under the classical Western, only to actively interfere, interrupt, and alter their myths, ideologies, and values (Campbell 2013: 37). For instance, if the classical Western moved toward resolution, settlement, community, and the establishment of a particular national identity, the post-Western seeks to stress "the 'provisional' and the contingent, the unfinished aspects of a people not already defined and labeled but still emerging and creating itself" (Campbell 2013: 36). For Campbell, post-Westerns are "political" in Rancière's sense of the term because they reconfigure taken-for-granted mythic discourses and codes, even " 'without being able to guarantee the absolute elimination of the social inequalities inherent in the police order' that creates and sustains them" (Campbell 2013: 352). The "post" of the post-Western, therefore, "does not just mean overcoming the 'past' " it also means " 'a process of disengagement' from the system it is in tension with" (Campbell 2013: 9).

Rather than warning viewers about the inadequacy of "applying the logic and moral assumptions of classical Westerns in contemporary situations" (González 2017: 70), the post-Western aesthetics of *No Peace for the Wicked* challenge the mythical, heroic cowboy narrative presumptively used to justify an infinite "war on terror"; in doing so, the film sets up a political scenario that "crack[s] open the unity of the given and the obviousness of

the visible, in order to sketch a new topography of the possible" (Rancière 2009: 49).

No Peace for the Wicked declines to explain what drives Trinidad to kill three people in a nightclub, leaving the viewer wondering whether it is the news on TV that triggers Trinidad's violence, his drunkenness, his troubled past as a member of a special operations unit, or the death of his partner in Cali, of which the viewer ultimately learns. Trinidad is thus best understood as what Shapiro calls an "aesthetic" rather than a "psychological" subject (2009: 8). In contrast to psychological characters, which demand attention to the underlying causes and motivations of their personal drama, "aesthetic subjects" are characters "whose movements and actions (both purposive and non-purposive) map and often alter experiential, political relevant terrains" (Shapiro 2013: xiv). By focusing on the aesthetic rather than on the psychological, the film "places an emphasis on images rather than narrative" (Shapiro 2009: 11) and encourages viewers to shift their attention away from Trinidad's personal drama towards the aesthetic realm where his movements and actions take place.

The film associates Trinidad with Western iconography and codes from the outset. The slot machine in the title sequences shows a sheriff with a gun against a background of a desert; on the right, a dance-hall girl appears under the doorway of a saloon. The icons on the slot machine, which mix and recombine several times, include dollar signs, revolvers, sheriff's stars, and cowboy hats, and at one point frame the credit of José Coronado, who plays Santos Trinidad. These Western references and the generic expectations (of genre) that go with them are subverted in a series of events. The sheriff with a star-shaped badge and a gun facing saloon-hall dancers becomes the image of a drunken cop with a badge and a revolver facing dancing girls on TV. Then the sheriff's star becomes a police badge which Trinidad uses to ask for one last drink at a nightclub. The saloon itself then becomes a nightclub and the site of a cold-blooded triple murder. Finally the desert, epitome of the classical Western landscape, becomes a wasteland on the outskirts of Madrid where Trinidad burns all the evidence that links him to the murder. In the background, viewers can see the "Four Towers Business Area," which, as Paul Julian Smith notes, is the film's way of "symboliz[ing] the unsustainable boom-and-bust of the Spanish economy" (2012: 7).

Set in 2004, four years before the bubble burst, the film shows the city of Madrid deeply immersed in the construction boom. Between 1998 and 2008, the motor of the Spanish economy lay in "the so-called 'wealth effects' generated by growth in the value of households' financial and property assets" (López and Rodríguez 2011:10). The 1998 Land Act,[11] commonly known as the "build anywhere" law, and the adoption of the Euro in 2002, played a

crucial role in catalyzing the real estate bubble. While the Land Act facilitated the procedures for acquiring building permits and made available large amounts of land for construction (López and Rodríguez 2011:14), the euro allowed money-laundering related to urban development projects (González Pérez et al. 2019: 2). Between 2002 and 2008, nearly 500,000 new homes were built in and around Madrid, and more than 3 million in the rest of Spain (González Pérez et al. 2019: 2). Every city across the country wanted to be the target of urban and infrastructure investment. Unemployment went from being over 20 per cent in the mid-1990s to 8 per cent in 2006. Millions of immigrants from Latin America, Eastern Europe, and North Africa arrived in Spain to work in the construction sector and in domestic services, increasing the Spanish population by 4.3 million people in a short period of time (González Pérez et al. 2019: 2). However, this economic bonanza ended in 2008, when the housing bubble crashed and the financial crisis hit Spain. It went from being celebrated as one of the most successful EU economies to being considered one of Europe's weakest economies and a possible threat to the Eurozone, along with Portugal, Italy, Ireland, and Greece, one of five countries earning the derogatory acronym PIIGS. By replacing the classical Western landscape by a wasteland with the four towers in the background, the film points to this imminent economic crisis for audiences still reeling from its impact.

Trinidad's name also indicates the overturning of the Western genre. It evokes the name of the protagonist of Enzo Barboni's Spaghetti Western comedy series, Trinity. Like Barboni's protagonist, Trinidad is also an ill-mannered, remorseless, unshaven gunfighter who is fearless and indifferent to the norms of law. Trinidad smashes the head of the nightclub owner against the counter just as Trinity bangs a man's head against a cash register. By associating Trinidad with the Spaghetti Western, Urbizu adds a critical layer to the character and establishes an ironic complicity with viewers (González 2017), who are encouraged to pierce the façade of the heroic, ideological cowboy narrative (see Frayling 1998).[12] Contrary to the religious connotations of his name ("Holy Trinity"), the film's Trinidad is no saint, but a crook.

The critical subversion operated by the post-Western is important in assessing the final confrontation between Trinidad and the terrorists, in which Trinidad is killed. Some critics have interpreted Trinidad's death at the end of the film as a form of redemptive sacrifice that grants him heroic status (e.g. Norton 2015). Tzvetan Todorov's distinction between sacrifice and massacre can be useful here. Todorov (1985: 144) writes:

> Sacrifice . . . is a religious murder: it is performed in the name of the official ideology and will be perpetrated in public places, in sight of all and to

everyone's knowledge. The victim's identity is determined by strict rules. . . . He must not be too alien, too remote . . . [T]he sacrificial victim also counts by his personal qualities: the sacrifice of brave warriors is more highly appreciated than that of just anyone. . . . The sacrifice . . . testifies to the power of the social fabric, to its mastery over the individual.

Massacre, on the other hand, reveals the weakness of this social fabric; hence it should be performed in some remote place where the law is only vaguely acknowledged. . . . The more remote and alien the victims, the better: they are exterminated without remorse, more or less identified with animals. The individual identity of the massacre victim is by definition irrelevant (otherwise his death would be murder). . . . Unlike sacrifices, massacres are . . . kept secret and denied. This is because their social function is not recognized, and we have the impression that such action finds its justification in itself.

The tension between these two types of violence can be seen in the final confrontation between Trinidad and the Islamic terrorists he has unwittingly uncovered. The scene shows Trinidad killing the main leaders of the terrorist cell, one by one: he cuts the throat of one, shoots the missing witness in the head, and finally fires multiple shots into El Ceutí, who manages to stab Trinidad fatally before dying. The scene of violence can be read either as sacrifice or as massacre depending on the aesthetic frames within which the various actions are evaluated as good/heroic and evil/villainous. If framed as a religious confrontation (emphasized in the biblical title of the film), viewers are encouraged to identify Trinidad as the victim of violence rather than as its agent. Through his sacrificial death, Trinidad would become the surrogate for all potential victims of the terrorist massacre (McKenna 1991: 205). In this reading, Trinidad's violence is justified as necessary to maintain cohesion of the social fabric threatened by terrorists, who are "the cause, the origin, of destructive violence that warrants its reciprocal and liberating response" (McKenna 1991: 205). This sacrificial scenario would bolster the ethical "dramaturgy of infinite evil, justice, and redemption" (Rancière 2006a: 1).

This reading, however, completely ignores the post-Western aesthetics of the film. The final confrontation between Trinidad and the terrorists recalls the classic Western shootout-showdown, where the hero stands alone, fearless against his enemies (*Stagecoach* 1939, *High Noon* 1952, *Shane* 1953). As John G. Cawelti explains, in the classic Western ritual of the shootout, "the cowboy hero does not seek out combat for its own sake, and he typically shows an aversion to the wanton shedding of blood. Killing is an act forced upon him" (Cawelti 1984: 87). Accordingly, one of the most important rules in Westerns is that "the hero cannot use violence without justification"

(Calweti 1970: 268). The hero can only resort to violence in order to help others or to protect higher values such as peace, law, and justice. In this way, the hero's "controlled and aesthetic mode of killing" gives a sense of moral significance to violence and imposes an aesthetic order that delineates the difference between hero and savage (Calweti 1984: 87–88). In contrast to the cowboy hero, "[t]he Indian or outlaw as savage delights in slaughter, entering into combat with a kind of manic glee to fulfill an uncontrolled lust for blood" (Calweti 1984: 87).

No Peace for the Wicked subverts the classic Western's "distribution of the sensible" in two ways. Trinidad fights and kills the terrorists not to save society but to cover up the first murders; he is unaware of the hidden bombs in the mall. He dies not as a result of selfless sacrifice in the name of a moral cause, but as a result of acting out his own self-interest. This can be more clearly discerned by comparing the scene of the moment of his death with the initial killing of the three Colombians in the nightclub, which function as mirror-like repetitions of each other. Right after the triple murder, the camera shows Trinidad sitting motionless on a chair in the darkness of his apartment with his back to the viewer. His right arm is extended, and his revolver hangs with his index finger touching the trigger and pointing in his direction.[13] The same image appears again after the final confrontation with the members of the terrorist cell: after being fatally stabbed, Trinidad sits on a chair outside the house with his back to the viewer. His finger lies on the trigger of his revolver, but as he heaves a last sigh before dying, the revolver flips and hangs in his direction. This visual connection invites viewers to identify Trinidad's death as punishment rather than redemption and his violence as a massacre rather than as a sacrifice.

Furthermore, the film denies the resolution typical of classical Western cinema in which the hero wins a clear-cut victory and restores a sense of order, community, and justice (Campbell 2013: 27). As Rancière states, "Victory belongs to the one who can crown the action with the words THE END" (2006b: 77). Trinidad cannot. After the final shootout, two more scenes follow. First, Judge Chacón and Inspector Leiva (Juanjo Artero) arrive at the crime scene, finding Trinidad dead, inviting a final scrutiny of his actions. Then, the closing image shows a crowded shopping mall where a series of undetected bombs remain active, raising the question of whether there might be "no end to violence" (Young 2010).

Judge Chacón and the Topography of the Possible

In her analysis of *No Country for Old Men* (2007), Alison Young notes that the Coen brothers' post-Western film shows that "the encounter between law and violence has the character of a Sisyphean struggle, in which the

agent of law toils to achieve a result, only to see it slip away, . . . or merely to reach the next stage of investigation which will never end" (2010: 169–170). Notwithstanding this violence without end, Young also points out that viewers of *No Country for Old Men* "should not forget the actuality of the *response* of law to violence," even though it might lead to nothing; for, in "the actuality of law's response, there is always already the possibility of the impossible, an end to violence" (Young 2010: 171, original emphasis). This is why viewers can still "see the glimmerings of . . . a 'hope against the evidence' in the hopeless encounter between law and [terror]" (Young 2010: 171). Young concludes that "the point is not that 'justice' demands a particular kind of outcome but rather that there should be some kind of outcome *which can bear the name of justice*: a sense of consequence which overweighs and effaces the violence that has preceded it" (Young 2010: 153, original emphasis). In this final section, I will try to demonstrate that Enrique Urbizu's *No Peace for the Wicked*, which some critics have explicitly compared with the Coen brothers' film, provides such a hope in the figure of Judge Chacón and her tenacious criminal investigation.

The first time Judge Chacón appears on the screen, she is trapped in a traffic jam applying eye drops to her eyes as if seeking to increase her power of vision on her way to the crime scene. This visual cue is important as it ties Judge Chacón, the embodiment of law in the film, to the sense of sight that is to be cleared and anticipates the external obstacles that jam her investigation. The film portrays Judge Chacón and Trinidad as opposites: although both show the same tenacity, one operates in a world of games (symbolized by the slot machine) where he plays by his own rules: he destroys evidence, searches without a warrant, and threatens people to get information; the other is a woman of integrity who strives to follow legal means towards the pursuit of justice: tracks clues, examines ballistic and forensic tests, interviews eyewitnesses, and interrogates suspects, informants, and members of different law enforcement agencies. Their antagonism also operates on an emotional register: one is "a man who nobody loves" (as Trinidad claims), unable to communicate with anyone; the other combines her role as an investigating judge with motherhood, interrupting her tasks to talk affectionately with her family on the phone at various points in the film.

Judge Chacón's investigation, and thus the film, places Trinidad under the scrutiny of the law. In a crucial scene in which Trinidad and Chacón encounter each other for the first time, Chacón questions Trinidad about his whereabouts at the time of the triple murder. The scene opens with the camera positioned behind Judge Chacón – again putting eye drops in her eyes – so that the viewer sees Trinidad entering the room from her perspective. The perfect straight lines of the walls frame the judge, in direct contrast

with the way Trinidad is seen throughout, reflected in fragmented mirrors, distorted surveillance footage, or observed through different railings. These different ways of framing the characters visually underline the gap between their two opposite ways of seeing and understanding law and justice. The interrogation takes place in medium close-up, where a series of shot-reverse shots emphasize the close examination. During the interrogation viewers learn that Trinidad received several distinctions for his work; that he killed one person (though "he was decorated for it" Trinidad clarifies); and that he later abandoned Special Operations. Viewers also learn that in recent years he has received psychiatric attention ("psychological," he corrects); that he has had problems with alcohol, and that while working for the Spanish Embassy in Colombia he "accidentally" shot his partner in a shootout on the outskirts of Cali, after which his partner became paraplegic and later died. At this point, inspector Leiva enters the room bringing the results from ballistics, which are negative. Without any solid evidence, Judge Chacón is forced to let Trinidad go free. What Trinidad does before leaving the room is telling: he removes the revolver from the plastic bag in which it was returned to him and throws the plastic bag to the floor, and in typical cowboy-style puts the revolver back into its holster. From Chacón's and Leiva's point of view, Trinidad's shadowy figure is seen crossing the doorway. Chacón states: "I don't get how this character can still be in the police," underscoring his outsider status.

Trinidad's shadowy image crossing the doorway echoes the iconic final shot of John Wayne's shadow in the doorway in *The Searchers* (John Ford 1956), when, playing the film's protagonist, Ethan Edwards, the actor stands at the same threshold where he stood at the beginning of the film. This time, however, instead of crossing the doorway into the interior of the house (civilization), his shadowy figure turns his back to the family he has helped to reunite and returns to the desert (wilderness). The motifs of the doorway and the threshold are also central to *No Peace for the Wicked*. Like in *The Searchers*, the image of Trinidad traversing and crossing doorways or standing at the threshold repeat throughout to demarcate the boundaries between the inside and the outside and to emphasize his ability to cross these boundaries.[14] As Thomas Elsaesser and Malte Hagener point out, "[a] threshold always points in two directions, because it simultaneously connects and separates – a border can be crossed precisely because a division always implies spatial proximity" (2010: 37). The image of Trinidad crossing the doorway of the interview room, however, marks a turning point in the film: there is no way back. Like Ethan in *The Searchers*, he turns his back to the law, but, instead of the desert, beyond the door, there is only darkness.

The second and final encounter between Chacón and Trinidad takes

place following Trinidad's death after the massacre has already occurred. The narrative appears to have come to an end, but the film shifts viewers' attention toward the figure of Judge Chacón and engages viewers in what Rancière calls "pensiveness" (2009a: 123): the image halts in a moment of suspension, where the logic of the narrative action is thwarted, and every conclusion is put in suspense (2009a: 123). The film engenders suspension by showing the scene of the massacre from Judge Chacón's point of view. In the sequential movement of the camera, viewers can see commissioner Ontiveiros examining the dead body of El Ceutí, who is lying on the floor. Ontiveiros looks up to Judge Chacón as she goes outside the house, where Trinidad's dead body is sitting on a chair. Following Chacón, viewers look down on Trinidad's dead body to see, for the third time, a close-up of the revolver that hangs from his bloody index finger and points towards him. Trinidad faces the camera with his dead eyes wide open. This moment of suspension encourages viewers to return to the scene of violence and to look over again and revise Trinidad's actions from Chacón's viewpoint.

The camera then cuts to a final montage of a series of images of the fire extinguishers with the bombs still active that the terrorists had installed in different spaces of the shopping center as seen earlier in the film. The camera silently shows each of one of these spaces: first, the supermarket, then, lockers and the mall, and finally, the playground. While at first, these spaces appear empty, they are progressively populated by people, who move about oblivious of the bombs. The montage leaves the viewer with a disquieting feeling of uncertainty and danger and raises the question of whether there is a place for justice between violence and the law.

As Rancière writes, "The only good end is the one that . . . leaves open the possibility that the action may be continued, restarted" (2006b: 92). The last shot of the film leaves open this possibility. Instead of the proverbial words "the end," the title of the film, *No Peace for the Wicked,* appears on a black background, implying that the action may be continued, restarted. But with Trinidad dead and the viewers' attention shifted towards Judge Chacón, the title acquires new meanings: On the one hand, there will be *no peace* as long as the bombs are still out there and can be detonated (Díaz 2012: 116). On the other hand, *the wicked* will continue to be persecuted. This time, however, the responsibility cannot lie in the hands of someone like Santos Trinidad. Rather Judge Chacón will uphold it. Within this new topography of the possible, the film confronts the viewer with the thought that justice might exist elsewhere than in the outcome (Young 2010: 20), and be always practiced otherwise.

Notes

1. The official translation is *No Rest for the Wicked*. I use "peace" both because it is closer to the original Spanish ("Paz") and because it is also the term used in the standard English translation of the biblical passage that the title references. The film won six Goya awards: Best film of 2011; Best director; Best leading actor; Best original screenplay; Best sound; and Best editing.

2. Judgment 65/2007, "Audiencia Nacional," Criminal Section, Second Section. The March 11, 2004 terrorist attacks took place three days before the Spanish general elections. Immediately following the attacks, the ruling *Partido Popular* (Popular Party, PP) of José María Aznar and the media blamed the Basque group ETA for the bombings even though all evidence pointed towards an Al-Qaeda cell. On March 13, thousands of Spaniards gathered in front of the PP's headquarters in different cities around the country accusing the government of lying and demanding the truth about the attacks. The election was scheduled for March 14, and Spain therefore considered March 13, a "day of reflection" on which political demonstration is illegal. As Cristina Flesher Fominaya points out, these protests were unprecedented not only in that they violated this law but also in that they were Spain's first political "flash mobs" (2011: 290). In any case, the PP's obfuscation ended in political defeat. Al-Qaeda claimed responsibility for the bombing in a video message it released on March 14. The Socialist Worker's Party (PSOE) led by José Luis Rodríguez Zapatero won the elections.

3. See Judgment 65/2007, "Audiencia Nacional," Criminal Section, Second Section.

4. In his speech to the Joint Session of Congress on September 20, 2001, President Bush stated: "Americans are asking, 'Why do they hate us?' They hate our freedoms – our freedom of religion, our freedom of speech, our freedom to vote and assemble and disagree with each other" (see Roy 2001).

5. Bush also stated: "Every nation has a choice to make. In this conflict, there is no neutral ground. If any government sponsors the outlaws and killers of innocents, they have become outlaws and murderers themselves. And they will take that lonely path at their own peril." (Address to the Nation Announcing Strikes against Al Qaeda Training Camps and Taliban Military Installations in Afghanistan, October 7, 2001).

6. Ibid.

7. As Rancière notes, "The word *ethos* signifies two things: ethos is the dwelling and the way of being, the way of life corresponding to this dwelling". Therefore, before signifying a certain norm or rule of morality, ethics is "the kind of thinking that establishes the identity between an environment, a way of being and a principle of action" (2006a: 2).

8. According to Rancière, *Dogville* (Lars von Trier, 2003) and *Mystic River* (Clint Eastwood, 2003) provide clear examples of the ethical turn (2010a: 115).
9. Enzo Barboni's well-known Italian Spaghetti Western comedy film series, which includes *They Called Me Trinity* (Lo chiamavano Trinità 1970) and *Trinity Is Still My Name* (*Continuavano a chiamarlo Trinità*, 1971).
10. Campbell applies the term to films produced after World War II to demonstrate that, far from dead, as Deleuze had argued, post-Westerns continue to live on in the present by taking new forms and settings (2013: 309).
11. Ley 6/1998, de 13 de abril, sobre régimen del suelo y valoraciones. [Disposición derogada]. Publicado en: « BOE » núm. 89, de 14 de abril de 1998.
12. In *Spaghetti Westerns: Cowboys and Europeans from Karl May to Sergio Leone*, Christopher Frayling (1998) argues that the Spaghetti Western functions as "critical cinema" in relation to classical Hollywood Western cinema and its ideology and myths. According to Frayling, Spaghetti Westerns "employ two main strategies of critical cinema through their use of the Hollywood genre: shocking the spectator into questioning what he or she is seeing, and compelling the spectator into recognizing ideas to think about after the film is over" (1998: xxiii).
13. Urbizu explains that this scene was inspired by John Boorman's film *Point Blank* (1967) (in Heredero 2011: 35).
14. For Norton, Trinidad's ability to cross boundaries and his easy use of guns and fisticuffs identifies him with the cinematic American vigilante, validating his sacrifice for the Spanish nation he dies trying to protect (2015: 181).

6

Policing the City: Haptic Visuality in *Grupo 7*

The Universal Exposition aims to convey to its visitors the idea of the diversity and the richness of the cultures that man has created, the idea of the innovative capacity of the human being, and also the idea of tolerance, of respect for plurality, of international solidarity. . . . The bridges that unite the island of La Cartuja with the city of Seville are therefore splendid symbols of what Spain wants to transmit about itself—[symbols of] the union of the past and the future, of art and technology, and of places of meeting for our visitors, with whom we will share friendship and dialogue. . . . The Universal Exposition of Seville is now inaugurated.

Former King of Spain Juan Carlos I[1]

This chapter examines the relationship between justice, aesthetics, and the "right to the city" through the 2012 Spanish crime thriller film *Grupo 7* (*Unit 7*) directed by Alberto Rodríguez.[2] Based on real events, the film follows a narcotic police unit tasked with cleansing the tourist downtown of Seville of prostitution and drug trafficking in order to convey an image of modernity for the Universal Exposition of 1992 (Expo '92), an event organizers hoped would turn Seville, and by extension Spain, into a global showcase. Organized under the theme "The Age of Discoveries," the Expo was in part designed to commemorate the 500th anniversary of Christopher Columbus' "discovery" of the Americas. The Expo was also intended to act as a catalyst for the physical and economic transformation of the city of Seville, which had experienced high unemployment and underdevelopment in the early 1980s.

Spain spent more than $10 billion on Seville's new urban infrastructure, including the construction of seven high-tech new bridges over the Guadalquivir river, a high-speed train (AVE) connection between Madrid and Seville, a new airport, and a new railway station (Riding 1992).[3] The film uses real archival footage chronologically to document the physical transformation of Seville, moving from images of urban planners and architects gathering around maps of the city to choose the site of the event in 1987 – the year that the new General Urban Development Plan (*Plan General de*

Ordenación Urbana) for the Expo was approved – to images of the former King of Spain, Juan Carlos I, inaugurating the magnificent architectural structures on April 20, 1992, when he uttered the celebratory words cited in the epigraph to this chapter. The Summer Olympics in Barcelona and the designation of Madrid as the Cultural Capital of Europe also occurred in 1992. Spain wanted to show the world that it had left the legacy of Franco's dictatorship behind and that the economic and political process of modernization and Europeanization, which had begun with Spain's entry into the European Economic Community in 1986, had culminated.

The title of the film refers to the name of the special police unit that was created to clean up the historic city center of Seville of drug trafficking during the five years preceding the inauguration of the Expo. Four police officers comprise the unit: Ángel (Mario Casas), an ambitious young cop who fails his detective test because he suffers from diabetes; Rafael (Antonio de la Torre), a violent officer whose brother has died of a drug overdose, a casualty of the heroin addiction epidemic that ravaged Spain in the 1980s; Mateo (Joaquín Núñez), a witty womanizer; and Miguel (José Manuel Poga), a homophobe who has an outsize (and unreasonable) fear of HIV/AIDS infection. Although fictional, the two protagonists of the film, Rafael and Ángel, evoke the leaders of two actual anti-narcotics units of Brigada de Seguridad Ciudadana (Grupo 6 and Grupo 10, of the Seville Brigade for Citizen Safety) who received the same assignment at the end of the eighties and used similar extra-legal methods (theft, torture, and drug dealing) to succeed in their mission (Petit 2012).[4] Like the members of Grupo 7 in the film, the two leaders of the actual anti-narcotics units were investigated by internal affairs, accused of misappropriation and illegal possession of weapons, and eventually exonerated of all charges.

The film contrasts the triumphant and celebratory images of the archival footage with the extra-legal methods that the four members of Grupo 7 use to accomplish their mission: theft, drug dealing, threats, brutal beatings, torture, and even murder. As the film invites viewers to experience the violent transformation of Seville, it also traces the corruption, brutality, and impunity concealed underneath the promises of modernity, in an allegory of the real estate bubble and the effects 2008 financial crisis in Spain. By 2012, the year that the film was released, unemployment had reached 24.5%, the highest rate in the European Union, with 51% among young people; hundreds of thousands of families had been evicted from their mortgaged homes; and around a million houses remained unsold or unfinished.[5] That same year, thousands of Spaniards took to the streets to mark the first anniversary of the eruption of the *Indignados*, and to protest the government's new austerity measures, which included social cuts in public education, health care,

and retirement pensions, and labor law reforms against workers' rights.[6] In response to the anti-austerity protests, Interior Minister Jorge Fernández Díaz of the ruling Popular Party proposed to Congress the bill, the Citizen Security Law, dubbed "gag law" (*Ley Mordaza*) by its critics, to criminalize forms of protests that "seriously disturb the public peace." By looking back at the 1980s and 1990s, a period of economic growth based on property development, tourism and urbanization, the film exposes the ways in which the state and the law (through regulations, law enforcement, and the courts) shape the social body, organize relations of power, and distribute the sensory order – meaning who and what is included or excluded and who and what is visible or invisible – in a way that erases difference and dissent from the urban fabric. It shows how the new bridges that were to become symbols of encounter, tolerance, and diversity are reinscribed as instruments of socioeconomic segregation and exclusion. It turns out that making the city "attractive for tourists" entails supposing that low-income residents and marginalized groups and individuals have no right to the new urban landscape.

In this chapter, I read *Grupo 7* within the context of what Dean Allbritton has labeled Spanish "crisis cinema" ("el cine de la crisis"), which refers to films that confront or engage with the devastating effects of the 2008 financial meltdown and the austerity policies: high unemployment, massive foreclosures and evictions, poverty, social exclusion, and the precarization of labor and living conditions (Allbritton 2014: 103).[7] According to Allbritton, crisis cinema portrays its protagonists as "teetering on the edge, facing the shock of being cast off from jobs, homes and lifestyles" and exposes the pain and suffering of living in a state of physical vulnerability and precarity (Allbritton 2014: 104, 102).[8] Crisis cinema thus tells the story of what Germán Labrador Méndez has called *vidas subprime*, that is, the story of those lives that embody and experience in a situation of serious biopolitical risk the conditions originated by the crisis (Labrador Méndez 2012: 570). Allbritton explains that the protagonists of these films are not paralyzed by their precarious condition. Instead, they "find recourse in unorthodox actions that theoretically undermine the institutions that have placed them in such states" and offer "a thin line of hope" in a vulnerable community that unites in its collective suffering (Allbritton 2014: 104). As Chris Perriam and Tom Whittaker remark, crisis cinema does both at once: it provides "a critique of the neoliberal economic policy in Spain, austerity, corruption and fraud," and draws on the wave of indignation and political mobilization of the *Indignados* movement to invite viewers "to think beyond the impasse of the neoliberal order" (2019: 3, 7).

In "Spanish Cinema of the 2010s: Back to Punk and Other Lessons from the Crisis," Núria Triana-Toribio argues that it is necessary to distinguish "crisis cinema" on which Allbritton focuses, which portrays victims of the

crisis directly, from "those films where the crisis is more obliquely present" (2019: 12). She observes that crisis films, which have medium-size budgets and are produced by minor independent producers, "have never received full endorsement of the mainstream hegemonic culture through Goya awards" (2019: 12). In contrast, films in the second category enjoy sizable budgets and are produced by established hegemonic producers, and often become major box office successes and may win the Goya award for Best Film (2019: 12). These include *Vivir es fácil con los ojos cerrados* (David Trueba, 2013), *Blancanieves* (Pablo Berger, 2013), *No habrá paz para los malvados* (Enrique Urbizu, 2011), *La isla mínima* (Alberto Rodríguez, 2014) and *Tarde para la ira* (Raul Arévalo, 2016). All these films set their stories in the past to reflect on a crisis-ridden present (Triana-Toribio 2019: 12). *Grupo 7* does precisely this. It looks back at the years before the economic crash of the mid-1990s to reflect on the failure and consequences of the neoliberal economic model in the present.

In the following, I analyze both the form and the content of *Grupo 7*. The aim is not to interrogate the level of accuracy or truthfulness in the film, but to examine the kind of viewing experience its aesthetic choices create in regards to the production of the urban space of Seville and the right to the city of its dwellers. By grounding its narrative on real events and people, the film informs viewers of the violence committed under the guise of "neutral" urbanization processes. However, as I will show, an exclusive focus on narrative overlooks the ways by which the aesthetic choices of the film shape both the content and the viewers' responses to it. My analysis distinguishes two types of aesthetics in the film. On the one hand, the film uses documentary techniques such as archival footage and panoramic shots to confer a sense of immediate reality and neutrality to the triumphant images of the urbanization of the city. On the other hand, the film uses close-up movements of the camera and extreme close-ups to create a haptic encounter with the violence of the processes of urbanization that the archival footage and the panoramic shots conceal. In putting these two types of aesthetics together, the film goes beyond the physical violence and its effects represented in the narrative and calls for an examination of the structural causes that produce and reproduce the problems of segregation and exclusion, while providing possibilities for resistance.

For these purposes, I have divided the chapter into five parts. First, I analyze the viewing experience the film's aesthetic choices create in regards to the production of the urban space as propounded by Henri Lefebvre. Second, I examine how urban space is regulated, molded, and controlled and the impact that this production has on the people who live in it. Third, I explore the question of who has the "right to the city" and fourth, whether the film

opens up any space for resistance. It will be argued that rather than offering a solution, the film constructs a haptic aesthetic where the viewer's sensory experience of the city inevitably includes the city's suburbs and outskirts, its messiness and noise, dissent and protest, in contrast to narratives of progress and modernization. The chapter concludes by exploring the role of law in the violent processes of urbanization and whether there is a space where spatial justice can emerge.

Mapping the City: The Production of Space

Grupo 7 opens with a series of panoramic panning shots showing different views of a city. Two superimposed big intertitles situate the images in time and space: Seville 1987. The camera then cuts to a montage of a series of archival images that pass almost too quickly to follow: urban planners, technocrats, and decision-makers gather around a map of the city, looking for a piece of land on which to build the new buildings for the Expo '92. A series of aerial shots show La Isla de La Cartuja, a largely empty landscape bordered by the Guadalquivir River chosen to host the Expo. Then, a series of long shots of bulldozers, trucks, and cranes show the city already under construction. An advertising billboard informs viewers that "The city prepares for the world showcase at the Expo '92." The montage closes with an image of the sixteenth-century Carthusian Monastery in ruins on the site. The Monastery, which hosted Columbus before his second trip to the Americas, would be restored and used as the Royal Pavilion – the headquarters of the exhibition. It was there that the former King of Spain gave his inaugural speech.

The second part of the opening title sequence cuts to an extreme close-up of a body in motion, shifting the viewers' attention from the planners of the city to its residents. The camera follows Joaquín (Julián Villagrán), a police informant who guides Ángel through the narrow and labyrinthine streets of Seville searching for Amador (Alfonso Sánchez), the leader of a drug trafficking network. The labyrinthine, chaotic, and fractional space of the city appears in contrast with the ordered, organized, and totalizing image projected earlier through its maps. An over-the-shoulder camera follows Joaquín and Ángel closely, forcing the viewer to experience the physical urban space through the close movements of their bodies. The scene closes with a medium close-up of Ángel looking off-screen. Rather than showing the object of his gaze, the screen turns black. Then, the title of the film *Grupo 7* appears on it.

As I will try to demonstrate based on Henri Lefebvre's theory of the production of space, the film's opening title sequence foregrounds the three "cartographic ways" of looking at the city of Seville and its inhabitants that will guide the viewer's urban experience throughout. First, there is the removed, panoramic gaze of urban planners, cartographers, and technocrats who look

at the city from above, wishing to project their abstract representations of maps, designs, and plans "onto the terrain of lived experience, as blueprints for its material transformation" (Wilson 2013: 367; Lefebvre 1991: 361). Through their distant, panoramic gaze, they reduce the city to a mere flattened visual surface – "that 'world of the image' which is the enemy of imagination" (Lefebvre 1991: 361). From this distant position, they conceive the city "as an empty space, . . . a container ready to receive fragmentary contents, a *neutral* medium into which disjointed things, people, and habitats might be introduced" (Lefebvre 1991: 308, emphasis original). What this neutralizing process produces is what geographer Derek Gregory has described as "decorporealization of space" (1994: 382). The eye and the gaze dominate this space, erasing the marks of the body and its embodied sensations (Gregory 1994: 392; see also Lefebvre 1991: 286; Simonsen 2015).[9] Under its apparent neutrality, this space is produced "to mould the spaces it dominates (i.e. peripheral spaces)"; that is, to reduce, often by violent means, "the obstacles and resistance it encounters there" (Lefebvre 1991: 49). Accordingly, the production of abstract space is ideological because it seeks "to impose itself on reality despite the fact that it is an abstraction" (Lefebvre 1991: 94). Lefebvre identifies such disembodied, visual conception of space as the dominant space of society, that of bureaucracy, wealth, and power.

The second way of looking at the city is the haptic, embodied vision of city dwellers, who look at the urban space from within, experiencing the design of the urban planners while seeking to appropriate the space through their bodies and imagination (Lefebvre 1991: 39).[10] Lefebvre calls this space "representational space": the space that is "directly *lived* and experienced through its associated images and symbols," often linked "to the clandestine or underground side of social life" (Lefebvre 1991: 39, 33). This is the space where spontaneity, creativity, and imagination are possible. Contrary to the abstraction of space, which is "in the head rather than in the body," representational space is "felt more than thought" (Merrifield 2006: 109, 110). Thus, while conceived space is constructed as rational, flat, empty, fixed, and static, representational space is imagined, experienced, alive, fluid, and embodied (Lefebvre 1991: 42).[11] For Lefebvre, this lived space opens up the possibility of counter-spaces that may escape the totalizing gaze of its planners and may offer resistance to representations, meanings, values, and uses imposed upon them (1991: 349; Zieleniec 2016; see also de Certeau 1984: 92–93). According to Lefebvre, resistance starts with the body because "each living body is space and has its space: it produces itself in space and it also produces that space" (Lefebvre 1991: 170; Stewart 1995: 615). As he contends, space cannot be reduced to a simple container to be filled with bodies and objects (1991: 170). Space is rather a "social product" – the product of a specific

society – and, as such, its production is always provisional and therefore subject to contestation (Lefebvre 1991: 26).

In addition to the conceived space and the lived space, there is a third distinctive way to produce space shown in the title sequence: the physical, material space of the city. This material space shapes and transforms the practices (perceptions and experiences) of those who occupy it, by means of its physical arrangement, for example, labyrinthine and narrow streets, alleys, and pathways. Lefebvre argues that under global capitalism, spatial practices are associated with "perceived space": how people perceive material space affects the way in which they use it and how they interact with others within it. In other words, perceived space creates certain concrete spatial practices by which people inhabit and use space. Spatial practices weave together the otherwise separated spaces of "daily reality (daily routine) and urban reality (the routes and networks that link up the places set aside for work, 'private' life and leisure)" (Lefebvre 1991: 38). In so doing, they ensure some degree of cohesion, competence, and performance (Lefebvre 1991: 33). Indeed, "people make sense of their daily actions by having an understanding of how things and social relations are structured in space" (Zieleniec 2007: 73). Spatial practices, therefore, refer to the implication of space "in processes of habituation, of people, places and practices" (Zieleniec 2007: 73).

Lefebvre argues that any meaningful examination of space must address the question of its production in three different but interdependent levels: *representations of space* (conceived space), *representational spaces* (lived space), and *spatial practices* (perceived space) (Lefebvre 1991: 116). Only by integrating them is it possible to grasp the complexity of the production of space – how it is molded, organized, classified, regulated, and controlled, as well as its impacts on the lived experience of those in it. The rest of the film alternates between these three ways of mapping the city – the distant, panoramic gaze of planners, the haptic, embodied experience of its users, and the physical, perceived space of the city – shifting viewers' attention from what exists in space to the actual processes that produce it. Therefore, the emphasis of the film is not on space as such – space understood as an empty container, but on the dynamic processes that are at work from the moment urban planners conceive the city of Seville as an abstract representation, to the embodied experience of Seville residents, to the moment of its material concretization in reality. By examining these processes, my analysis seeks to show how space in the film does not function as a mere neutral background for the manifestation of different forms of violence (segregation, exclusion, and displacement), but rather how space actively produces and reproduces this violence (Dikeç 2001: 1792–1793; 2002: 96).[12]

Policing the City

From its first shots, the film invites viewers to follow police action closely "on the ground" and to adopt the officers' perspective. Right after the opening title sequence, a medium close-up shows Mateo, Rafael, and Miguel inside their patrol car monitoring Ángel's and Joaquín's movements through the narrow streets of the city. Through the windshield of their patrol car, viewers can see a scarred urban space, deteriorated buildings, high concentration of poverty, drug trafficking, homelessness, and prostitution. In the unit's eyes, the people who occupy this space – sex workers, drug dealers, homeless people, and drug addicts – are subjects of surveillance and possible sources of danger. Joaquín points to the building where the drug dealer Amador is hiding in, and a foot chase ensues between Ángel and Amador. A handheld camera follows both from the streets of the city to the inner space of its buildings, showcasing the miserable living conditions of those who occupy them – low-income families, abandoned children, squatters, and drug addicts. Exterior and interior space thus mirror each other. The chase sequence culminates on the rooftop of the majestic but derelict Royal Artillery Factory, a Sevillian iconic building from the sixteenth century situated in the working-class neighborhood of San Bernardo. San Bernardo is a historically marginalized neighborhood that was degraded until the General Urban Development Plan targeted it in preparation for the Expo due to its central location.

The first scene of violence in the film takes place on the rooftop of this iconic building as the officers confront Amador. The spatial arrangement of the scene is worth noting. A series of medium and extreme close-ups show a brutal confrontation between Rafael and Amador in the foreground: Rafael arrives to the rooftop where Amador is holding a knife to Ángel's throat. Rafael frees Ángel by violently beating Amador. Then, Rafael takes Amador by his feet and hangs him from the roof. Finally, Rafael threatens to drop Amador if he does not promise never to return to the city center. The viewer understands in this moment that Grupo 7 has been tasked with establishing a clear spatial demarcation between the city and the periphery. In the background, the silhouette of a multitude of construction cranes is visible at all times, pointing to the distant but imminent physical transformation of the city. As the process of urbanization expands, high rise towers, magnificent bridges, and pavilions for the Expo '92 will replace them. This is what geographer and social theorist David Harvey calls a process of "creative destruction" (Harvey 2013: 16). As he notes, such processes generally disadvantage those already disadvantaged, and the new structures bear "no trace of the brutality that permitted their construction" (Harvey 2008: 34). As the film shows, the police members of Grupo 7 are actively implicated in this violent process.

The spatial arrangement of the scene suggests that police violence should not be viewed in isolation but deeply intertwined with the processes of urbanization, which the preceding montage showing the planning of the city highlighted. As Lefebvre notes, violence, in this case, does not stem from an external force intervening aside from the urban planner's rationality. Rather, the violence "manifests itself the moment any action introduces the rational into the real, from the outside, by means of tools which strike, slice and cut" (Lefebvre 1991: 289). Although Lefebvre does not define violence, it seems evident that he is not merely referring to violence such as that Rafael perpetrates against Amador. Rather he refers to what Slavoj Žižek identifies as the "'objective,' systemic, anonymous" violence inherent in the economic and political systems (Žižek 2008: 13, 9).[13] As Lefebvre puts it, "*there is a violence intrinsic to abstraction*" (Lefebvre 1991: 289, original emphasis). It seeks to destroy "its own (internal) differences . . . in order to impose an abstract homogeneity" and conceal its systemic violence behind it (Lefebvre 1991: 370, 306).[14] By visually linking the urbanization of the city with police brutality, the film makes visible how the effective production of abstract space – the space of urban planners, developers, and political elites – depends not only on abstract economic forces but also on the coercive power of the state and the police (Butler 2012: 58; 2019: 56; Wilson 2013: 520).

The dependence of urban planning on coercion becomes particularly evident in a later scene in the film in which the members of Grupo 7 capture six men during one of their random roundups in the city center, including Joaquín and Amador. The neighbors, who are watching the roundup from their balconies, complain about the dangers posed by abandoned syringes on their courtyards and about the insecurity of the streets. "A bastard stabbed my son-in-law with a screwdriver!" one neighbor relates. "Scumbags!" yells another. The camera then cuts to an isolated landscape outside the city. Amador is handcuffed in their patrol car while the officers force the other men to strip, throw their clothes to the river, burn their shoes with gasoline, and instruct them to run naked towards the suburbs and to never come back. Rafael returns to the patrol car and brutally beats Amador, telling him he should have stayed away from the center. The scene closes with the image of the back of Joaquín's naked body walking towards the city. Amador's body lies beaten on the ground, and his whimpering can be heard in the background. The state's answer to the neighbors' demand for protection and security is not to address the causes of their problems but forcibly to remove the "problem" to the outskirts of the city to make it disappear from sight. In a city conceived as a showcase, as "an object of cultural consumption for tourists" (Lefebvre 1996: 148), they can no longer be tolerated and therefore must be displaced in order to produce a cityscape that suits the tourist gaze

and conforms to the ends of consumption (Harvey 2008: 38). To ensure this, Grupo 7 divides and organizes the city in a way that produces a hierarchical and homogenous space. Furthermore, the media celebrates the unit's policing strategies, as viewers learn when a close-up of a newspaper shows the headline: "The streets clean: Unit 7 takes down drug dealers." The members of the unit become local heroes.

The nature and range of the policing strategies the members of Grupo 7 use are not only contingent upon their goal of removing drug trafficking from up the city center, but also upon their perceptions of the sexual orientation and gender identity of the people who occupy the city (see Herbert 1997). In other words, people's sexual orientation and gender identity affect how police officers define the city's spatial boundaries of inside/outside, central/peripheral, and visible/invisible, as well as how they enforce these boundaries. In a series of raids, they not only target sex workers, drug users, and drug dealers but also queer and transgender people, who they harass verbally (describing them as "dirty and perverts") and physically. They express a sense of unease and disgust at the mere physical proximity of such people. "Don't touch me, you homo!" yells Miguel to an arrestee, fearing he might have HIV. In the name of public order, the members of Grupo 7 stigmatize LGTBQ people in a way that criminalizes their identities and behaviors. In the eyes of the police, these individuals are dirty and ill, irreconcilable with a clean and healthy city.

By assigning the "problem people" to their "proper" place in the hierarchal order of the city – the suburbs, the members of the unit fulfil the ultimate goal of the planners of the city (Dikeç 2002: 94–95): to reduce the lived space of the city to a spatial abstraction, a space defined as the entirety of places, functions, and identities and whose principle is saturation, that is, the absence of any void or supplement (Rancière 2010b: 36; see also Dikeç 2016: 92). Policing therefore not only refers to the repressive force of police officers but also to what Rancière calls the "distribution of the sensible": "the system of self-evident facts of sense perception that simultaneously discloses the existence of something in common and the delimitations that define the respective parts and positions within it" (Rancière 2004b: 12). The production of abstract space thus involves both a symbolic way of conceiving the city and its concretization in material reality (Dikeç 2016: 90–91; Wilson 2013: 374). Abstract space conceals and perpetuates the relations of domination and segregation through this double process (symbolic and concrete). This raises the question of whether there is a space for resistance and where it might be located.

The Right to the City

Despite the pressures of the abstract, conceived space towards homogeniza-
tion, a totally "saturated society" can never be completed. As Lefebvre (1996:
156, emphasis added) states:

> Between the sub-systems and the structures consolidated by various means
> (compulsion, terror, and ideological persuasion) there are holes and chasms.
> These voids are not there due to chance. They are the places of the possible.
> They contain *the floating and dispersed elements of the possible*, but not the
> power which could assemble them. Moreover, structuring actions and the
> power of the social void tend to prohibit action and the very presence of
> such power. The conditions of the possible can only be realized in the
> course of a radical metamorphosis.

The "floating and dispersed elements of the possible" to which Lefebvre refers
to are precisely the "problem people" that the homogenizing forces of the
state and the police have expelled from the city because they are "no longer
convenient or useful" to the totalizing system (Merrifield 2017:16). They
are the "residues," the remainders that do not fit the whole and need to be
discarded (Lefebvre 1996: 152–153; Merrifield 2017: 16). For Lefebvre, the
power to create the conditions of the possible does not lie in the voids that
scape the control of the system, but with the residues themselves, through
their capacity to join forces and mount a counterattack or "revolutionary ini-
tiative" against the established order (Lefebvre 1996: 154). Only by joining
forces will they be able to break free from the totalizing logic of homogeniza-
tion and put an end to the segregation directed against them. This collective
power of the excluded to reclaim their own space is what Lefebvre calls the
"right to the city."

The "right to the city" for Lefebvre "cannot be conceived of as a simple
visiting right or as a return to traditional cities. It can only be formulated as a
transformed and renewed *right to urban life*" (1996: 158, emphasis original).
Against the conceived city of urban planners and technocrats, who regard
the "urban" primarily as space to be owned, sold, and consumed, Lefebvre
envisions the "urban" as "a mental and social form, that of simultaneity, of
gathering, of convergence, of encounter (or rather encounters)" (1996: 131).
In other words, the urban space prioritizes lived experience and use-value
over profit and exchange-value (Lefebvre 1996: 148). This is why excluding
certain groups of people and individuals from the urban space also implies
"exclude[ing] them from civilization, if not from society itself" (Lefebvre
1996:195). The right to the city for Lefebvre is not merely an individual
legal entitlement to inhabit the city (Madden and Marcuse 2017: 32). Nor

is it a natural or a contractual right (Butler 2009: 325). Instead, the right
to the city "manifests itself as a superior form of rights: . . . The right to the
oeuvre, to participation and *appropriation* (clearly distinct from the right to
property)" (Lefebvre 1996: 174, original emphasis). The right to the city is
thus the right to shape and produce the urban space (center and periphery) as
one's own (Merrifield 2017: 14). It legitimizes both the refusal to be expelled
by the discriminatory and segregative powers of the state and the market
(Lefebvre 1996: 195) and "the right to be different," that is, "not to be clas-
sified forcibly into categories which have been determined by the necessarily
homogenizing powers" (cited in Dikeç 2001: 1790). Lefebvre insists that
"residues" cannot reassert their right to the city nor their right to be different
without producing their own space. Nothing and no one can ever avoid what
he calls a "trial by space" (Lefebvre 1991: 416). As he puts it:

> It is in space, on a worldwide scale, that each idea of "value" acquires or
> loses its distinctiveness through confrontation with the other values and
> ideas that it encounters there. [The residues] cannot constitute themselves,
> or recognize one another, as "subjects" unless they generate (or produce) a
> space. Ideas, representations or values which do not succeed in making their
> mark on space, and thus generating (or producing) an appropriate mor-
> phology, will lose all pith and become mere signs, resolve themselves into
> abstract descriptions, or mutate into fantasies. (Lefebvre 1991: 416–17)

With the notion of "trial by space" Lefebvre underscores both the capac-
ity and the need of the residues to resist the established order of the city
and to produce "a counter-space" that challenges its legitimacy. In doing so,
"residues" become the agents and producers of their own lived space and not
the objects of manipulation and calculations of planners and technocrats. The
urban is thus the *oeuvre* of its inhabitants (Lefebvre 1996: 117). It is a "space
of 'subjects' rather than of calculations" (Lefebvre 1991: 362). For Lefebvre,
the right to the city "does not abolish confrontations and struggles" (1996:
195); just the contrary, it remains a potent source of resistance and possibility
(Vasudevan 2017: 47).

Over the last two decades, urban policymakers and activists alike have
invoked Lefebvre's notion of the right to the city with the goal of encouraging
reforms in the legal order to create more inclusive and just cities. Brazil was
early to institute this notion, adopting the City Statute (Federal Law Number
10.257) guaranteeing urban-dwelling "the right to sustainable cities, under-
stood as the right to urban land, to housing, to environmental sanitation,
to urban infrastructure, to public transit and public services, to work and to
leisure, for present and future generations" in 2001. In 2004, after the World
Urban Forum held in Barcelona, Spain, the World Charter of the Right to

the City was adopted "as an instrument intended . . . as an aid in the process of recognition of the right to the city in the international human rights system."[15] In 2005, UN-HABITAT and UNESCO affirmed this right in their joint project, "Urban Policies and the Right to the City," with a mission to "reduc[e] poverty by identifying good practices and initiatives in law and urban planning." In 2007, a network of grassroots organizations established *The Right to the City Alliance* in the US as "a unified response to gentrification and a call to halt the displacement of low-income people, people of color, marginalized LGBTQ communities, and youths of color from their historic urban neighborhoods." The Alliance promotes "an idea of a new kind of urban politics that asserts that everyone . . . not only has a right to the city, but as inhabitants, have a right to shape it, design it, and operationalize an urban human rights agenda."[16] The International Meeting on the Right to the City took place in São Paulo, Brazil in 2014, establishing the Global Platform for the Right to the City as a civil society initiative with the purpose of "building an international movement for the Right To The City." Most recently, the National Human Rights Cities Alliance, an initiative of the US Human Rights Network, has been established in order "to strengthen relationships among human rights city organizers . . . to advance human rights in the places where people live."

Some scholars argue the right to the city has lost the radical potential of Lefebvre's original idea (Soja 2010; Purcell 2002; de Souza 2010; Purcell 2013; Butler 2019). In their view, the right to the city has been reduced to a global "catchphrase" (Purcell 2002: 100) running the risk of becoming "useless for critical-radical purposes" (de Souza 2010: 319); to a mere slogan for protests and social movements fighting against neoliberal urbanization worldwide – (i.e. gentrification, urban speculation; Vasudevan 2017);[17] or to "the status of a positivist juridical right in order to position it within a broadly social liberal, distributive rights agenda" (Butler 2019: 60). As these scholars point out, the fact that Lefebvre's right to the city cannot be reduced to any of these features does not mean it lacks substance. The concept of the right to the city draws attention to the capacity of the different bodies inhabiting the city to resist and to transform the given order from below.

The Construction of Urban Space as Resistance

Grupo 7 does not reduce the urban space of Seville to a mere container or backdrop where police action takes place. Nor is space just a passive physical element for urban planners, the state, and the police to mold. Space in the film is also a space of resistance where the residues – those forcibly removed from the city – transform the streets of Seville into a battleground from which they confront the given spatial order and create counter-spaces through which

they can reassert their right to the city in the Lefebvrian sense of the term. My analysis identifies three modes of resistance in the film: creative, collective, and physical appropriation of space.

Graffiti as an Aesthetic and Creative Appropriation of Space

The first act of resistance in the film takes place through a graffiti message that appears written on an advertising billboard located in an empty construction site in the Island of La Cartuja. The scene that introduces the message opens with a car arriving at the empty construction site. A static long shot shows the site in detail. At the center, a huge billboard announces the Expo '92 as "Una exposición de todos" (An exhibition of all). In the background, the Guadalquivir River separates the construction site from the city. On the left, one of the new bridges traversing the river is visible. On the right, concrete pillars and canals dug for infrastructure indicate that such promise of unity and inclusiveness is in the making. As soon as Ángel and Joaquín exit the car, Ángel asks Joaquín to look at the billboard and read what is written on it aloud. Joaquín reads aloud the announcement of the Expo. Ángel tells him to read instead the spray-painted graffiti message written above it, which reads "Ángel niñato ya te cojeremos [sic] maricona." (Ángel, punk, we'll get you, faggot.) When Ángel inquires about the authors of the graffiti, Joaquín informs him that it could be "any junkie since there are plenty around" and that there are similar graffiti "everywhere." Ángel instructs him "to find out who has written this." Joaquín replies that he "doesn't want to do this anymore" because "one of these days they are going to blow my head off." The scene closes with an image of the car leaving the construction site. This time Joaquín stands in front of the billboard watching as Ángel drives away, apparently having abandoned him to the errand he is reluctant to undertake.

Since criminologists, James Q. Wilson and George L. Kelling (1982) introduced the "broken windows" theory, which claims that social disorder, such as graffiti, broken windows, drunkenness, prostitution, if not regulated, encourage more serious and violent crime, graffiti has often been associated with "antisocial deviant behavior" and taken as a "symbol of community decline" (Austin 2002; Zieleniec 2016; Young 2012; Young 2014: 102–9).[18] This theory has been used worldwide to legitimate aggressive policing strategies such as "Zero Tolerance" policing, which gives no mercy for the most minor infractions committed in public space (Waquant 2006: 104). "Broken windows" has also been used to justify the exercise of police discretion as how to enforce the law, often outside due process and equal treatment (Young 2014:109), and to provide judges with increased sentencing powers (Young 2012: 309; Mitchell 2003: 201).

In line with scholarly arguments that counter "broken windows" by

viewing graffiti as a creative form of resistance that challenges the regu-
lated structure of the city and constructs alternative ways of understanding
it (Ferrell 1995; Snyder 2009; Young 2014; Bengtsen and Arvidsson 2014;
Zieleniec 2016), I find that the graffiti on the billboard functions as an act
of resistance against the homogenizing forces of urbanization. At the level
of content, the graffiti articulates a direct threat to Ángel and his aggressive
policing practices. The insults "maricona" and "niñato" imply a lack of man-
liness and weakness, deeming him deficient and unsuited for policing (see
Silvestri 2017: 294). Fearing the stigma of being publicly marked as fragile
and vulnerable, Ángel becomes in subsequent scenes more physically violent
in an attempt to reassert his masculine authority and restore his reputation.[19]

At the aesthetic level, the graffiti acts to resist the conceived city and its
logic of visibility. The two messages of the billboard expose two conflicting
ways of understanding the city. On the one hand, the very presence of the
graffiti, with the spelling mistake suggesting the marginalized position of the
writer, undermines and contradicts the official message of the Expo promis-
ing "an exhibition of all." By inscribing themselves – making a mark – in a
space that seeks to exclude them, the graffiti writer challenges the "aesthetics
of authority" (Ferrell 1995: 37) that regulate and control what is visible
and invisible within the urban space. Through this unauthorized aesthetic
intervention, the graffitist asserts his or her agency and demonstrates the
impossibility of total control of the city.

At the spatial level, the construction site of the graffiti is also relevant.
Even though Joaquín informs Ángel that there are similar graffiti everywhere
in the city, the film focuses on the graffiti written on the billboard located in
the Island of La Cartuja, where the Expo will take place. For viewers familiar
with the legacy of the Expo '92 for the city of Seville, the graffiti might func-
tion as a comment. Released in 2012, the 20th anniversary of the Expo, the
film invites viewers to draw connections between the inhospitable image of
La Isla de La Cartuja under construction in the 80s and the state of the island
today. Despite the promises of the Expo's planners, the island remains a
disjointed space, what journalist Carlos Mármol (2017) calls a "desolate post-
card" where broken sidewalks, weeds between pavers, and rusted furniture
reflect years of abandonment and negligence by the public administrators and
their failure to reuse its infrastructures.[20]

The Suburbs as Spaces of the Possible: A Collective Appropriation of Space

Resistance also emerges in the suburbs, when inhabitants decide to claim
their right to the city and fight back against the brutality of the members
of Grupo 7. The first time that the suburbs appear on the screen is halfway
through the film when the unit decides to enter the fictional "Polígono de

los Canarios" where those expelled from the city center are exiled.[21] In a city conceived as a showcase, the suburbs function as warehouses, as "disposal sites for depositing the wasted lives of marginalized urban inhabitants who . . . have no real value within the circuits of capital that constitute the new global economy" (Murray 2008: 37; see also Mahmud 2010). The members of Grupo 7 describe the suburbs as a space beyond police control, such as when Ángel tells an informant, "We cannot enter the suburbs." This places their inhabitants at the margins of legality (Mahmud 2010). Positioning the suburban dwellers as outlaws legitimizes the lack of institutional support and protection. It also justifies (extra-legal) intervention by the police. The suburbs are the "'Invisible City' . . . outside the boundaries of official scrutiny and institutional governance. Those who occupy these marginal sites are 'both invisible and too visible'" (Murray 2008:17). Throughout the film, the police commissioner turns a blind eye towards the aggressive policing strategies of the members of Grupo 7, suggesting the ends justify the means regardless of legality and abuse.

However, two scenes that mirror and reinvert the earlier scenes of violence at the city center show that Grupo 7's approach backfires. The first of the two follows a montage of archival footage indicating it is 1989. A series of long shots of construction sites crowded with cranes, trucks, and bulldozers links the arrival of Grupo 7's patrol car in El Polígono de Los Canarios with the destructive processes of urbanization.[22] A handheld camera closely follows the unit through narrow winding stairs leading to the apartment where they suspect Amador is hiding. A second foot chase ensues. Ángel chases Amador down the drainpipe of the building until he falls to the ground – inverting the opening chase sequence and foreshadowing the fall of the unit that follows the rise to the rooftop. After brutally beating Amador, Ángel finds himself standing alone in the middle of a courtyard of a group of building blocks. Much like the earlier scene, all the neighbors are watching, but this time they criticize the brutality. Shouting from their windows instead of the balconies of the earlier scene, the neighbors demand that Ángel stop beating Amador and offer all sorts of insults. When one of the neighbors fires a shot at him, Ángel raises his gun and asks the shooter, "Where are you?" A fast-moving camera circles around the officer revealing the entire space, now filled with empty windows and silence. The shooter can be anywhere. Every neighbor can be a potential enemy. Ángel shoots to a window, then a child appears in it, who throws his gun at him. Ángel screams: "Come out and look! We are Unit 7! Nobody sells drugs here!" No one is there to watch his vain display of authority except Rafael, who is still in one of the buildings following the chase. Rafael looks down at Ángel pityingly from one of the windows of the apartment block. Ángel has not yet recognized that the unit's policing

practices do not work in this space. They do not control space; here, space controls them. [23]

The second scene suggesting the demise of the unit occurs when the men decide to go back to the suburbs. Amador and his men have brutally beaten La Caoba (Estefanía de los Santos), a sex worker who is Mateo's lover and informant, leaving her on life support. Guided again by Joaquín, Grupo 7 traverses narrow pathways, vacant lots, and abandoned houses filled with syringes. This time, however, Joaquín betrays the unit and leads its members to a trap where Amador and his men make them confront the entire community of neighbors (women, children, elders, mothers with their babies). A 180-degree shot shows all the neighbors standing together around them. Mirroring the earlier scene in which Grupo 7 had arrested Joaquín and five others, Amador instructs them to take their clothes off. He instructs Rafael, Mateo, and Miguel to put their hands on their head and walk on their knees. He forces Ángel to crawl all fours like a dog. Finally, they are told to leave their neighborhood naked and to never come back. In contrast to Ángel's frustrated exhibition of power that had no spectators, all the suburban dwellers participate in Amador's spectacle. In a scene that oscillates between celebration and violence, playfulness and revenge, the community all laughs at the members of the unit, insults them, and spits on them. An elderly woman beats them, and a child rides on Ángel's back. A neighbor tells Miguel he is HIV-positive, then bites him, taunting, "That's how you get it!" mocking Miguel's terror of AIDS infection. This scene of "collective festivity" creates a sense of empowerment through which the neighbors reassert themselves, demonstrating that, despite the pressures towards homogenization, differences can never be totally eliminated.

Walking through the City: Haptic Appropriation of Space

While Joaquín played a part in engineering the unit's scene of humiliation, he individually creates the third act of resistance through his physical movements. A "residue," in his daily life, Joaquín is profiled and patrolled, chased out and arrested, forcibly removed from the center and displaced to the periphery (Merrifield 2017: 16). No matter where he wanders, he faces a wide range of interdictions that regulate his movements and restrict his behavior. Excluded from everywhere, he becomes a "floating element" forced to be constantly on the move (Murray 2008: 17): moving from the narrow and labyrinthine streets of the city center, to the abandoned lots and vacant buildings at the outskirts of the city, to the secluded passages and inner courtyards of the suburbs. Despite the pressures of abstract space to fix boundaries and regulate lived space, Joaquín is able to circumvent the rules and boundaries imposed upon him and move in ways that scape the system's totalizing

gaze. He manages to take shortcuts and detours that are "not determined or captured by the systems in which they develop" (see de Certeau 1984: xviii). This ability allows him both to return to the city center whenever he wants as well as to lead the members of Grupo 7 into Amador's trap. In this way, Joaquín manages to transgress, from within, the abstract policed space, and to re-appropriate it in the midst of the repressive police violence. In doing so, he demonstrates that he is able to produce his own alternative lived space.

Through Joaquín's movements, the film invites viewers to navigate the entire city, to move from place to place, not as a voyeurs who observe the city from above or as visual *flâneurs*, but as ordinary practitioners, who live down below (de Certeau 1984: 93). The viewer is immersed in the streets of the city and necessarily engaged in a haptic spatial experience. The haptic, according to Giuliana Bruno, is "the measure of our tactile apprehension of space, an apprehension that is an effect of our movement in space" (Bruno 2018: 250). As Bruno argues, the distant gaze cannot explain space, "it is the tactile sense that extends surface into space" and makes its corporeal and kinesthetic exploration possible (Bruno 2018: 252; see also de Certeau 1984: 97).[24] Through Joaquín's corporeal immersion in the streets of the city, the film creates a haptic aesthetic that brings distant people and things into proximity (Paterson 2007: 1). This proximity enables viewers to come into contact with the city's suburbs and outskirts, messiness and fissures, uneven surfaces and textures, differences and contradictions, that the logic of visibility of planners brushes off, and hence fails to capture.[25] Contrary to the logic of visuality that flattens space and empties it of its bodies, haptic aesthetics eliminates the separation between body and space and creates instead "an immediate relationship . . . between the body's deployment in space and its occupation of space" (Lefebvre 1991: 170). As Lefebvre points out, the body that occupies space is not a general or abstract sense of corporeality, but a specific body "capable of indicating direction by a gesture, of defining rotation by turning round, of demarcating and orienting space" (1991:170). By exposing how space is produced through the body, haptic aesthetics invite viewers to experience the city, not as a fixed abstract map, but rather as a concrete, dynamic lived space.

Conclusion: Law and Space

While *Grupo 7* shows the capacity of the residues to resist the given spatial order and create counter-spaces, a series of precipitating closing scenes appear to suggest the ephemeral condition of these acts of resistance and the tendency of legal forms of control to reassert themselves. First, after their humiliating experience in the suburbs, Ángel and Rafael decide to go back to restore their honor by murdering Amador. The next scene jumps directly to

the police commissioner's complaints about their methods, to which Ángel responds that the authorities always knew what Grupo 7 was doing. Images of Juan Carlos I proclaiming the official inauguration of the Expo follow. Then, balloons are launched skyward, thousands of doves are released, puffs of colored smoke spread, spectacular fireworks illuminate the city, and a series of long shots show the magnificent pavilions and infrastructures in 1992. The last scene of the sequence opens inside the courtroom, where a jury acquits the members of Grupo 7 of wrongdoing in the line of duty. By exonerating police brutality, the verdict turns away from the protection of the rights of the most disadvantaged and instead endorses violent and exclusionary spatial strategies. In this way, the legal system does not limit the violence of the abstract space but acts as its accomplice.

The conclusion of the film raises important questions: Is the role of law in the processes of urbanization to legitimize, and thus conceal, the violence of abstraction? Does this complicity entail the relegation to the margins of the residues and (their acts of) resistance?

As the film illustrates, urban planning, regulations, law enforcement, and the court – all instruments of law – are actively involved in maintaining and reproducing the exclusionary practices of homogenization, fragmentation, and hierarchical ordering that characterize abstract space (see Butler 2012: 79; Butler 2019: 57). Yet, as Chris Butler argues, the fact that law plays a role in the violent processes of abstraction does not mean that law should be reduced to one-sided caricatures of its coercive, constraining, and manipulative role (2012: 79). Rather, law should be understood as "spatialized and materially carried by bodies as they engage in the practices of everyday life" (2019: 64).[26] In this way, multi-directional pressures operated through the resistance of these bodies, which challenge the one-directional assertions of legal authority, create law (2019: 64). If law is thoroughly spatial, the intervention that the legal order makes in space cannot be viewed as the imposition of coercive power on a passive "neutral space." As Lefebvre argues, and the film also illustrates, space is at the same time an ensemble of relations, interactions, and networks that create opportunities for "fresh actions to occur, while suggesting others and prohibiting yet others" (Lefebvre 1991: 73; see also Butler 2009: 321).[27] Accordingly, the relation between law and space is not unidirectional but mutually constitutive (2009: 316).[28] In other words, as Butler writes, law is simultaneously "a tool of the state in its strategies of spatial production, and . . . a politically contested body of spatial representations" (2009: 327). For Butler, this mutual relationship between law and space allows spatial justice. Drawing on Lefebvre's relational theory of space, Butler conceptualizes spatial justice as a moment of rupture through which challenges to law's abstraction may be expressed (2019: 51). A crucial

aspect of this "moment" is its capacity to rupture the routines of everyday life and "reconfigure the spatial relations between bodies caught up within it" (2017: 127). However, spatial justice cannot be understood as a utopic, pure moment of re-appropriation of space, because such interpretation would fetishize this moment as a miraculous solution for the violence of abstraction (Butler 2019: 63–64). On the other hand, the attempt to project the moment of justice as "absolute" is "destined to fail," which grants the quest for justice a certain tragic character (Butler 2017: 124; Butler 2019: 63). Caught up between the utopian and the tragic, for Butler spatial justice can only emerge from within the bodily rhythms and the material and spatial relations of everyday life, all the while opening them to their transformative possibilities (2017: 120, 127). Moments of spatial justice are hence fleeting: they are marked by an "impossible possibility," namely, that "of the juridical reassembly of spatial relationships amongst bodies inhabiting and appropriating their own spaces" (2019: 64).

As the film demonstrates, despite the pressures of abstract space to reassert forms of control through the coercive power of the state, the police, and the law, the "residues" that do not fit the system can never be totally quieted. "Though defeated, they live on, and from time to time they begin fighting ferociously to reassert themselves and transform themselves through struggle" (Lefebvre 1991: 23). This means that the legal order does not negate the three acts of resistance (aesthetic, physical, and collective appropriations of space) identified in the film, though they remain ephemeral. Rather they persist as alternative counter-spaces to the existing conceived, abstract space, making visible that alternative ways of living in the city are always possible.

* * *

On April 10, 2015, "No Somos Delito" (We Are Not Crime), a platform of over a hundred activist organizations, launched an original form of protest in front of the Spanish Parliament in Madrid to oppose the recently passed "Organic Law on the Protection of Citizen Security."[29] What made this protest distinct from traditional forms was that none of the protesters of the so-called *Ley Mordaza* ("Gag Law") were physically present. Instead, a looped film was projected onto a translucent scrim set up in front of the Parliament building (Wood and Flesher Fominaya 2015: 146). Images of hologram protesters marching with slogans, banners, and placards were synchronized with voice-messages and shouts that thousands of people from all around the world had uploaded on the website "Holograms for Freedom" (hologramasporlalibertad.org), which had been created for the event (Wood and Flesher Fominaya 2015: 146). The size, lighting, and position of the scrim were carefully designed to line up with the street, so that to eyewitness

observers it appeared the protesters were actually present (Blitzer 2015: n.p.). As the organizers of the protest explained, the goal of the protest was to denounce the law as part of the government's attempt "to convert citizens into a type of hologram whose only function is to obey the wishes of those who have reached the heights of the parliamentary system" (nosomosdelito. net). They condemned the law as designed "to target, repress, and silence social movements," particularly the "occupy social movements" that took to the streets of Spain to oppose the austerity measures introduced after the 2008 global financial crisis and the banking bailouts (Wood and Flesher Fominaya 2015: 144).

A defining feature of the anti-austerity movements was the variety of spatial practices employed to re-appropriate public space as the privileged locus of a collaborative and non-hierarchical democratic engagement (Moreno-Caballud 2015; Hayes 2017). For example, protesters occupied *La Puerta del Sol*, the main square in Madrid, and *Plaça Catalunya* in Barcelona (the *15M movement*) for several weeks each, had surrounded government buildings (*Rodea el Congreso*, *Aturem el Parlament*), and staged *escraches*, gatherings of activists in front of the headquarters of political parties or in front of a politician's home. Protesters also occupied private spaces such as bank offices to oppose home evictions (organized by the *Plataforma de Afectados por la Hipoteca/Platform of People Affected by Mortages*) and hospitals to protest against the privatization of public services (the *Marea Blanca/White Tide* of health demonstrations). As scholars analyzing these movements have pointed out, through these occupation practices protesters did not simply mobilize against the effects of the austerity measures; they also demonstrated the ability of people of all ages, social classes, races, and political ideologies to come together in a common space and produce a "counter-space" (Lefebvre 1991: 382) – that is, a space for resistance that questions "the very public character of the space" (Butler 2011: n.p.; Douzinas 2012; Zevnik 2014; Martín Rojo 2014; Snyder 2015). The protesters' corporeal presence in the public space produces "a legal disquiet, a seething roughness before the law and at its hands" and marks "a rupture in the calm and peaceful sense that everything is as it should be" (Wall 2015: 151, 164).

Such protests prompted the passage of the "Gag Law" by the conservative ruling party. Citing national security, the law introduced strict limitations on the physical occupation of public space. For instance, Article 36.2 identifies as a "serious offense" any unauthorized protest in front of the Spanish Parliament, the Senate, or other government building, even when they are empty. Even peaceful protesters could be deemed to be "disrupt[ing] public safety" and subject to a fine of EUR 30,000. The law also penalizes any form of unauthorized protest near key infrastructures or installations with a fine of

up to EUR 600,000 (Article 36.9); similarly, it allows for fines of up to EUR 30,000 for the occupation of any property, house, or building against the owner's will (Article 37.7). Other measures within the law increase the surveillance of protests. For instance, Article 22 allows police officers to record "people, places, and objects by means of fixed or mobile video surveillance cameras." Articles 16 and 20 allow them to carry out body searches without permission. Conversely, the law prohibits the recording of police intervention on the basis that recording police officers could endanger their personal security or that of their families and might put the success of a police operation at risk. Article 36.23 classifies the "unauthorized use of images or the personal or professional information of authorities or members of the Security Forces" as a "serious infringement" of the law.[30] Thus, the law subjects protesters to a regime of visual control that restricts their right to protest, while granting police officers new discretionary powers to surveil and discipline protesters while shielded by invisibility. Moreover, by treating protests as a disruption of the public order, rather than as an expression of political dissent, the law legitimizes police intervention as a form of control of criminality (Bondia García 2015: 175; Estévez 2015: 18; Comisión Legal Sol 2015: 116; Calvo and Portos 2018: 38, 41). As social-movement scholars Kerman Calvo and Martín Portos argue, the law belongs to an increasing range of "technologies of power" that seek to "reframe societal responses to economic uncertainty, labor precariousness and a growing feeling of social injustice as security problems" (Calvo and Portos 2018: 34). In other words, the law frames protests as a problem not because of what they do but because of what they symbolize.

The state's determination to depoliticize public space and criminalize its physical occupation made it necessary for social movements like *No Somos Delito* to imagine innovative forms of resistance. The hologram protest provides a good example of such an alternative expression. By turning protests in person into protests by holograms, the April 2015 demonstration circumvented the law in two ways. On the one hand, by asserting their visual presence in public space through their physical absence, protesters demonstrated their capacity to withdraw and to comply with the law. On the other hand, their projection of protest onto the Parliament building demonstrates their ability to appropriate this legislative space and to reconfigure it virtually as a space of resistance (Escobar López 2016; Boletsi 2018; García Agustín 2017).[31] The hologram protest successfully demonstrated, like the "residues" in *Grupo 7*, that gag laws cannot wipe out imaginative ways of claiming the right to the city.

Notes

1. The translation of the discourse comes from Maddox 2004. For the integral discourse in Spanish see: <http://www.casareal.es/CA/actividades/Paginas/actividades_discursos_detalle.aspx?data=2638> (last accessed June 15, 2020).
2. Co-written with Rafael Cobos, *Grupo 7* won two Goya awards in 2013: Best New Actor (Joaquín Núñez) and Best Supporting Actor (Julián Villagrán).
3. For a detailed examination of the impact of the Expo on Seville see Maddox 2004 and Díaz 2010.
4. Rodríguez has explained that he used files from a 1980s trial of a case of corruption and the newspapers of the time (in Abad 2012).
5. "EU Employment and Social Situation." *Quarterly review.* December 2012. Luxembourg: Publications Office of the European Union, 2013, 90–91.
6. On May 15, 2011, over a hundred thousand Spaniards took to the streets to protest against the neoliberal austerity measures the government had implemented in response to the 2008 financial crisis. (In recognition of that date *Indignados* is also known as the 15M movement.) Marching under the slogans "¡Democracia Real Ya!" (Real democracy now!) and "No somos mercancía en manos de políticos y banqueros" (We are not commodities in the hands of politicians and bankers), protesters expressed their outrage against political and urban development corruption, forced evictions, unemployment, and precariousness. Protesters also demanded a radical change in the Spanish political system and participatory democratic action (Snyder 2015: 3, 11; see also Pereira-Zazo & Torres 2019).
7. Allbritton provides a list of films that he classifies as crisis cinema: *Amador* (Fernando león de Aranoa, 2010), *La chispa de la vida* (Álex de la Iglesia, 2011), *5 metros cuadrados* (Max Lemcke, 2011), *A puerta Fría* (Xavi Puebla, 2012), *Los últimos días* (Àlex Pastor and David Pastor, 2013), *Los amantes pasajeros* (Pedro Almodóvar, 2013), *Ayer no termina nunca* (Isabel Coixet, 2013), and *Murieron por encima de sus posibilidades* (Isaki Lacuesta, 2014).
8. According to Allbritton, "'precarity' seems to most often denote the neoliberal labor practices that have placed citizens in socioeconomic states of vulnerability; vulnerability, in contrast, often speaks generally of a susceptibility to harm, physical or otherwise. In this ideation, vulnerability leads to precarity; that is, if one is vulnerable a priori, one can be placed in a precarious situation" (2014: 102). In the edited volume *La imaginación hipotecada*, which studies the "precariousness of the present" in the context of the Spanish crisis, Palmar Álvarez-Blanco and Antonio Gómez López-Quiñones define the term "precarity" as a "social and geographically determined condition resulting from neoliberal policies, encapsulat[ing] a social and geographically determined condition that is embodied, in a visible way, in a multitude of labor, educational, health,

migration, housing, and salary, but also psychological, affective, and symbolic situations" (2016: 12, my translation).

9. Lefebvre writes: "the senses of smell, taste, and touch have been almost completely annexed and absorbed by sight" (1991:139).

10. As film and media theorist Laura Marks explains, haptic, embodied vision is "an understanding of vision as embodied and material" (2002: xiii).

11. As Benjamin Fraser states, "Lefebvre's approach to space places bodily knowing before intellect, rhythms before blueprints, and life before analysis" (2013: 13).

12. This is what Geographer Mustafa Dikeç calls "spatial dialectics of injustice," which draws attention to the "spatiality of injustice" and the "injustice of spatiality" (2001: 1792). As Dikeç explains, while "spatiality of injustice" provides a spatial perspective to justice that might be used to discern how different forms of injustice manifest *in* space (2001: 1792; 2002: 96), "injustice of spatiality" draws attention to the dynamic social, economic, and political processes that produce and reproduce injustice *through* space (2001: 1793; 2002: 96). Such a dialectic approach departs from an exclusively distributional approach and suggests that injustice, understood as domination and repression, is not a question of distribution in space, but of spatialization itself (Dikeç 2001:1788: 2002: 94–95).

13. According to Žižek, one should resist the fascination of the spectacle of the overt physical violence because, through its visible materiality, it draws attention away from the invisible but destructive forces of global capitalism that secretly sustain and naturalize "relations of domination and exploitation, including the threat of violence" (Žižek 2008: 9–11).

14. As Lefebvre puts it: "Abstraction passes for an 'absence' – as distinct from the concrete 'presence' of objects, of things. Nothing could be more false. For abstraction's *modus operandi* is devastation, destruction (even if such destruction may sometimes herald creation)" (Lefebvre 1991: 289).

15. Other charters have been created with the same goal: European Charter for the Safeguarding of Human Rights in the City (Saint-Denis, 2000); the World Charter for Women's Right to the City (Barcelona, 2004); Montreal Charter of Rights and Responsibilities (Montreal, 2006); Mexico City Charter for the Right to the City (Mexico, 2010); Global Charter-Agenda for Human Rights in the City (Florence, 2011); Gwangju Human Rights Charter (South Korea, 2012), and so on.

16. In the wake of the 2008 financial crisis, social theorist David Harvey took Lefebvre's idea a step further and added that the right to the city is "one of the most precious yet most neglected of our human rights" (Harvey 2008: 23).

17. For instance, the *Platform of People Affected by Mortgages* (Plataforma de Afectados por la Hipoteca) was founded in February 2009 in Spain to stop

evictions, responding to the eviction of over 400,000 home owners during the Spanish financial crisis (2008–2012), and to defend the human (and constitutional) right to housing (Art 32 Spanish Constitution) (see Vasudevan 2017: 51–54).

18. For a critique of the "broken windows" theory see Harcourt, B. E. *Illusion of Order: The False Promise of Broken Windows Policing*, Harvard: Harvard University Press, 2005.

19. For an interesting analysis of the relationship between the masculine body of the main protagonists and the city see Venkatesh 2017. For a study of different manifestations of masculinities in contemporary Spain, see Corbalán and Ryan 2017.

20. An image that evokes the millions of abandoned construction sites, unfinished urban projects, and ghost towns that became the symbol of the crisis.

21. The fictional neighborhood of El Polígono de los Canarios might refer to Seville's neighborhood El Polígono Sur or Los Pajaritos, which were in the late 80s and continue to be the poorest neighborhoods in Spain according to the National Statistics Institute (see de los Santos 2019).

22. This linkage suggests that the suburbs are not self-generated and self-confined spaces external to the processes of urbanization but instead, they are also the product of these processes (Dikeç 2002: 95).

23. I'm grateful to Rubi Vergara-Grindell for drawing my attention to this scene.

24. The haptic exploration of space does not exclude vision but points to the fact that the body is involved (Diaconu 2001: 24; Marks 2002: xiii; Paterson 2007: 86; Bruno 2018: 252). As Deleuze and Guatari remark in *A Thousand Plateaus*, "'Haptic' is a better word than 'tactile' since it does not establish an opposition between two sense organs but rather invites the assumption that the eye itself may fulfill this nonoptical function" (1987: 492).

25. For an insightful analysis of the logic of visuality and its effects see Butler 2012: 57–80.

26. In a similar vein, Andreas Philippopoulos-Mihalopoulos writes, "Law is carried by and within bodies. . . . Bodies embody the law, carry the law with them in their moves and pauses, [and] take the law with them when they withdraw" (2015: 55).

27. As Lefebvre points out, space is "at once result and cause, product and producer" (1991: 142).

28. Philippopoulos-Mihalopoulos emphasizes the mutually constitutive relation between law and space in what he calls the *lawscape*, meaning that the body itself is conditioned by the space around it and every spatial positioning is actually or potentially controlled by law (2015: 175).

29. The Spanish Parliament passed *Ley Orgánica 4/2015, de 30 de marzo, de protección de seguridad ciudadana* in March 2015, with only the votes of the conserva-

tive ruling party *Partido Popular* (PP), led by Mariano Rajoy. Its provisions came into force on July 1, 2015.

30. Amnesty International's report *Spain: The Right to Protest under Threat* (2014) documents and denounces the excessive use of force against protesters by police in Spain.

31. Cf. Sheean 2018. According to Jacqueline Sheean, the hologram film turns the dissenting bodies into "technical objects" that depend on a technological apparatus for agency (2018: 474–476).

Conclusion

In this book, I have focused on the aesthetic frames that mediate the *senses* (i.e., sensory perceptions and significations) of law and justice through a close analysis of a selection of contemporary Spanish films. Moving beyond the narrative and visual approaches dominant in law and film scholarship, I have addressed cinema as a multisensory embodied practice that combines ways of sensing, feeling, being, moving, and thinking. This approach not only enriches the cinematic analysis, but it simultaneously enables us to think of law in aesthetic terms, both as a symbolic way of conceiving the world and as its concretization in material practices.

Each chapter has analyzed the role of law in reproducing hierarchical and exclusionary distributions of the sensible – such as those imposed by war (chapter 1), patriarchal and homophobic orders (chapter 2), neoliberalism (chapter 3), multinational corporations (chapter 4), securitization (chapter 5), and urban planning (chapter 6) – and the resistance and disruption of these distributions from within. The aesthetic approach understands law, not as a disembodied abstraction, but as materialized in actual encounters with other bodies (human and non-human), which are not passive objects of legal regulation, but actively affect and act upon law in reciprocal interactions. The analysis of the aesthetic and the corporeal dimensions of law has enabled us to identify two opposite ways of framing sensory experience and meaning: one presents itself to our senses as given and univocal; the other disrupts the given field of the sensible and demonstrates new forms of perception and signification.

The films analyzed have helped us to examine this double dimension of law within the context of Spain, in particular within the period that spans from Franco's dictatorship (1939–1975), consolidation of democracy after the transition (1976–1978), entry into the European Economic Market (1986), the global financial crisis (2008) and into the present moment of economic, social, and political anxiety. My analysis of films across this historical trajectory demonstrates the persistence of aesthetic frames that seek to construct the sensory world according to the logics of exclusion, homogeni-

zation, fragmentation, and hierarchization. Over the course of almost eight decades, the repressive forces of the state; the dehumanizing and desensitizing practices of torture; the discriminatory logics of patriarchy, hetero-nomativity, and homophobia; the flattening forces of neoliberalism; the unethical practices of corporations; the invasive presence of surveillance technologies; the securitization discourses of fear and anti-terrorism legislation; and the spatial segregation of low-income populations in urban planning and gentrification, enacted these logics. At the same time, each of the films analyzed illustrate the possibility for imagination to seep in and find ways to crack the controlling frames of perception and signification. Such cracks, however small, encourage new ways of sensing and feeling that invite us to question the sense(s) of law and justice taken for granted and to reconfigure them anew.

Looking back at the Spanish post-Civil War years and the resistance of the anti-Francoist guerrillas, Guillermo del Toro's *El laberinto del fauno* illustrates how in war and in torture states and their agents dehumanize the adversary in order to justify acts of physical violence. The film reflects on the visual and narrative frames that mediate our ethical responses to images of torture and death, encouraging a form of ethical witnessing that connects our capacity to respond to the suffering of others to the perception and recognition of the other as human. Continuing with discriminatory frames that hinder the possibility of an ethical encounter with the vulnerable other, I then moved to examine the role that law plays in reducing heterogeneity to uniformity and difference to sameness. Pedro Almodóvar's *Tacones lejanos* called attention to patriarchal and homophobic structures operating within Franco's dictatorship that continued legally in place during the transition to democracy. The film's camp aesthetics invites us to deconstruct law's binary oppositions (masculine/feminine, identity/difference, natural/artificial) and to re-conceptualize law as queer performance. Queering law opens up the possibility of an ethical response to the call of those traditionally excluded from the law.

Chapter 3 identifies the neoliberal logics of consensus that seeks to confine individuals to a depoliticized space of consumption, in the context of the anxieties attending Spain's integration in the European Monetary Union. Álex de la Iglesia's *La Comunidad* illustrates these neoliberal logics by turning a greedy community of neighbors into a police-like order where each member is assigned predetermined roles, functions, and places. Despite the pressures imposed by the community – which functions as an allegory of consensus democracy – I have shown how the most marginal character is able to dis-identify from his assigned place and stage a *dissensus* that paves the way for alternative forms of subjectivity. If *La Comunidad* centers on neoliberal regimes of visibility and their depoliticizing tendencies, Marcelo Piñeyro's *El*

Método pays attention to surveillance and disciplinary technologies of multinational corporations in the context of global capitalism. The film's visual language appears to reproduce the same logic that the narrative criticizes, but the film's use of sound breaks the viewer's complicity in the regime of the visible. By rendering the anti-corporate globalization protest "acousmatic," I have stressed that the film creates a form of sonic resistance that exposes the limits of the visual, while inviting a multisensorial experience of justice.

Enrique Urbizu's *No habrá paz para los malvados* allowed us to map the "violent cartographies" of the contemporary war on terror after Madrid train bombings on March 11, 2004. The state and the media jointly induce the public perception of fear and terror, which justifies a permanent state of surveillance in the name of security. Once again pitting narrative against aesthetics, the post-Western aesthetics of film challenge mythical and heroic narratives presumptively used to justify an infinite "war on terror." While narratively the film seems to suggest that only extra-legal methods employed by rogue police officers like Santos Trinidad can save society, the film's aesthetic confronts the viewer with the thought that justice must exist elsewhere and practiced otherwise. The concluding chapter of the book addresses the 2008 burst of the housing bubble and its devastating aftermath through Alberto Rodríguez's *Grupo 7*, which looks back to an earlier period of massive urban development and gentrification implemented to prepare for the 1992 Universal Exposition in Seville. The film exposes the segregation, displacement, and exclusion that lie behind seemingly abstract processes of urbanization, where low-income residents and marginalized individuals are forcibly removed from the new urban landscape. I have emphasized the creation of a haptic or tactile aesthetics that invites viewers to experience the city not as a map, but as a lived space where spontaneity and imagination can reassert their "right to the city" and spatial justice eventually emerge.

Sensing Justice demonstrates that while justice can never be predetermined in advance, it can nevertheless be sensed in newly constituted aesthetic spaces of encounter and material emplacements.

Bibliography

Abad, C. (2012), "Alberto Rodríguez, director y guionista de 'Grupo 7'," *Revista Fila 7*.

Adam Donat, A., and Alvar Martínez Vidal (2008), "'Infanticidas, Violadores, Homosexuales y Pervertidos de todas las Categorías.' La Homosexualidad en la Psiquiatría del Franquismo" in *Una Discriminación Universal. La Homosexualidad bajo el Franquismo y la Transición*, ed. Ugarte-Pérez, Javier. Barcelona-Madrid: Editorial Egales, pp. 109–138.

Agamben, G. (2001), "Security and Terror," *Theory & Event*, vol. 5, no. 4.

Agudelo Ramírez, M. (2015), *Cine y derechos humanos. Una aventura fílmica.* Medellín: Ediciones Unaula.

Ahmed, S. (2004), *The Politics of Emotion*. Edinburgh: Edinburgh University Press.

Ajuria Ibarra, E. (2014), "History through the Fairy Tale: Mediating the Horror of the Spanish Civil War in Guillermo del Toro's Pan's Labyrinth," in Kathryn Anne Morey (ed.) *Bringing History to Life through Film: The Art of Cinematic Storytelling*, Rowman & Littlefield, pp. 153–170.

Allbritton, D. (2014), "Prime Risks: The Politics of Pain and Suffering in Spanish Crisis Cinema," *Journal of Spanish Cultural Studies*, vol. 15, issue 1–2, pp. 101–15.

Álvarez-Blanco, P., and Antonio Gómez López-Quiñones (eds.) (2016), *La imaginación hipotecada: Aportaciones al debate sobre la precariedad del presente*. Madrid: Libros de acción.

Amnesty International, *Spain - The Right to Protest Under Threat*, April 24, 2014, Index number: EUR 41/001/2014.

Anonymous (1996), "The Rattle of the Thompson Gun. Resistance to Franco, 1939–1952," in "Another Spain. Anti-francoist Action," *Fighting Talk*, issue 15, pp. 24–25.

Arnalte, A. (2008), "Gays en la Picota. Su Representación el los Medios de Comunicación" in *Una Discriminación Universal. La Homosexualidad bajo el Franquismo y la Transición*, ed. Ugarte-Pérez, Javier. Barcelona-Madrid: Editorial Egales, pp. 139–170.

Arroyo, J. (2006), "Review of Pan's Labyrinth," *Sight&Sound*, BFI, vol. 16, issue 12, December 2006, pp. 66–68.

Attali, J. (1985), *Noise: The Political Economy of Music*, Translated by Brian Massumi. Minneapolis: University of Minnesota Press.

Austin, J. (2002), *Taking the Train: How Graffiti Art Became an Urban Crisis in New York City*, Columbia University Press.

Aznar, J. M. (1994), *España. La segunda transición*, Madrid: Espasa Calpe.

Aznar, J. M., and Tony Blair (2000), *El crecimiento, objetivo esencial para Europa*, El Mundo, Tuesday, June 13, 2000. Available at <http://www.elmundo.es/2000/06/13/opinion/13N0025.html> (last accessed June 15, 2020).

Babuscio, J. (1999), "The Cinema of Camp (*Aka* Camp and the Gay Sensibility" in *Camp. Queer Aesthetics and the Performing Subject—A Reader,* ed. Fabio Cleto. Ann Arbor: The University of Michigan Press, pp. 117–135.

Bakan, J. (2004), *The Corporation: The Pathological Pursuit of Profit and Power.* Toronto: Viking Canada.

Balfour, S. (2005), "The Reinvention of Spanish Conservatism. The Popular Party Since 1989," ed. Sebastian Balfour, in *The Politics of Contemporary Spain.* New York: Routledge, pp. 146–168.

Baudrillard, J. (1993), "The Evil Demon of Images and the Precession of Simulacra," in Thomas Docherty, ed., *Postmodernism: A Reader.* New York: Columbia Univ. Press.

Baudrillard, J. (1998), *The Consumer Society. Myths and Structures,* [La Société de Consommation 1970]. London: Sage publications.

Baudry, J.-L. (1974–1975), "Ideological Effects of the Basic Cinematographic Apparatus," *Film Quarterly,* vol. 28, no. 2, Winter 1974–1975, pp. 39–47.

Bégin, R. (2014), "The Objective: The Configuration of Trauma in the 'War on Terror,' or the Sublime Object of the Medium," in Flisfeder, M. and Willis, L. P. (ed.) *Žižek and Media Studies A Reader*, New York: Palgrave Macmillan.

Ben-Dor, O. (ed.) (2011), *Law and Art Justice ethics and Aesthetics.* Abingdon: Routledge.

Bengsten P. and Matilda Arvidsson (2014), "Spatial Justice and Street Art". *NAVEIŃ: Nordic Journal of Law and Social Research* (NNJLSR) no. 5, pp. 117–130.

Benjamin, W. (1969), "The Work of Art in the Age of Mechanical Reproduction," in *Illuminations*, edited by Hannah Arendt, translated by Harry Zohn, from the 1935 essay New York: Schocken Books.

Bergman, D. (1993), *Camp Grounds: Styles and Homosexuality*, ed. Amherst: The University of Massachusetts Press.

Bergman, P., & Michael Asimow (1996), *Reel Justice: The Courtroom Goes to the Movies.* Kansas City: Andrews and McMeel.

Bernárdez Rodal, A., Irene García Rubio, Soraya González Gurrero (eds.) (2008), *Violencia de género en el cine español: análisis de los años 1998 a 2000 y guía didáctica.* Madrid: Complutense.

Bizzocchi, J. (2009), "The Fragmented Frame: the Poetics of the Split-Screen", Media in Transition 6 Conference: Stone and Papyrus Storage and Transmission, Cambridge MA, April 24–26, 2009.

Blitzer, J. (2015), "Protest by Hologram," *The New Yorker*, April 20, 2015.

Boletsi M. (2018), "Towards a Visual Middle Voice: Crisis, Dispossession and Spectrality in Spain's Hologram Protest," *Komparatistik: Jahrbuch der Deutschen Gesellschaft für Allgemeine und Vergleichende Literaturwissenschaft* (2017): pp. 19–35. Postprint version: pp. 1–21.

Bondia Garcia, D. (2015), "La criminalización de la protesta: ¿Un nuevo reto para los derechos humanos?" in *Defender a quien defiende Leyes mordaza y criminalización de la protesta en el Estado español,* David Bondia (dir.) Felip Daza (coord.) Ana Sánchez (coord.), 1st ed. Barcelona: *Icaria*, pp. 169–213

Bordwell, D. and Kristin Thompson (2004), *Film art: an introduction*, New York: McGraw-Hill; 7th edn.

Boykoff, J. (2006), "Framing Dissent: Mass-Media Coverage of the Global Justice Movement," *New Political Science*, vol. 28, no. 2, June 2006.

Booth, M. (1999), "Campe-Toi! On the Origins and Definitions of Camp" in *Camp. Queer Aesthetics and the Performing Subject—A Reader,* ed. Fabio Cleto. Ann Arbor: The University of Michigan Press, pp. 66–95.

Bronkhorst, D. (2003), "Human Rights Film Network: Reflections on its History, Principles and Practices," Amnesty International Film Festival. Available at: <https://is.muni.cz/el/1421/jaro2012/FAVKz047/um/Daan_Bronkhorst_Amnesty_International_Film_Festival.pdf> (last accessed June 15, 2020).

Bruno, G. (2018), *Atlas of Emotion: Journeys in Art, Architecture, and Film*. Brooklin, NY: Verso Books, (First edition 2002).

Buchanan, R., and Rebecca Johnson (2009), "Encounters: Exploring Law and Film in the Affective Register" *Studies in Law, Politics, and Society*, vol. 46, pp. 33–60.

Butler, C. (2009), "Critical Legal Studies and the Politics of Space," *Social & Legal Studies*, vol. 18, no. 3, pp. 313–332.

Butler, C. (2012), *Henri Lefebvre: Spatial Politics, Everyday Life and the Right to the City*. New York: Routledge.

Butler, C. (2017), "Space, Politics, Justice", in Butler, Chris and Edward Mussawir (eds.), *Spaces of Justice: Peripheries, Passages, Appropriations*, Abingdon and New York: Routledge, pp. 113–30.

Butler, C. (2019), "Spatial Abstraction, Legal Violence and the Promise of Appropriation," in Andreas Philippopoulos-Mihalopoulos (ed.), *Routledge Handbook of Law and Theory*. Abingdon, Oxon [UK]; New York NY: Routledge, pp. 67–88.

Butler, J. (1999), "From Interiority to Gender Performatives" in *Camp. Queer Aesthetics and the Performing Subject—A Reader,* ed. Fabio Cleto. Ann Arbor: The University of Michigan Press.

Butler, J. (2009), *Frames of War. When is Life Grievable?*, London, Verso.

Butler, J. (2011), "Bodies in Alliance and the Politics of the Street," *Transversal* 10/11.

Buse, P. (2007), Núria Triana-Toribio, & Andrew Willis, *The Cinema of Álex de la Iglesia*. Manchester: Manchester University Press.

Calvo Borobia, K., & Martín Portos (2018), "Panic works the 'Gag Law' and the Unruly Youth in Spain," in *Governing Youth Politics in the Age of Surveillance*. coord. Maria T. Grasso, Judith Bessant. London: Routledge, pp. 33–47.

Calvo-García, M. (2018), "2015 Spanish Public Security Law: The Expansion of Security Society to Governing Public Order," *Rivista di Sociologia del diritto*. vol. 3: pp. 45–65.

Campbell, N. (2013), *Post-Westerns: Cinema, Region, West*, Lincoln, NE: University of Nebraska Press.

Cawelti, J. G. (1970), "Prolegomena to the Western," *Western American Literature*, vol. 4, no. 4, pp. 259–271.

Cawelti, J. G. (1984), *The Six-Gun Mystique*, Bowling Green, OH: Bowling Green U Popular Press.

Chase, A. (2002), *Movies on Trial. The Legal System on the Silver Screen*. New York. The New Press.

Chaudhuri, S. (2014), *Cinema of the Dark Side: Atrocity and the Ethics of Film Spectatorship*. Edinburgh: Edinburgh University Press.

Cheah, P., David Fraser and Judith Grbich (eds.) (1996), *Thinking through the Body of the Law*. Australia: Allen & Unwin.

Chion, M. (1994), *Audio-Vision: Sound on Screen*. Translated by Claudia Gorbman, New York: Columbia University Press.

Chion, M. (1999), *The Voice in Cinema*. Translated and edited by *Claudia Gorbman*. New York: Columbia University Press.

Cleto, F. (1999), *Camp: Queer Aesthetics and the Performing Subject—A Reader,* ed. Fabio Cleto, Ann Arbor: The University of Michigan Press.

Closa, C. (2001), "The Domestic Basis of Spanish European Policy and the 2002 Presidency," *Notre Europe, European Studies* 16.

Cochrane, K. (2007), "The girl can help it," *Guardian Unlimited*, Friday April 27, 2007.

Cohen, S. (2002), *Folk Devils and Moral Panics: The Creation of the Mods and Rockers*, 3rd ed. London and New York: Routledge.

Collins, B. (2017), "Human Rights Cinema: The Act of Killing and the Act of Watching," *No Foundations: An Interdisciplinary Journal of Law*, no. 14, pp. 65–86.

Comisión Legal Sol (2015), "La ciudadanía como enemiga: balance tras cuatro años de represión de la protesta," in *Defender a quien defiende Leyes mordaza y criminalización de la protesta en el Estado español*, David Bondia (dir.), Felip Daza and Ana Sánchez (coord.), 1st ed. Barcelona: Icaria, pp. 107–140.

Compitello, M. A. (1999), "From Planning to Design: The Culture of Flexible Accumulation in Post-Cambio Madrid," *Arizona Journal of Hispanic Cultural Studies* 3, pp. 129–219.

Cooper, S. (2006), *Selfless Cinema? Ethics and French Documentary*, Oxford, Legenda.

Corbalán, A. (2017), & Lorraine Ryan, *The Dynamics of Masculinity in Contemporary Spanish Culture*, New York: Routledge.

Corcoran, S. (2010), "Editor's Introduction" in Rancière, J. *Dissensus: On Politics and Aesthetics*, edited and translated by Corcoran S., London and New York: Continuum.

Córdoba, A. (2016), "Urban Avatars of el 'Maligno': Sacredness in Álex de la Iglesia's El día de la bestia and Manuel Martín Cuenca's Caníbal" in Antonio Córdoba and Daniel García-Donoso (eds.) *The Sacred and Modernity in Urban Space: Beyond the Secular City*. New York: Palgrave Macmillan.

Cusick, S. G. (2016), "Music as Torture/Music as Weapon," in M. Bull & L. Back (Eds.), *The Auditory Culture Reader* (2nd ed.) London: Bloomsbury, pp. 379–392.

Dahlberg, L. (ed.) (2012), *Visualizing Law and Authority. Essays on Legal Aesthetics*. Berlin and Ney York: De Gruyter.

Davies, A. (2012), *Spanish Spaces Landscape, Space and Place in Contemporary Spanish Culture*. Liverpool: Liverpool University Press.

Davis, C. (2011), "Mindhole Blowers: 20 Facts about Pan's Labyrinth that Might Make You Believe in Magic," *Seriously Random List*, November 28.

de Certeau M. (1984), *The practice of everyday life*. Translated by Steven Rendall. Berkeley: University of California Press.

de los Santos, E. J. (2019), "El Polígono Sur y Los Pajaritos, los barrios más pobres

de España" *El Diario de Sevilla*, May 29, 2019. Available at <https://www.diari odesevilla.es/sevilla/Poligono-Sur-Pajaritos-Amate-barrios-mas-pobres-Espana_ 0_1359164458.html> (last accessed August 29, 2019).

de Souza, M. L. (2010), "Which Right to Which City? In Defence of Political-strategic Clarity," *Interface: A Journal for and about Social Movements Response to Harvey*, vol. 2 (1), May 2010, pp. 315–333.

del Arco Blanco, Miguel Ángel (2010), "Hunger and the Consolidation of the Francoist Regime (1939–1951)," *European History Quarterly*, vol. 40, issue 3, pp. 458–483.

del Campo. E. (2012), "Ella despató el verdadero Grupo 7," El Mundo, April 22, 2012. Available at <https://www.elmundo.es/elmundo/2012/04/21/andalucia_ sevilla/1335031348.html> (last accessed August 29, 2019).

del Toro, G. (2006a), *Pan's Labyrinth*. Screenplay in English, Picture House.

del Toro, G. (2006b), Interview by Billy Chainsaw, "Guillermo del Toro on Pan's Labyrinth Movie maverick trawls Pan's Labyrinth for a truly fairytale . . ." *Bizarre*. Available at <http://www.bizarremag.com/film-and-music/interv iews/4570/guillermo_del_toro_on_pans_labyrinth.html> (last accessed April 1, 2013).

Delage C., & Peter Goodrich (eds.) (2013), *The Scene of the Mass Crime. History, Film, and International Tribunals*, Abingdon, Routledge.

Deleuze, G. (1992), "Postscript on the Societies of Control" October, vol. 59, Winter 1992, pp. 3–7.

Deleuze G., and Felix Guattari (1988), *A Thousand Plateaus: Capitalism and Schizophrenia*. Translation and Foreword by Brian Massumi. Minneapolis/ London: University of Minnesota Press.

Derrida, J. (1992), "Force of Law: The 'Mystical Foundation of Authority'" tr. Mary Quaintance, in *Deconstruction and the Possibility of Justice*, eds. Drucilla Cornell, Michael Rosenfeld, and David Gray Carlson. New York: Routledge, pp. 3–67.

Diaconu, M. (2001), "Matter, Movement, Memory. Footnotes to an Urban Tactile Desire," in Madalina Diaconu, Eva Heuberger, Ruth Mateus-Berr, Lukas Marcel Vosicky (eds.), *Senses and the City: An Interdisciplinary Approach to Urban Sensescapes*. LIT Verlag, pp. 13–32.

Díaz, I. (2010), *Sevilla, cuestion de clase. Una geografía social de la ciudad*. Sevilla: Atrapasueños.

Díaz, S. (2012), "Viaje al fondo de la noche: No habrá paz para los malvados (Enrique Urbizu, 2011)," *L'ATALANTE*, pp. 115–121.

Dikeç M. (2001), "Justice and the Spatial Imagination," *Environment and Planning A*, vol. 33, pp. 1785–1805.

Dikeç M. (2002), "Police, Politics and the Right to the City," *GeoJournal*, vol. 58, pp. 91–98.

Dikeç, M. (2016), *Space, Politics and Aesthetics*, Edinburgh: Edinburgh University Press.

Dillon, A. (2017), "Galceran x Piñeyro: una transposición del teatro al cine," *El Hilo De La Fabula* 17, version pdf, pp. 1–15.

D'Lugo, M. (2006), *Pedro Almodóvar*, Chicago: University of Illinois Press.

Dodwell, K. (2004), "From the Center: The Cowboy Myth, George W. Bush, and the War with Iraq" *The American Popular Culture Online Magazine*. Available

at <http://www.americanpopularculture.com/archive/politics/cowboy_myth. htm> (last accessed June 15, 2020).

Dolar, M. (2006), *A Voice and Nothing More*, Cambridge: MIT Press.

Dolar, M. (2011), "The Burrow of Sound," *Differences. A Journal of Feminist Cultural Studies* 22, 2–3: pp. 112–139.

Dollimore, J. (1999), "Post/Modern: on the Gay Sensibility, or the Pervert's Revenge on Authenticity" in *Camp. Queer Aesthetics and the Performing Subject—A Reader*, ed. Fabio Cleto, Ann Arbor: The University of Michigan Press, pp. 221–236.

Douglas, L. (2001), *The Memory of Judgment. Making Law and History in the Trials of the Holocaust*, New Haven and London: Yale University Press.

Douzinas, C. (2012), "Stasis Syntagma: The Names and Types of Resistance," M. Stone, I. Rua Wall, & C. Douzinas (eds.). *New Critical Legal Thinking: Law and the Political*. Abingdon, UK: Routledge, pp. 32–45.

Douzinas C. and Lynda Nead (eds.) (1999), *Law and the Image: The Authority of Law and the Aesthetics of Law*, Chicago: University of Chicago Press.

Douzinas, C., and Ronnie Warrington (1994), *Justice Miscarried: Ethics, Aesthetics and the Law*. Hemel Hempstead: Harvester Wheatsheaf.

Edwards, K. (2008), "Alice's Little Sister: Exploring Pan's Labyrinth," *Film as Text*, pp. 141–146.

El laberinto del fauno (2006), directed by Guillermo del Toro, Telecinco Cinema.

El Método (2005), directed by Marcelo Piñeyro, Tornasol Films.

Elsaesser, T. and Malte Hagener (2015), *Film Theory: An Introduction Through the Senses*.

Escobar López, A. (2016), "Invisible Participation: The Hologram Protest in Spain," *Afterimage*, vol. 43, issue 4, pp. 8–11.

Estévez, J. (2015), "La expansión del gobierno neoliberal: Securitización, autoritarismo liberal y resistencias," in *Defender a quien defiende Leyes mordaza y criminalización de la protesta en el Estado español*, David Bondia (dir.) Felip Daza and Ana Sánchez (coord.), 1st ed., Barcelona: Icaria, pp. 17–44.

Ferrell, J. (1995), "Urban Graffiti: Crime, Control, and Resistance," *Youth & Society*, vol. 27, no. 1 Sep 1995, pp. 73–92.

Fischer, L. (1998), "Modernity and Postmaternity: *High Heels* and *Imitation of Life*" in *Play it Again, Sam: Retakes on Remakes*, eds. Andrew Horton and Stuart Y. McDougal, Berkeley: University of California Press.

Flesher Fominaya, C. (2011), "The Madrid Bombings and Popular Protest: Misinformation, Counter-information, Mobilisation and Elections After '11-M'" *Contemporary Social Science*, vol. 6, issue 3, pp. 289–307.

Foucault, M. (1977), *Discipline and Punish: The Birth of the Prison*, Translated by Alan Sheridan, New York: Vintage Books.

Foucault, M. (1980), *Power/knowledge: Selected interviews and other writings, 1972–1977*, New York: Pantheon.

Fraser, B. (2013), *Henri Lefebvre and the Spanish Urban Experience. Reading the Mobile City*, Lewisburg: Bucknell University Press.

Frayling, C. (2006), *Spaghetti Westerns: Cowboys and Europeans from Karl May to Sergio Leone*, London: I. B. Tauris, 1998. Friedberg, A., *The Virtual Window: From Alberti to Microsoft*, Cambridge: The MIT Press.

Gabriel, Y., and Tim Lang (1995), *The Unmanageable Consumer. Contemporary Consumption and its Fragmentations*, London: Sage Publications.

Galán, R. (2005), "El Método" en Capital Humano. Available at <https://apren-deconomia.files.wordpress.com/2011/04/el-mc3a9todo-art-emprendedores.pdf> (last accessed June 15, 2020).

García A. O. (2017), "The Aesthetics of Social Movements in Spain," in *Street Art of Resistance*, Awad, S. & Wagoner, B. (eds.), London: Palgrave Macmillan, pp. 325–348.

García Amado, J. M., and Juan Antonio Paredes Castañón (eds.) (2005), *Torturas en el cine*, Tirant lo Blanch.

García Manrique, R., and Mario Ruiz Sanz (eds.) (2009), *El derecho en el cine español*, Valencia: Tirant lo Blanch.

Garlinger, P. P., and H. Rosi Song (2004), "Camp: What's Spain Got to Do with It?" *Journal of Spanish Cultural Studies* 5.1, pp. 3–10.

Gearey, A. (2001), *Law and Aesthetics*, Oxford: Hart Publishing.

Gerbaz, A. (2008), "Direct Address, Ethical Imagination, and Errol Morris's Interrotron," *Film-Philosophy*, vol. 12, issue 2, pp. 17–29.

Gómez-Castellano, I. (2013), "Lullabies and Postmemory: Hearing the Ghosts of Spanish History in Guillermo del Toro Pan's Labyrinth (El Laberinto del Fauno 2006)," *Journal of Spanish Cultural Studies*, pp. 1–18.

Gómez García J. A. (ed.) (2017), *Los derechos humanos en el cine español*. Madrid: Editorial Dykynson.

González, J. A. (2016), "Transnational Post-Western in Irish Cinema," *Journal of Transnational American Studies*, vol. 7, no. 1, pp. 1–26.

González, J. A. (2017), "A Genre Auteur? Enrique Urbizu's Post-Western Films," *Hispanic Research Journal*, vol. 18, no.1, pp. 60–73.

González Pérez, J. M. (2019), Francisco Cebrián-Abellán, María José Piñeira-Mantiñán (eds.), "Land Squandering and Social Crisis in the Spanish City," *Urban Science*.

Goodrich, P. (2014), *Legal Emblems and the Art of Law: Obiter Depicta as the Vision of Governance*. Cambridge University Press.

Greenfield, O. (2010), Guy Osborn and Peter Robson, *Film and the Law, The Cinema of Justice*. Hart Publishing.

Gregory, D. (1994), *Geographical imaginations*. Cambridge, MA, and Oxford, UK: Blackwell.

Grupo 7 (2012), directed by Alberto Rodríguez, Atípica Films.

Gutierrez Albilla, J. D. (2017), *Aesthetics, Ethics, and Trauma in the Cinema of Pedro Almodóvar*, Edinburgh: Edinburgh University Press.

Gutiérrez-Dorado, A. (2008), "La Voz de la Memoria" in *Una Discriminación Universal. La Homosexualidad bajo el Franquismo y la Transición*, ed. Ugarte-Pérez, Javier (Barcelona-Madrid: Editorial Egales), pp. 247–256, at 248.

Hagener, M. (2008), "The Aesthetics of Displays: How the Split-Screen Remediates Other Media," *Refractory: A Journal of Entertainment Media* 14.

Hamblin, S. (2016), "The Form and Content of Human Rights Film: Teaching Larysa Kondracki's The Whistleblower," "Teaching Human Rights," Special Issue of *Radical Teacher*, vol. 104, pp. 38–47.

Hamilton, S. N., Diana Majury, Dawn Moore and Neil Sargent (eds.) (2018), *Sensing Law*. Abingdon: Routledge.

Hanley, J. (2008), "The walls fall down: Fantasy and power in El laberinto del fauno," *Studies in Hispanic Cinema*, vol. 4, issue 1, pp. 35–45.

Harvey, D. (2008), "The right to the city," *New Left Review*, 53, pp. 23–40.

Harvey, D. (2013), *Rebel Cities: From the Right to the City to the Urban Revolution*, New York: Verso Book.

Hayes, G. (2017), "Regimes of austerity," *Social Movement Studies*, vol. 16, no. 1: pp. 21–35.

Herbert S. (1997), *Policing Space. Territoriality and the Los Angeles Police Department*, Minneapolis and London, University of Minnesota Press.

Heredero, C. F. (2011), "Entrevista Enrique Urbizu: La ética de la mirada," *Cahiers du Cinéma*, pp. 32–35.

Hodgen, J. M. (2007), "Embracing the Horror: Tracing the Ideology of Guillermo Del Toro's Pan's Labyrinth," *Velox: Critical Approaches to Contemporary Film*, vol. 1, no. 1.

Hoffman, K. S. (2011), "Visual Persuasion in George W. Bush's Presidency: Cowboy Imagery," *Congress & the Presidency*, vol. 38, no. 3, pp. 322–343.

Howes, D., and Constance Classen (2014), *Ways of Sensing: Understanding the Senses in Society*. Abingdon: Routledge.

Hubner, L. (2010), "*Pan's Labyrinth*, Fear and the Fairy Tale," in Stephen Hessel and Michèle Huppert (eds.), *Fear Itself: Reasoning the Unreasonable*, Amsterdam and New York: Rodopi, pp. 45–55.

Human Rights Film Network: *Charter: Statement of Principles and Practices*. Available at <https://www.humanrightsfilmnetwork.org/content/charter> (last accessed September 8, 2019).

Human Rights Watch: *Human Rights Watch Film Festival*. Available at <https://ff.hrw.org/> (last accessed September 8, 2019).

Irigaray, L. (1985), *This Sex Which is Not One*, tr., Catherine Porter. Cornell UP, Ithaca.

James, C. (1992), *Almodóvar, Adrift in Sexism*, New York Times, January 12, 1992.

Jordan, B., & R. Morgan-Tamosunas (1998), *Contemporary Spanish Cinema*, New York: Manchester University Press.

Kamir, O. (2006), *Framed: Women in Law and Film*, Durham: Duke UP.

Kane, B. (2014), *Sound Unseen: Acousmatic Sound in Theory and Practice*, Oxford: Oxford University Press.

Kinder, M. (1993), *Blood Cinema. The Reconstruction of National Identity in Spain*, Berkeley: The University of California Press.

Kozloff, S. (1989), *Invisible Storytellers: Voice-Over Narration in American Fiction Film*, Berkeley, University of California Press.

La Comunidad (2000), directed by Álex de la Iglesia, Spain: Lolafilms.

LaBalle, B. (2018), *Sonic Agency. Sound and Emergent Forms of Resistance*, London: Goldsmith Press.

Labrador Méndez, G. (2012), "Las vidas *subprime*: la circulación de *historias de vida* como tecnología de imaginación política en la crisis española (2007–2012)," *Hispanic Review*, vol. 80, no. 4 Autunm 2012: 557–581.

Lapolla Swier, P. (2011), "New Age Fairy Tales: The Abject Female Hero in *El laberinto del fauno* and *La rebelión de los conejos mágicos*," *Journal of Feminist Scholarship*, vol. 1 Fall 2011, pp. 65–79.

Lefebvre, H. (1991), *The Production of Space*, translated by Donald Nicholson-Smith, Malden, MA: Blackwell.

Lefebvre, H. (1996), "The Right to the City," in Eleonore Kofman and Elizabeth Lebas (eds.) *Writings on Cities*, Malden, MA: Blackwell.

Levin, T. Y. (2002), "Rhetoric of the Temporal Index: Surveillant Narration and the Cinema of Real Time," in *CTRL Space: Rhetorics of Surveillance from Bentham to Big Brother*, eds. Thomas Y. Levin, Ursula Frohne and Peter Weibel, Karlsruhe and Cambridge: ZKM & MIT Press, pp. 578–593.

Levinas, E. (1982a), *Éthique et infini. Dialogues avec Philippe Nemo*, Paris: Fayard.

Levinas, E. (1982b), "La realité et son Ombre," *Revue des Sciences Humaines*, vol. 185, no. 1, pp. 103–117.

Levinas, E. (1998), *Entre Nous: Thinking-of-the Other*, trans. Michael B. Smith and Barbara Harshaw, New York, Columbia University Press.

Levinas, E., and Richard Kearney (1986), "Dialogue with Emmanuel Levinas," in *Face to Face with Levinas*, Albany: SUNY Press, pp. 23–4.

Levinson, B. (2004), *Market and Thought. Meditations on the Political and Biopolitical*, New York: Fordham University Press.

Lezra, J. (2016), "Terror," in Bunz, M., Kaiser, B. M., and Thiele, K. (eds.), *Symptoms of the Planetary Condition: A Critical Vocabulary*, Lüneburg: Meson Press.

Lincoln, B. (2006), *Holy Terrors: Thinking About Religion After September 11*, Chicago: Chicago University Press.

López, I., and Emmanuel Rodríguez (2011), "The Spanish Model," *New Left Review* 69 May/June 2011.

López Lerma, M. (2011), "The Ghosts of Justice and the Law of Historical Memory," *Conserveries mémorielles*, no. 9.

López Lerma, M. (2015), "What Judicial Memory for the Amnesty Law of 1977?" in *Europe at the Edge of Pluralism*, eds. D. Gozdecka and M. Kmak, Benelux: Intersentia, pp. 183 200.

López Lerma, M. & Julen Etxabe (eds.) (2018), *Rancière and Law*, Nomikoi Critical Legal Thinkers, Routledge.

López Pérez, J. (2010), Entrevista a Marcelo Piñeyro, director de Las viudas de los jueves. Available at <http://www.elblogdecineespanol.com/?p=1348> (last accessed June 15, 2020).

Luckhurst, R. (2010), "Beyond Trauma: Torturous Times," *European Journal of English Studies*, vol. 14, issue 1, pp. 11–21.

Machura, S. & Peter Robson (eds.) (2001), *Law and Film: Introduction*, Oxford: Blackwell Publishers.

MacNeil W. (2007), *Lex Populi: The Jurisprudence of Popular Culture*, Stanford: Stanford University Press.

Madden, D. & Peter Marcuse (2017), "The Residential is Political," in *The Right to the City: A Verso Report*, London: Verso, pp. 29–33.

Maddox, R. F. (2004), *The Best of All Possible Islands: Seville's Universal Exposition, the New Spain, and the New Europe*. Albany: State University of New York Press.

Mahmud T. (2010), "'Surplus Humanity' and the Margins of Legality: Slums, Slumdogs, and Accumulation by Dispossession," *Chapman Law Review*, vol. 14, no. 1, pp. 1–3.

Manderson, D. (2000), *Songs without Music, Aesthetic Dimensions of Law and Justice*, Berkeley: University of California Press.

Manovich, L. (2001), *The Language of New Media*. Cambridge: MIT Press.

Marks, L. U. (2000), *The Skin of the Film. Intercultural Cinema, Embodiment, and the Senses*. Durham and London: Duke University Press.

Marks, L. U. (2002), *Touch: Sensous Theory and Multisensory Media*. Minnesota/ London: University of Minnesota Press.

Mármol, C. (2017), "La Cartuja: la asignatura pendiente de la Expo 92," El Mundo, April 20.

Maroto Camino, M. (2005), "'Madrid me Mata': Killing the Husband in Alex de la Iglesia's *La Comunidad* (2000) and Pedro Almodóvar's *¿Qué he Hecho yo para Merecer Esto?* (1984)," *Forum for Modern Languages Studies*, vol. 41, issue 3, pp. 332–341.

Maroto Camino, M. (2010), "Blood of an Innocent: Montxo Armendariz's Silencio Roto (2001) and Guillermo del Toro's El Laberinto del Fauno (2006)," *Studies in Hispanic Cinemas*, vol. 6, no. 1, pp. 45–64.

Marsh, S. & Parvati Nair (eds.) (2004), "Introduction" in *Gender and Spanish Cinema*, New York; Oxford: Berg.

Martín Rojo, L. (2014), "The Spatial Dynamics of Discourse in Global Protest Movements," *Journal of Language & Politics*, vol. 13, issue 4: pp. 583–598.

Marusek, S. (2016), *Synesthetic Legalities: Sensory Dimensions of Law and Jurisprudence*, Abingdon: Routledge.

Massumi, B. (1993), *A User's Guide to Capitalism and Schizophrenia: Deviations from Deleuze and Guattari*, Cambridge, MA: MIT Press.

May, T. (2008), *The Political Thought of Jacques Rancière. Creating Equality*, University Park: The Pennsylvania State University Press.

McKenna, A. J. (1991), "The Law's Delay: Cinema and Sacrifice," *Legal Studies*, vol. xv, no. 3, pp. 199–213.

Merrifield A. (2006), *Henri Lefebvre: A Critical Introduction*, London: Routledge.

Merrifield A. (2017), "Fifty Years On: The Right to the City," in The Right to the City: A Verso Report, London: Verso, pp. 15–18.

Metz, C. (1977), *The Imaginary Signifier: Psychoanalysis and the Cinema*, trans. Celia Britton, Annwyl Williams, Ben Brewster, and Alfred Guzzetti. Bloomington and Indianapolis Indiana University Press 1982 [1977].

Metz, C. (2016), *Impersonal Enunciation, or the Place of Film*. Transl. by Deane, Cormac, New York: Columbia University Press.

Metz, C., and Georgia Gurrieri (1980), "Oral Objects" *Yale French Studies*, no. 60, Cinema/Sound, pp. 24–32.

Miller, W. I. (1997), The Anatomy of Disgust, Cambridge, MA: Harvard.

Minkkinen, P. (2008), "The Expressionless: Law, Ethics and the Imagery of Suffering," Law and Critique, vol. 19, issue 1, pp. 65–85.

Mira, A. (2000), "Laws of Silence: Homosexual Identity and Visibility in Contemporary Spanish" in Contemporary Spanish Cultural Studies, edited by Barry Jordan and Rikki Morgan-Tamosunas. London: Arnold; New York: Oxford University Press.

Mitchell, D. (2003), *The Right to the City: Social Justice and the Fight for Public Space*, NewYork: Guilford Press.

Moran, L. J. et al. (2004), *Laws Moving Images*, London: Cavendish.

Moreiras Menor, C. (2002), *Cultura herida: Literatura y cine en la España democrática*, Madrid: Libertarias.

Moreiras Menor, C. (2008), "Nuevas fundaciones: Temporalidad e Historia en La Comunidad de Álex de la Iglesia," *MLN (Hispanic Issue)*, vol. 123, no. 2, pp. 374–395.

Moreiras Menor, C. (2011), *La estela del tiempo. Imagen e historicidad en el cine español contemporáneo*, Vervuert: Iberoamericana.

Moreno-Caballud, L. (2015), *Cultures of Anyone: Studies on Cultural Democratization in the Spanish Neoliberal Crisis*, Liverpool: Liverpool University Press.

Moreno Nuño, C. (2012), "Armed Resistance: Cultural Representations of the Anti-Francoist Guerrilla," *Hispanic Issues On Line*, Fall 2012, pp. 1–8.

Mulvey, L. (2004), "Visual Pleasure and Narrative Cinema," in *Film Theory and Criticism*, 6th edn., Gerald Mast, Marshall Cohen, Leo Braudy, Oxford: Oxford University Press, pp. 837–848.

Murray M. J. (2008), *Taming the Disorderly City: The Spatial Landscape of Johannesburg after Apartheid*, Ithaca, NY: Cornell University Press.

Narváez Hernández, J. R. (2017), "Los derechos en el laberinto" in Gómez García J. A. (ed.), *Los derechos humanos en el cine español* Madrid: Editorial Dykynson.

Newman, S. (2007), "Anarchism, Poststructuralism and the Future of Radical Politics," *SubStance*, vol. 36, no. 2, pp. 3–19.

Newton, E. (1999), "Role Models" in *Camp. Queer Aesthetics and the Performing Subject—A Reader*, ed. Fabio Cleto, Ann Arbor: The University of Michigan Press, pp. 96–109.

No habrá paz para los malvados (2011), directed by Enrique Urbizu, LaZona Films.

Norton, D. (2015), "Immigration and Spanish Subjectivity in "No habra paz para los malvados'," in Corbalán, A. and Mayock, E. (eds.), *Toward a Multicultural Configuration of Spain: Local Cities, Global Spaces*, Maryland: Fairleigh Dickinson University Press.

Núñez Seixas, X. M. (2001), "What is Spanish nationalism today? From legitimacy crisis to unfulfilled renovation (1975–2000)," *Ethnic and Racial Studies*, vol. 24, no. 5, September 2001, pp. 719–752.

Oliver, K. (2001), *Witnessing: Beyond Recognition*, Minnesota: University of Minnesota.

Oliver, K. (2007), *Women as Weapons of War: Iraq, Sex, and the Media*, New York, Columbia University Press.

Orme, J. (2010), "Narrative Desire and Disobedience in *Pan's Labyrinth*," *Marvels & Tales: Journal of Fairy-Tale Studies*, vol. 24, no. 2, pp. 219–234.

Pally, M. (1990), *The Politics of Passion: Pedro Almodóvar and the Camp Aesthetic*, 10 Cineaste 1.

Palomeras, R. (2005), "Un mètode diferent Cultura i espectacles."

Parés Pulido, M. (2017), "De la parodia a la denuncia social: la pérdida de la ironía en la adaptación cinematográfica de El Método Grönholm" in *El texto y sus fronteras: Estudios entre literaturas hispánicas y disciplinas artísticas*, Tibisay López García, Roberto Dalla Mora, Fernando José Pancorbo Murillo, Blanca Santos de la Morena, Weselina Gacinska (coord.). Madrid: Philobiblion: Asociación de Jóvenes Hispanistas; Universidad Autónoma de Madrid: pp. 235–253.

Parsons, D. L. (2002), "Fiesta Culture in Madrid Posters, 1934–1955," in *Constructing Identity in Contemporary Spain. Theoretical Debates and Cultural Practice*, ed. Jo Labanyi, Oxford: University Press, pp. 178–205.

Parsons, D. L. (2003), *A Cultural History of Madrid. Modernism and the Urban Spectacle*, Oxford, New York: Berg.

Patel, T. G. (2012), "Surveillance, Suspicion and Stigma: Brown Bodies in a Terror-Panic Climate," *Surveillance & Society*, vol. 10, no. 3, pp. 215–234.

Paterson, M. (2007), *The Senses of Touch: Haptics, Affects and Technologies*, Oxford: Berg.

Pavoni, A. (2018), "Introduction" in *SEE*, Andrea Pavoni, Danilo Mandic, Caterina Nirta & Andreas Philippopoulos-Mihalopoulos (eds.), London: University of Westminster Press.

Pereira-Zazo, O., & Steven L. Torres (2019), *Spain After the* Indignados/*15M Movement: The 99% Speaks Out*, Cham, Switzerland: Palgrave Macmillan.

Pérez Treviño, J. L. (2007), "Cine y derecho. Aplicaciones docentes," *Quaderns de cine*, no. 1, pp. 69–78.

Perriam, C. (2014), *Spanish Queer Cinema*. Edinburgh: Edinburgh University Press.

Perriam, C. & Tom Whittaker (2019), "Introduction: Contemporary Spanish Screen Media and Responses to Crisis and Aftermath," *Hispanic Research Journal*, vol. 20, issue 1, pp. 2–9.

Petit, J. and Empar Pineda (2008), "El Movimiento de Liberación de Gays y Lesbianas durante la Transición (1975–1981)" in *Una Discriminación Universal. La Homosexualidad bajo el Franquismo y la Transición*, ed. Ugarte-Pérez, Javier. Barcelona-Madrid: Editorial Egales, pp. 171–197.

Petit, Q. (2012), "Fuimos una máquina contra la droga" *El País*. Available at <https://elpais.com/cultura/2012/04/28/actualidad/1335638296_116872.html> (last accessed August 31, 2019).

Pheasant-Kelly (2013), Frances, *Fantasy Film Post 9/11*, New York, Palgrave Macmillan.

Philippopoulos-Mihalopoulos, A. (2011), "Critical Autopoiesis: The Environment of the Law" in De Vries, U. and Francot, L. (eds.) *Law's Environment: Critical Legal Perspectives*, The Hague: Eleven International Publishing.

Philippopoulos-Mihalopoulos, A. (2015), *Spatial Justice: Body, Lawscape, Atmosphere*. Routledge.

Picart, Caroline Joan S., John Edgar Browning, and Carla María Thomas (2012), "Where Reality and Fantasy Meet and Bifurcate: Holocaust in *Pan's Labyrinth* (2006), *X-Men* (2000), and *V* (1983)," in Caroline Joan S. Picart and John Edgar Browning (eds.) *Speaking of Monsters. A Teratological Anthology*, New York, Palgrave Macmillan, pp. 271–290.

Plantinga, C. (2009), *Moving viewers: American film and the spectator's experience*, Berkeley: University of California Press.

Pohl, B. (2007), "El Lado Oscuro de la Nación: *La Comunidad* (Álex de la Iglesia, 2000)" in *Mirada Glocales: Cine Español en el Cambio de Milenio*, eds. Burkhard Pohl and Jörg Türschmann (Madrid: Iberoamerica), pp. 119–138.

Preston, P. (1995a), *The Politics of Revenge: Fascism and the Military in Twentieth-Century Spain*, London and New York, Routledge.

Preston, P. (1995b), "Resisting the State: The Urban and Rural *Guerrilla* of the 1940s in H. Graham and J. Labanyi (eds.) *Spanish Cultural Studies: an Introduction: The Struggle for Modernity*, Oxford, Oxford University Press, pp. 229–237.

Preston, P. (2005), "The Crimes of Franco," The 2005 Len Crome Memorial Lecture, delivered at the Imperial War Museum on March 12, 2005.

Preston, P. (2012), *The Spanish Holocaust, Inquisition and Extermination in Twentieth-Century Spain*, London, Harper Press.

Purcell, M. (2002), "Excavating Lefebvre: The Right to the City and its Urban Politics of the Inhabitant," *GeoJournal*, no. 58, pp. 99–108.

Purcell, M. (2013), "The Right to the City: The Struggle for Democracy in the Urban Public Realm," *Policy and Politics*, vol. 41, no. 3, pp. 311–327.

Rancière, J. (1995a), *On the Shores of Politics*, 1992 tr. Liz Heron, New York: Verso.

Rancière, J. (1995b), "Politics, Identification, and Subjectivization" in *The Identity in Question*, ed. John Rajchman, New York: Routledge.

Rancière, J. (1999), *Disagreement: Politics and Philosophy*, 1995, tr. Julie Rose, Minneapolis: University of Minnesota Press.

Rancière, J. (2003), "The Thinking of Dissensus: Politics and Aesthetics," Fidelity to the Disagreement: Jacques Rancière and the Political, conference organized by the Post-Structuralism and Radical Politics and Marxism Specialist Groups of the Political Studies Association of the UK, Goldsmiths College, London, pp. 1–15.

Rancière, J. (2004a), "Introducing Disagreement," *Angelaki: Journal of Theoretical Humanities*, vol. 9, no. 3, pp. 3–9.

Rancière, J. (2004b), *The Politics of Aesthetics: The Distribution of the Sensible*, translated with an introduction by G. Rockhill, London: Continuum.

Rancière, J. (2004c), *Who is the Subject of the Rights of Man*, South Atlantic Quarterly, vol. 103, issue 2/3, pp. 297–310.

Rancière, J. (2006a), "The Ethical Turn of Aesthetics and Politics," *Critical Horizons* 7 (1), pp. 1–20.

Rancière, J. (2006b), *Film Fables*. Translated by Emiliano Battista. New York: Berg.

Rancière, J. (2006c), "De la peur à la terreur,» in Novaes, A. (ed.), *Les aventures de la raison politique*, Paris: Métailié, pp. 275–291.

Rancière, J. (2006d), *Hatred of Democracy*, tr. Steve Corcoran, New York: Verso.

Rancière, J. (2007), "Does Democracy Means Something?" in *Adieu Derrida* ed. Costas Douzinas New York: Palgrave Macmillan, pp. 84–100.

Rancière, J. (2009a), *The Emancipated Spectator*, London: Verso.

Rancière, J. (2009b), "The Aesthetic Dimension: Aesthetics, Politics, Knowledge," *Critical Inquiry*, vol. 36, Autumn 2009, pp. 1–19.

Rancière, J. (2009c), "Contemporary Art and the Politics of Aesthetics," in Beth Hinderliter et al. (eds.), Communities of Sense: Rethinking Aesthetics and Politics. Durham, NC: Duke University Press, pp. 31–50.

Rancière, J. (2010a), *Chronicles of Consensual Times* edited and translated by S. Corcoran, London: Continuum.

Rancière, J. (2010b), *Dissensus: On Politics and Aesthetics*, edited and translated by S. Corcoran, London and New York: Continuum.

Rancière, J. (2010c), "Racism: A Passion from Above," *MR Online*.

Rancière, J. (2011), "Against an Ebbing Tide," in Paul Bawman and Richard Stamp (eds.), *Reading Rancière: Critical Dissensus*, London and New York: Continuum, pp. 238–51.

Rancière, J. (2014), *Moments Politiques: Interventions 1977–2009*, translated by M. Foster, New York and Oakland: Seven Stories Press.

Rawls, J. (1971), *A Theory of Justice*, Cambridge, MA: Harvard University Press.

Reinares, F. (2010), "The Madrid Bombings and Global Jihadism," *Survival*, vol. 52, no. 2, pp. 83–104.

Riding, A. (1992), "Seville's Extravaganza, Expo '92," *New York Times*, February 23, 1992.

Rikki, M. (1992), *Dress to Kill* 1 Sight and Sound 12, April 1992: 28–29.

Richards, M. (1998), *A Time of Silence: Civil War and the Culture of Repression in Franco's Spain, 1936–1945*, Cambridge, Cambridge University Press.

Richards, M. (2013), *Making Memory and Re-making Spain since 1936*, Cambridge, Cambridge University Press.

Rivaya García, B (2003). *Cine y pena de muerte*, Valencia: Tirant lo Blanch.

Rivaya García, B. (2006), "Derecho y cine. Sobre las posibilidades del cine como instrumento para la didáctica jurídica," in Rivaya García, B., & Miguel Ángel Presno Linera (eds.), *Una introducción cinematográfica al cine*, Valencia: Tirant lo Blanch.

Rivaya García, B. (2010), "Algunas preguntas sobre Derecho y Cine," *Anuario de Filosofía del Derecho*, no. XXVI, Enero 2010, pp. 219–230, 226.

Robertson, P. (1999), "What Makes the Feminist Camp?" in *Camp. Queer Aesthetics and the Performing Subject—A Reader*, ed. Fabio Cleto, Ann Arbor: The University of Michigan Press.

Rockhill, G. (2004), *The Politics of Aesthetics*, with an afterword by Slavoj Žižek, tr. Cabriel Rockhill, London & New York: Continuum.

Rodríguez, M. P. (2016), "El mal en la sociedad Española contemporánea: el cine negro de Enrique Urbizu," *Pasavento: Revista de Estudios Hispánicos*, vol. iv, no. 1, pp. 139–155.

Roy, A. (2001), "The Algebra of Infinite Justice," *The Guardian* (London) September 29, 2001.

Rubio, A. (2014), "Sin lugar en el mundo. Narrativa, puesta en escena y discurso en las películas hispanoargentinas de Marcelo Piñeyro," *Fotocinema. Revista científica de cine y fotografía,* 8: pp. 133–174.

Ruiz Sanz, M. (2010), "Es conveniente enseñar derecho a través del cine?" *Anuario de filosofía del derecho*, no. XXVI, pp. 257–264.

Ruiz Vargas, J. M. (2006), "Trauma y memoria de la Guerra Civil y la dictadura franquista," *Hispana Nova. Revista de Historia Contemporánea*, 6, pp. 299–336.

Sarat, Austin et al. (eds.) (2005), *Law on the Screen*, California: Stanford University Press.

Saxton, L. (2008), *Haunted Images: Film, Ethics, Testimony and the Holocaust*, London, Wallflower Press.

Scarry, E. (1985), *The Body in Pain. The Making and Unmaking of the World*, New York, Oxford University Press.

Serrano, M. (2017), "SEVILLA. Una cara oculta de violencia policial en el marco de la Expo 92" *Público*. May 28, 2017. Available at <https://www.publico.es/sociedad/sevilla-cara-oculta-violencia-policial.html> (last accessed September 8, 2019).

Serrano, S. (2002), *Maquis: Historia de la guerrilla antifranquista*, Madrid, Temas de Hoy.

Schneier, B. (2003), *Beyond Fear: Thinking Sensibly About Security in an Uncertain World*, New York: Copernicus Books.

Shapiro, M. J. (2009), *Cinematic Geopolitics*, Abingdon: Routledge.

Shapiro, M. J. (2013), *Studies in Trans-Disciplinary Method: After the Aesthetic Turn*, London: Routledge.

Shaw, D. (2000), *Men in High Heels: The Feminine Man and Performances of Femininity in* Tacones Lejanos *by Pedro Almodóvar*, vol. 6, *Tesserae: Journal of Iberian and Latin American Studies* 1.

Sheean, J. (2018), "A (New) Specter Haunts Europe: The Political Legibility of Spain's Hologram Protests," *Journal of Spanish Cultural Studies*, vol. 19, no. 4, pp. 465–480.

Sherwin, R. K. (2000), *When Law Goes Pop: The Vanishing Line Between Law and Popular Culture*, Chicago and London: University of Chicago Press.

Sherwin, R. K. (2011), *Visualizing Law in the Age of the Digital Baroque*, New York: Routledge.

Silvestri, M. (2017), Police Culture and Gender: Revisiting the 'Cult of Masculinity.' *Policing*, vol. 11, no. 3, pp. 289–300.

Simonsen, K. (2005), "Bodies, sensations, space and time: the contribution from Henri Lefebvre," *Geografi ska Annaler B*, 87(1), pp. 1–14.

Smith, P. J. (1994), "*Tacones Lejanos (High Heels*, 1991): Imitations of Life" in *Desire Unlimited: The Cinema of Pedro Almodóvar*, London: Verso.

Smith, P. J. (2007), "Pan's Labyrinth (El laberinto del fauno)," *Film Quarterly*, Summer 2007, vol. 60, issue 4, pp. 4–9.

Smith, P. J. (2012), "Spanish Cinema Roundup," *Film Quarterly*, vol. 66, no. 1, pp. 5–8.

Snyder, G. J. (2009), *Graffiti Lives: Beyond the Tag in New York's Urban Underground*, New York and London: NYU Press.

Snyder, J. (2015), *Poetics of Opposition in Contemporary Spain: Politics and the Work of Urban Culture*, New York: Palgrave Macmillan.

Sobchack, V. (1992), *The Address of the Eye. A Phenomenology of Film Experience*, Princeton: Princeton University Press.

Sobchack, V. (2004), *Carnal Thoughts. Embodiment and Moving Image Culture*, Berkeley and London, University of California Press.

Soja, E. W. (2010), *Seeking Spatial Justice*, Minneapolis: University of Minnesota Press.

Sontag, S. (1999), "Notes on 'Camp'" in *Camp: Queer Aesthetics and the Performing Subject—A Reader*, ed. Fabio Cleto, Ann Arbor: The University of Michigan Press, pp. 53–65.

Sosa-Ramírez, M. (2013), "Globalization and Simulation in Jordi Galcerán's El método Grönholm," Revista *Karpa: Journal of Theatricalities and Visual Culture*, Issue 6, pp. 1–11 n. p.

Soto Nieto, F., & Francisco J. Fernández (2004), *Imágenes y justicia: el derecho a través del cine*, Madrid: La Ley.

Stam, R. (1992), *Reflexivity in Film and Literature: From Don Quixote to Jean-Luc Godard*, New York: Columbian University Press.

Stewart, L. (1995), "Bodies, Visions, and Spatial Politics: A Review of Henri Lefebvre's *The Production of Space*," *Environment and Planning D: Society and Space*, vol. 3, pp. 609–618.

Susan D. (2012), "Genre, Space, and the Individual in the Films of Álex de la Iglesia," in *Capital Inscriptions: Essays on Hispanic Literature, Film and Urban Space in honor of Malcolm Alan Compitello*, ed. Benjamin Fraser, Newark, DE: Juan de la Cuesta, 333–56.

Swimelar, S. (2014), "Making Human Rights Visible through Photography and

Film," *The SAGE Handbook of Human Rights*, ed. Anja Mihr and Mark Gibney, Thousand Oaks, CA: Sage, pp. 413–32.

Tacones Lejanos (1991), directed by Pedro Almodóvar, El Deseo.

Tanvir, K. (2009), "Pan's Labyrinth: The Labyrinth of History," *Wide Screen*, vol. 1, issue 1, pp. 1–4.

Tascón, S. (2012), "Considering Human Rights Films, Representation and Ethics: Whose Face?" *Human Rights Quarterly*, vol. 34, no. 3, pp. 864–883.

Tascón, S. (2015), *Human Rights Film Festivals. Activism in Context*, Palgrave Macmillan, London.

Terrasa M. J. (2008), "La Legislación Represiva" in *Una Discriminación Universal. La Homosexualidad bajo el Franquismo y la Transición*, ed. Ugarte-Pérez, Javier, Barcelona-Madrid: Editorial Egales, pp. 79–107.

Thormann, J. J. (2008), "Other Pasts: Family Romances of *Pan's Labyrinth*," *Psychoanalysis, Culture & Society*, July 2008, vol. 13, issue 2, pp. 175–187.

Todorov, T. (1985), *The Conquest of America: The Question of the Other*, translated by Richard Howard, New York: Harper and Row.

Triana-Toribio, N. (2019), "Spanish Cinema of the 2010s: Back to Punk and Other Lessons from the Crisis," *Hispanic Research Journal*, 20:1, pp. 10–25.

Tsinonis, N. (2006), "Memoria y Homosexualidad: Sufrimiento, Olvido y Dignidad" in ed. Felipe Gómez Isa, in *El derecho a la memoria*, Bilbao: Alberdania, pp. 461–496.

Vasudevan, A. (2017), "Re-imagining the Squatted City," in *The Right to the City: A Verso Report*, London: Verso, pp. 47–52.

Venkatesh, V. (2017), "Bodies, Spaces, and Transitions in Alberto Rodríguez's *Grupo 7* (2012) and *La Isla Mínima* (2014)," in D. Ochoa and M. DiFrancesco (eds.), Gender in Spanish Urban Spaces: Literary and Visual Narratives of the New Millenium. Cham: Springer, pp. 31–52.

Vilas, C. M. (2006), "Neoliberal Meltdown and Social Protest: Argentina 2001–2002," *Critical Sociology*, vol. 32, no. 1: pp. 163–186.

Virilio, P. (2012), *The Administration of Fear*, trans. Ames Hodges, Los Angeles: Semiotext(e).

Wall, I. (2017), "The Agitated Veil: A Spatial Justice of the Crowd," in Chris Butler and Edward Mussawir (eds.), *Spaces of Justice Peripheries, Passages, Appropriations*, Routledge, pp. 150–166.

Walsh, J. P. (2016), "Moral Panics by Design: The case of Terrorism," *Current Sociology*, pp. 1–20.

Waquant, L. (2006), "The 'Scholarly Myths' Of The New Law And Order Doxa," *Socialist Register*, vol. 42, pp. 93–115.

West, R. (1997), *Caring for Justice*, New York: New York University Press.

White, J. B. (1973), *The Legal Imagination: Studies in the Nature of Legal Thought and Expression*, Chicago: The University of Chicago Press.

White, J. B. (1999), *From Expectation to Experience: Essays on Law and Legal Education*, Ann Arbor: The University of Michigan Press.

Whittaker, T., and Wright, Sarah (eds) (2017), *Locating the Voice in Film: Critical Approaches and Global Perspectives*, New York: Oxford University Press.

Williams, B. (2004), "The Text in the Third Degree: Gay Camp Recoupment in What Ever Happened To . . .? and High Heels," *New Review of Film and Television Studies*, vol. 2, issue 2, pp. 161–79.

Wilson, J. (2014), "The Violence of Abstract Space: Contested Regional Developments in Southern Mexico," *International Journal of Urban and Regional Research*, vol. 38, no. 2, pp. 516–538.

Wilson, J. (2013), " 'The Devastating Conquest of the Lived by the Conceived': The Concept of Abstract Space in the Work of Henri Lefebvre," *Space and Culture*, vol. 16, issue 3, pp. 364–380.

Wilson, J. Q. & Kelling, G. (1982), "Broken Windows: The Police and Neighbourhood Safety," *Atlantic Monthly*, March 1982, pp. 29–38.

Wright, S. (2013), *The Child in Spanish Cinema*, Manchester: Manchester University Press.

Wood., L. and Flesher Fominaya, C. (2015), "Hologram Protest. Interview," *Interface: a journal for and about social movements*, Interview, vol. 7, issue 1, May 2015: pp. 144–149.

Yarza, A. (1999), *Entre Tinieblas* in *Un canibal en Madrid: la sensibilidad camp y el reciclaje de la historia en el cine de Pedro Almodóvar*, Madrid: Libertarias.

Yarza, A. (2018), "Under the Sign of Saturn: The Labyrinth of Moral Choices in Francoist Spain" in *Making and Unmaking of Francoist Kitsch Cinema: From Raza to Pan's Labyrinth*, Edinburgh: Edinburgh University Press.

Young, A. (2010), *The Scene of Violence. Cinema. Crime. Affect*, Abingdon: Routledge.

Young, A. (2012), "Criminal Images: The Affective Judgment of Graffiti and Street Art," *Crime, Media, Culture*, vol. 8, issue 3, pp. 297–314.

Young, A. (2014), *Street Art, Public City: Law, Crime and the Urban Imagination*, Abingdon: Routledge.

Zevnik, A. (2014), "Maze of Resistance: Crowd, Space and the Politics of Resisting Subjectivity," *Globalizations*, vol. 12, issue 1: pp. 101–115.

Zieleniec, A. (2016), "The right to write the city: Lefebvre and graffiti," *Environnement Urbain / Urban Environment* [Online], vol. 10.

Zieleniec, A. (2007), *Space and Social Theory*. London: Sage Publications.

Zimmer, C. (2015), Surveillance Cinema. New York: New York University Press.

Zimmer, C. (2011), "Surveillance cinema: Narrative between technology and politics," *Surveillance & Society*, vol. 8, no. 4, pp. 427–440

Zipes, J. (2007), "Pan's Labyrinth (El laberinto del fauno)," *Journal of American Folklore*, Spring 2008, vol. 121, issue 480, pp. 236–240. Zieleniec, A., *Space and Social Theory*, London: Sage Publications.

Žižek, S. (2002), "Are We in a War? Do we Have an Enemy?" *London Review of Books*, vol. 14, no. 10.

Žižek, S. (2008), *Violence Six Sideways Reflections*, New York: Picador.

Zorach, R. (2000), " 'Tu imagen divina': The Fetishism of the Femme and Her Secret in Pedro Almodóvar's Tacones lejanos," *Torre de Papel*, vol. 10, 1, pp. 120–33.

Index